THE COMPLETE IDIOT'S GUIDE TO

DRAWING

MANGA

SHOUJO

Illustrated

Matt Forbeck and
Tomoko Taniguchi
for Idea + Design Works, LLC

ALPHA

A member of Penguin Group (USA) Inc.

741.5
For

To my daughter, Helen, my wife, Ann, my mother, Helen, and my grandmother, Angie, the most precious "girls" in my life.

—*Matt Forbeck*

I really appreciate that I was given the opportunity to work on this book. I enjoyed drawing all of the illustrations myself, and I would be really happy if American people would try to draw Japanese manga with this book!

—*Tomoko Taniguchi*

ALPHA BOOKS

Published by the Penguin Group

Penguin Group (USA) Inc., 375 Hudson Street, New York, New York 10014, U.S.A.

Penguin Group (Canada), 10 Alcorn Avenue, Toronto, Ontario, Canada M4V 3B2 (a division of Pearson Penguin Canada Inc.)

Penguin Books Ltd, 80 Strand, London WC2R 0RL, England

Penguin Ireland, 25 St Stephen's Green, Dublin 2, Ireland (a division of Penguin Books Ltd)

Penguin Group (Australia), 250 Camberwell Road, Camberwell, Victoria 3124, Australia (a division of Pearson Australia Group Pty Ltd)

Penguin Books India Pvt Ltd, 11 Community Centre, Panchsheel Park, New Delhi—110 017, India

Penguin Group (NZ), cnr Airborne and Rosedale Roads, Albany, Auckland 1310, New Zealand (a division of Pearson New Zealand Ltd)

Penguin Books (South Africa) (Pty) Ltd, 24 Sturdee Avenue, Rosebank, Johannesburg 2196, South Africa

Penguin Books Ltd, Registered Offices: 80 Strand, London WC2R 0RL, England

THE COMPLETE IDIOT'S GUIDE TO and Design are registered trademarks of Penguin Group (USA) Inc.

International Standard Book Number: 978-1-59257-738-5
Library of Congress Catalog Card Number: 2007941344

10 09 08 8 7 6 5 4 3 2 1

Interpretation of the printing code: The rightmost number of the first series of numbers is the year of the book's printing; the rightmost number of the second series of numbers is the number of the book's printing. For example, a printing code of 08-1 shows that the first printing occurred in 2008.

Printed in the United States of America

Note: This publication contains the opinions and ideas of its authors. It is intended to provide helpful and informative material on the subject matter covered. It is sold with the understanding that the authors and publisher are not engaged in rendering professional services in the book. If the reader requires personal assistance or advice, a competent professional should be consulted.

The authors and publisher specifically disclaim any responsibility for any liability, loss, or risk, personal or otherwise, which is incurred as a consequence, directly or indirectly, of the use and application of any of the contents of this book.

Most Alpha books are available at special quantity discounts for bulk purchases for sales promotions, premiums, fund-raising, or educational use. Special books, or book excerpts, can also be created to fit specific needs.

For details, write: Special Markets, Alpha Books, 375 Hudson Street, New York, NY 10014.

Publisher	**Marie Butler-Knight**
Editorial Director/Acquiring Editor	**Mike Sanders**
Senior Managing Editor	**Billy Fields**
Development Editor	**Ginny Munroe**
Production Editor	**Megan Douglass**
Copy Editor	**Jan Zoya**
Book/Cover Designer	**Kurt Owens**
Proofreader	**Aaron Black**

Contents

Part 1: Characters

Part 2: Settings

Part 3: Tropes and Trappings

Appendixes

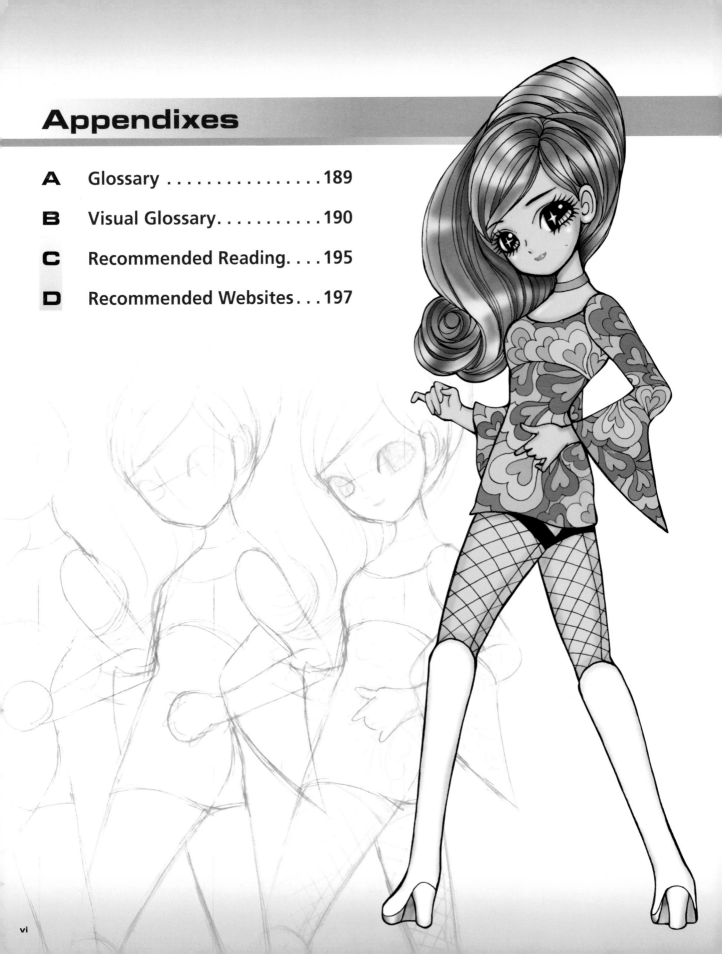

Introduction

Welcome to *The Complete Idiot's Guide to Drawing Manga Illustrated: Shoujo.* Despite that being a mouthful of a title, we hope you'll find the contents of this book easy to swallow.

While this is a *Complete Idiot's Guide*, this is not a beginner's course. If you are still searching for the first steppingstone on your path toward manga enlightenment, we suggest starting with *The Complete Idiot's Guide to Drawing Manga Illustrated.* You'll recognize most of the title from this book, except for the "shoujo" part.

Shoujo is one of the most popular varieties of manga. Girls of all ages read it, from 3 to 103, and men and boys enjoy it, too. If you like solid characters, deep relationships, and soap-operatic drama accompanied by wonderful artwork, too, then you're in good company.

How to Use This Book

This book is broken down into three large sections. We start with the simpler stuff first and become more adventurous as we move along.

Part 1: "Characters." You don't have a story until you have a cast of characters. In this section, we cover the basics: girls, boys, women, and men. What else is there?

Part 2: "Settings." While a lot of shoujo is set in modern-day Japan, there's plenty that's not. We start with and then step out of the standard and explore some different places and times in which you can set your stories.

Part 3: "Tropes and Trappings." The classic shoujo story revolves around romance, no matter where it's set or who's in it. That's not where it ends, though, so we take a tour through horror, fantasy, and comedy as well.

Extras

Throughout the book, you'll find snappy little side-bars designed to help answer questions and illuminate the world of manga fantasy creatures for you.

Manga-nese These definitions of words come from the world of manga. Often these are Japanese words, like "ganbatte!" which means "good luck!"

Chimeric Koans These are miscellaneous bits of information that don't seem to fit anywhere else—but which we're sure you'll appreciate.

AIIEEE!!! These feature warnings about things that might go wrong with a particular drawing. Pay careful attention here, or you'll end up saying "AIIEEE!!!" too.

Pearls of Wisdom These are bits of knowledge that you'll want to hold on to like the precious things they are.

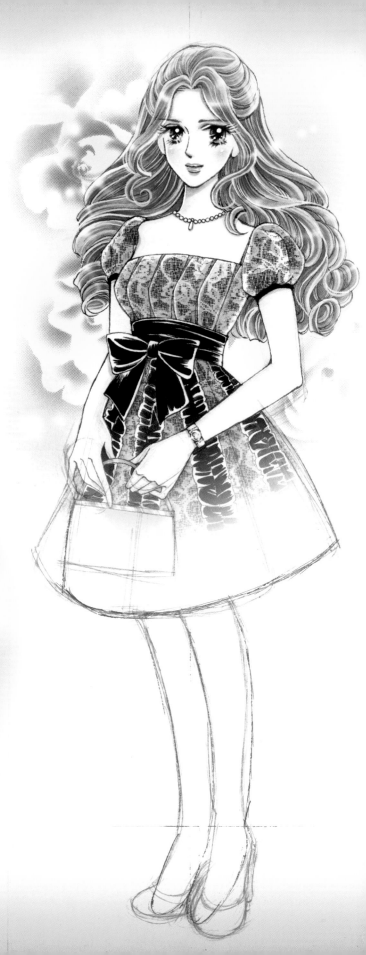

Acknowledgments

We'd like to thank the fine people at IDW for asking us to create this book and giving us the encouragement to finish it. Special thanks go to Kris Oprisko for his wise and steady guidance.

Trademarks

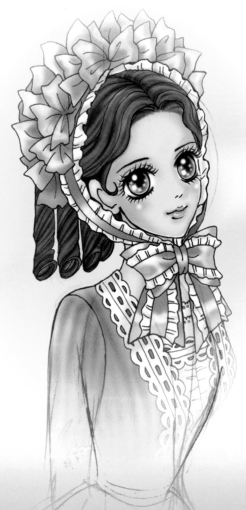

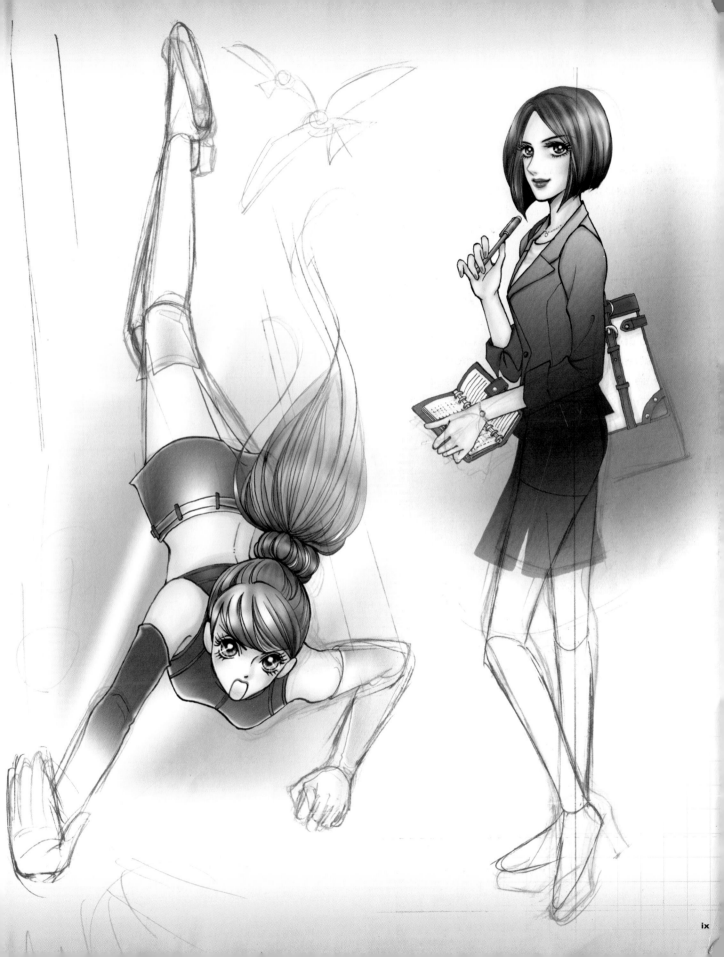

Part 1
Characters

All stories feature characters, whether in shoujo manga or any other form of literature. To understand shoujo manga, it's good to know some of the basic types of recurring characters that show up in its pages, and that's just what this part is about.

Manga is the most popular form of literature in Japan. People of all classes and genders read it from their earliest grades to their dying days. It stretches across all barriers and can be found in every genre, from wild tales of princesses and distant planets to business manuals.

Being for girls, most shoujo manga features girls as the protagonists. They also crop up as the main friends and rivals.

Boys figure largely in these stories, too. Sometimes they are friends. Other times they take the role of villains. Often one of them is an object of desire or affection.

Being young, girls often have to deal with their elders, too. Mothers and fathers, mentors and predators, and more, populate shoujo stories of all kinds.

We cover how to draw examples of all these sorts and more. By the time you're done, you'll be able to recognize these archetypes and concoct vivid characters of your own.

Girls:
Otherwise Known as the Heroines

1

Shoujo manga is directed at girls, so it's no surprise that some of the most popular characters in it are also girls. Just about any young lady can star in a shoujo tale, but there are three that you see crop up most often in modern-day stories: the beauty, the nerd, and the schoolgirl.

We start with the traditional Japanese schoolgirl. In Japan, girls usually wear a specific type of uniform when at school, and many shoujo stories feature such girls. Here we show by example just how such clothing looks.

After that, we examine the beauty, as most girls in manga (or comics of any kind) tend to be gorgeous. Readers would rather look at pretty characters than ugly ones, and shoujo caters to this by showing idealized versions of most of the characters, especially the central protagonists.

We wind up with the nerdy girl. Brainy and clever, she often neglects her beauty because she just doesn't care too much about it. She cleans up well when given the chance, and you can see the prettiness underneath her disheveled shell.

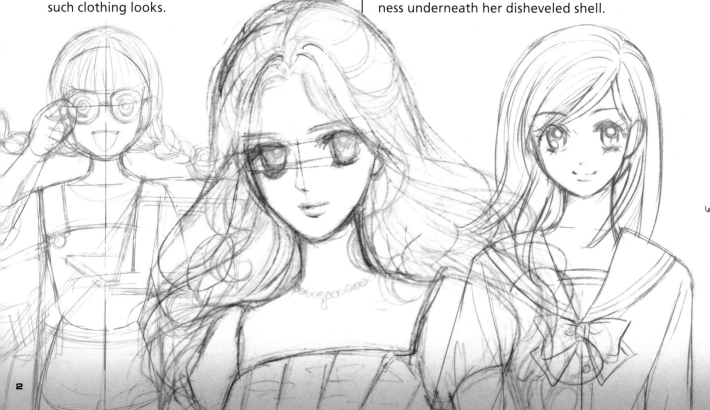

The Schoolgirl

Like many works of fiction, shoujo features elements of escapism and unreality. Not everyone in the real world is beautiful, but most of the girls in shoujo look great. Some are absolutely breathtaking, as you'll see in this section.

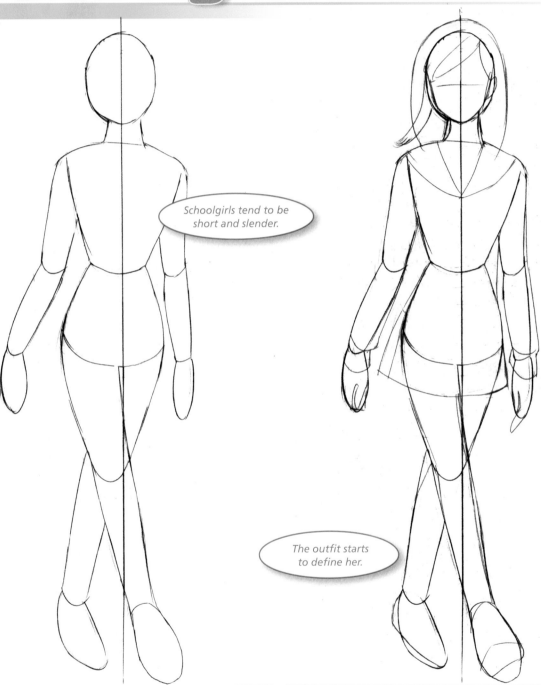

Schoolgirls tend to be short and slender.

The outfit starts to define her.

1. Break down the figure into its component shapes. Make the shapes as simple as possible right now. Circles and cylinders should make up most of your figure. Think of it as a mannequin without clothes.

2. Add some more details. Start with the schoolgirl's hair and clothing. The skirt and shirt have a distinctive shape.

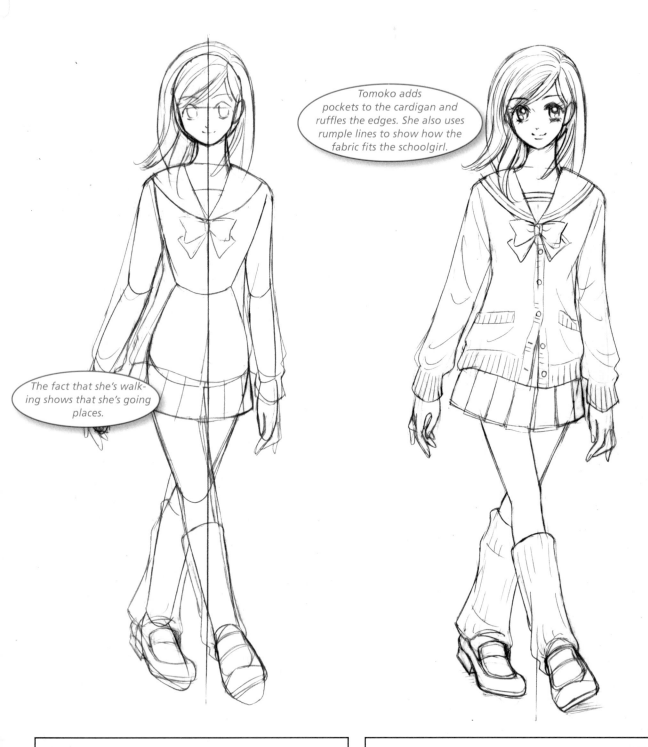

Shonen means "boy," while *shoujo* means "girl." Over 100 years ago, shonen only meant "child," and there wasn't a specific word for boy or girl.

Chimeric Koans

Tomoko adds pockets to the cardigan and ruffles the edges. She also uses rumple lines to show how the fabric fits the schoolgirl.

The fact that she's walking shows that she's going places.

3. Pick out the large eyes on her face. Add a bow to her cardigan and a fringe to her skirt. Note the knee-high leggings and the practical shoes.

4. Bring the character to life. Define the fingers and the face. Add the traditional lines to her clothing. Define the waves of her hair.

**Pearls
of Wisdom**

Almost all Japanese children wear uniforms to school. Boys wear a black suit called a *gakuran*, while girls where what's known as a sailor's outfit, based upon the old uniforms of the British Navy.

You can black in the centers of the eyes, but be sure to use white space to show the light sparkling in them, too.

Tomoko uses a dark band around the top of the schoolgirl's hair, which looks funny for now. Watch how it changes soon.

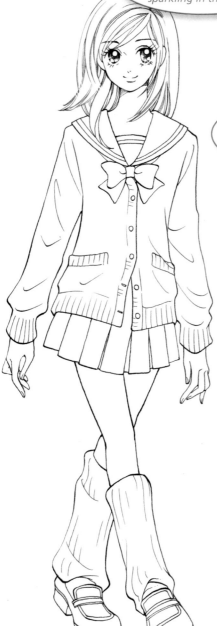

5. Now it's time to lay down some inks. Use thicker lines around the figure's skin and the edges of her clothing to separate them strongly. Use thinner lines for her hair and for the interior lines, like the ruffles on her cardigan and her socks. Once you're done, make a copy of this before you move on. You'll need it later.

6. Fill in some spots with screentones. Stick with solid grays on the clothing, but use gradations on the hair and shoes, directed to show how the light plays on the figure.

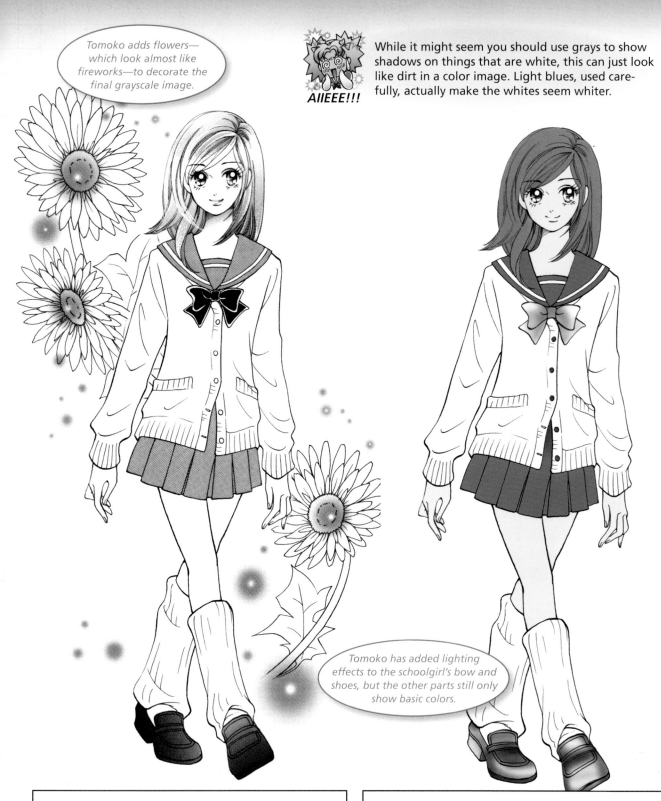

Tomoko adds flowers—which look almost like fireworks—to decorate the final grayscale image.

AIIEEE!!!

While it might seem you should use grays to show shadows on things that are white, this can just look like dirt in a color image. Light blues, used carefully, actually make the whites seem whiter.

Tomoko has added lighting effects to the schoolgirl's bow and shoes, but the other parts still only show basic colors.

7. While most manga interior pages use grayscale (black and white) artworks, working in color is fun and useful for covers and the like. Go back to an unmarked copy of your inks and add some colors here. Don't bother with gradations yet.

8. Add shadows and lights to add a three-dimensional feel to your schoolgirl. Tomoko uses blues for shadows on the girl's shirt and socks. She also adds bands of white in the girl's hair to depict lights shining on her. These also help frame the girl's face.

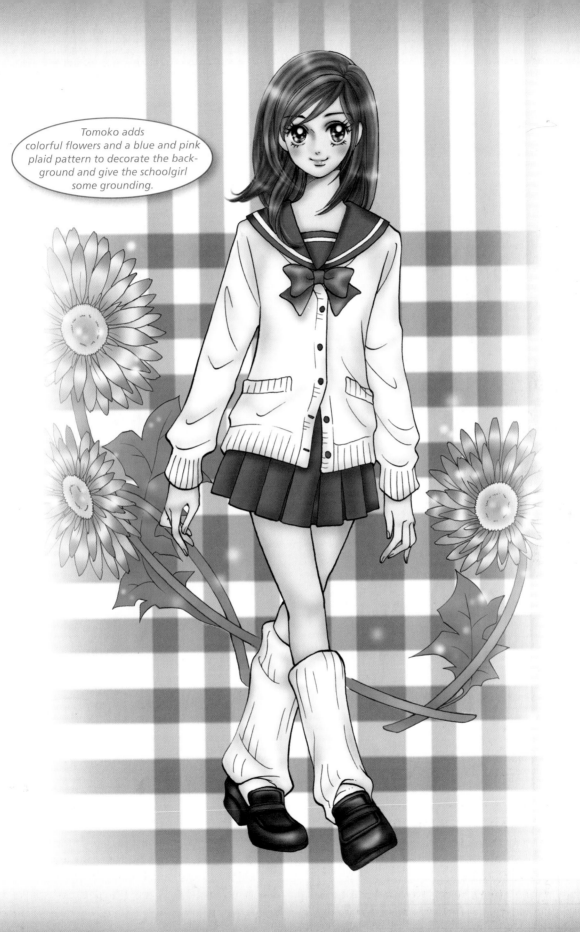

Tomoko adds colorful flowers and a blue and pink plaid pattern to decorate the background and give the schoolgirl some grounding.

The Beauty

Many works of fiction feature idealized heroes, people who look better than anyone humanly could. Most shoujo heroines, for instance, are stunning beauties, also known as *bishoujo*. Their looks make it easy to see how the heroes—and sometimes the villains—are so attracted to them.

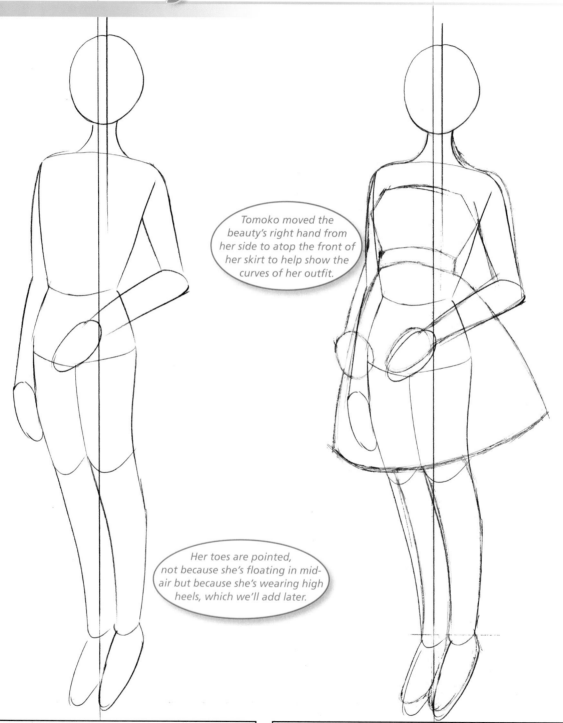

Tomoko moved the beauty's right hand from her side to atop the front of her skirt to help show the curves of her outfit.

Her toes are pointed, not because she's floating in mid-air but because she's wearing high heels, which we'll add later.

1. Again, start out with a mannequin figure. See how the beauty stands straight up, almost like she's stretching toward the sky.

2. Add in the outline of the beauty's clothing. Notice how the skirt flairs away from her hips.

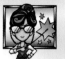

Manga-nese

Bishoujo is a particular kind of manga or anime that features pretty girls. To be clear, shoujo is for girls, and bishoujo is about them.

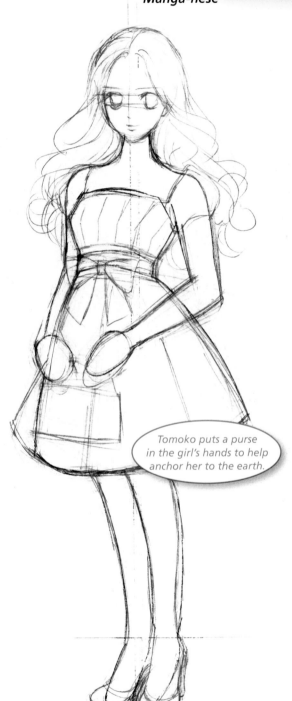

The darkening around the eyes makes her seem more human.

Tomoko puts a purse in the girl's hands to help anchor her to the earth.

3. Add in the girl's hair and eyes, and add some details to her dress. Add the heels to the shoes. Note the long, curly hair that represents beauty in many shoujo stories.

4. Add curls to the hair. Go as elaborate with these as you like. Work ruffles into the sides of the dress and add puffy, short sleeves to it, too. Add a watch if you like.

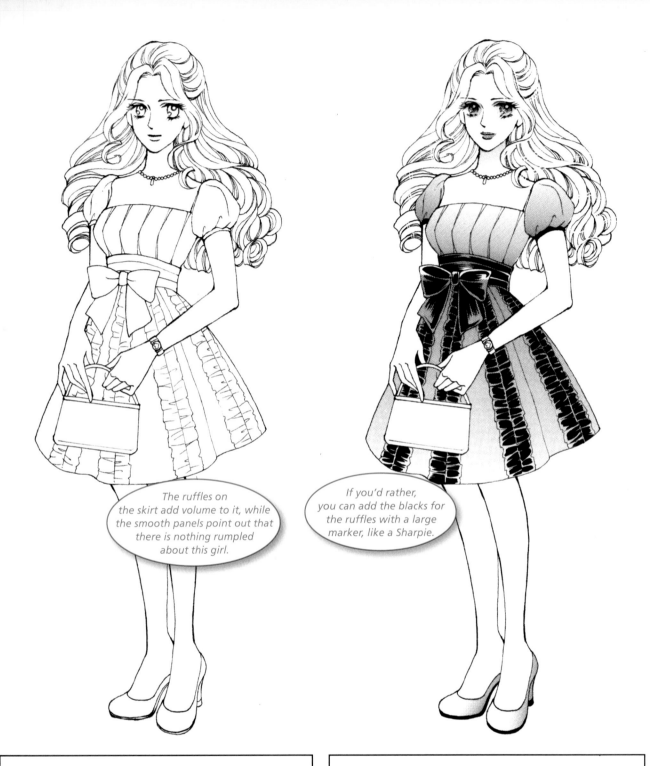

The ruffles on the skirt add volume to it, while the smooth panels point out that there is nothing rumpled about this girl.

If you'd rather, you can add the blacks for the ruffles with a large marker, like a Sharpie.

5. The beauty demands a lot of detail from your inks. Varying your line thickness in her hair enables you to blend thick strands of hair without making them look as rubbery as tentacles.

6. Add your screentones. Go dark with the bow and the skirt's ruffles to add depth to the dress. The gradations in the smooth parts of the skirt and dress indicate the lighting.

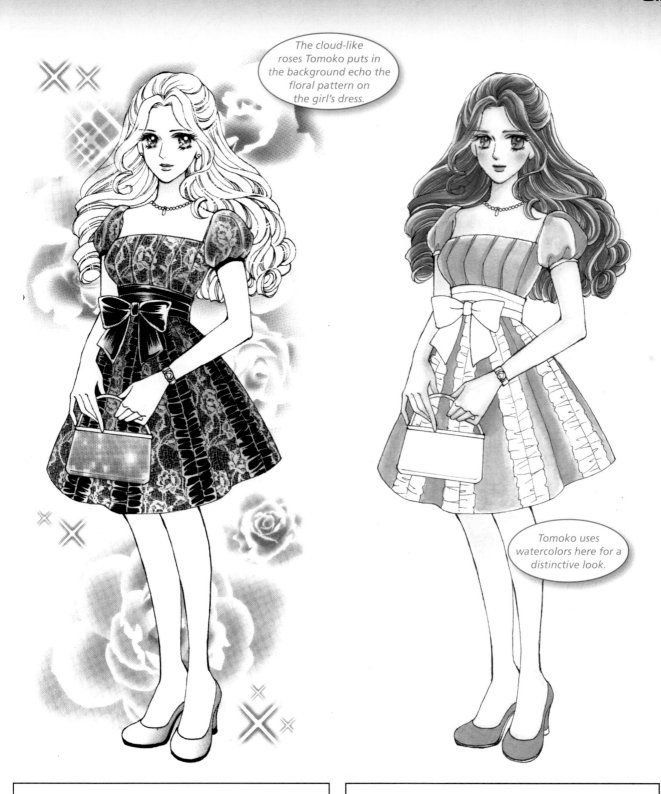

The cloud-like roses Tomoko puts in the background echo the floral pattern on the girl's dress.

Tomoko uses watercolors here for a distinctive look.

7. Add more screentones and weather them to fit your lighting. If you can't find a screentone texture you like for the smooth parts of the dress, you might have luck with a computerized version.

8. Going back to your inks, choose feminine colors for the girl's dress, skin, and hair. Notice how the yellow highlights work within the red.

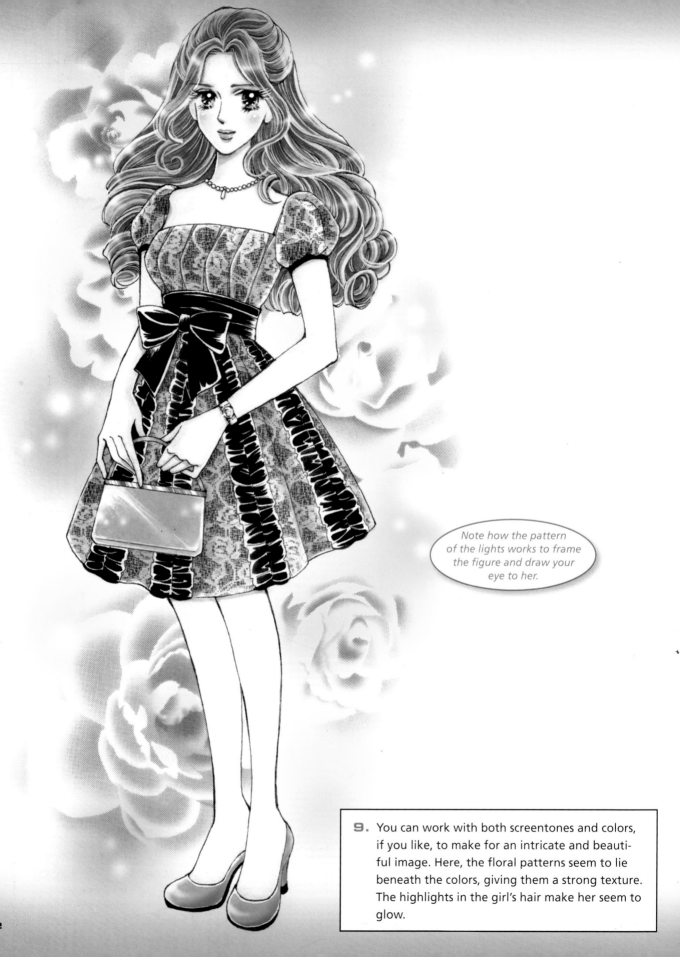

Note how the pattern of the lights works to frame the figure and draw your eye to her.

9. You can work with both screentones and colors, if you like, to make for an intricate and beautiful image. Here, the floral patterns seem to lie beneath the colors, giving them a strong texture. The highlights in the girl's hair make her seem to glow.

The Nerd

While most girls in manga are pretty, they don't all care about their looks as much as others. Some are more concerned about their families, their pets, or their schoolwork, among other things. By way of example, we'll examine a nerd, a cute and friendly girl who worries more about her hobbies than her appearance.

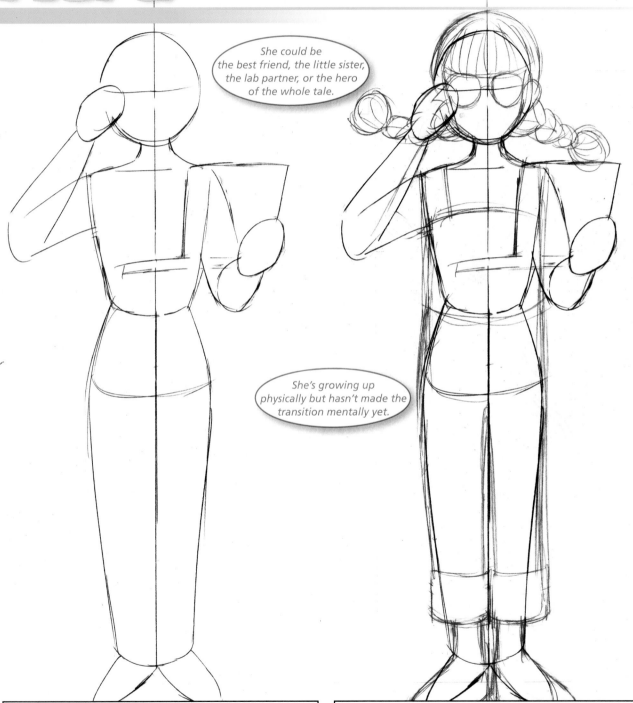

She could be the best friend, the little sister, the lab partner, or the hero of the whole tale.

She's growing up physically but hasn't made the transition mentally yet.

1. This girl starts out with her feet firmly on the ground. She has one hand to her head, showing that she has an idea. In her other hand, she holds her laptop.

2. Work in the details. Her hair is in easy-to-handle braids, and she wears glasses and overalls. Note how her pants don't quite reach all the way to her ankles.

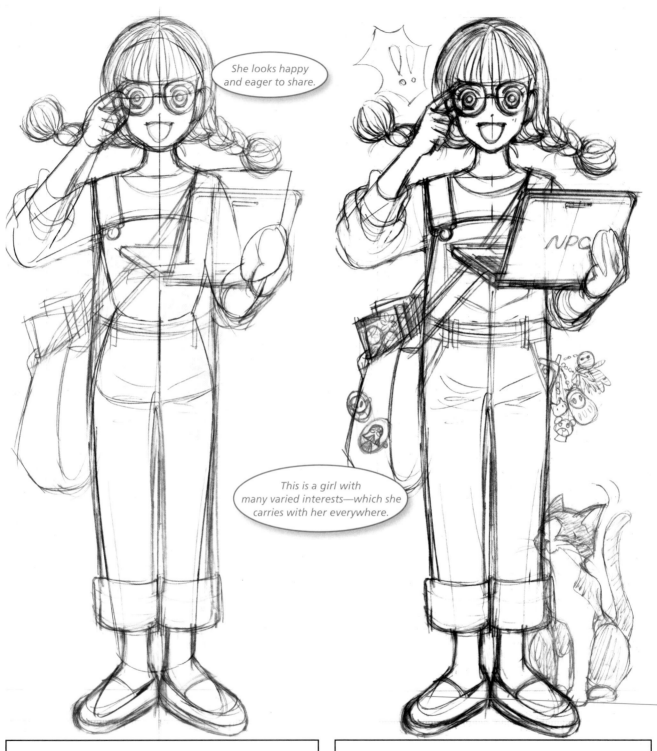

3. Add a messenger bag around her shoulder and hip, overflowing with her stuff. Show more details on her hair and face. Sketch out the edges of her shirt.

4. Add in more details. The exclamation points indicate she has an idea. The items spilling from her pockets and the cat nuzzling her leg show that she has many things she cares about.

Chimeric Koans

The "NPC" on her computer is a nice touch. It means "nonplayer character" (or someone not the hero) in roleplaying games. It's also a play on the generic initials for a Personal Computer (PC).

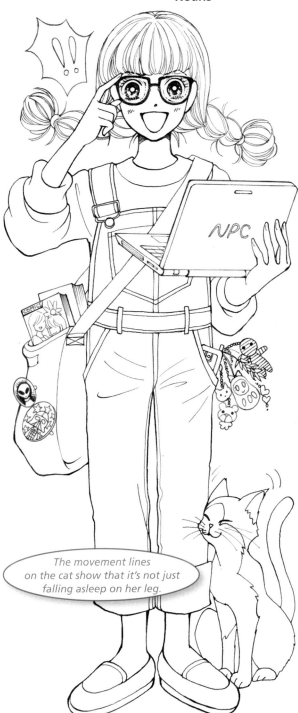

The movement lines on the cat show that it's not just falling asleep on her leg.

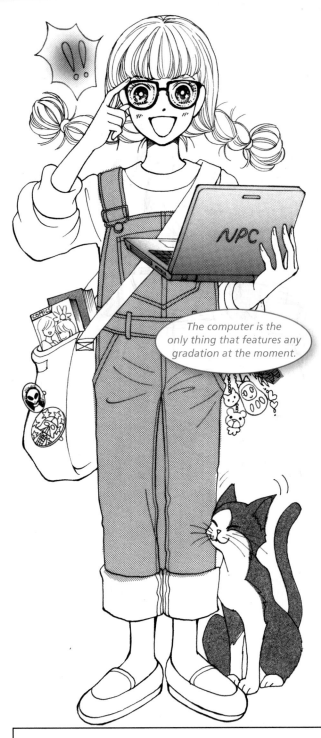

The computer is the only thing that features any gradation at the moment.

5. The inked details on the girl tell you a lot about her. See how her hair doesn't stay in its braids very well. Her exposed skin looks feminine, but the lines of her clothes are boyish.

6. For a girl with simple tastes, we go with simple screentones. No floral patterns here. Her bib overalls come in a single, dense pattern, while a more mottled pattern does a better job of depicting the cat's fur.

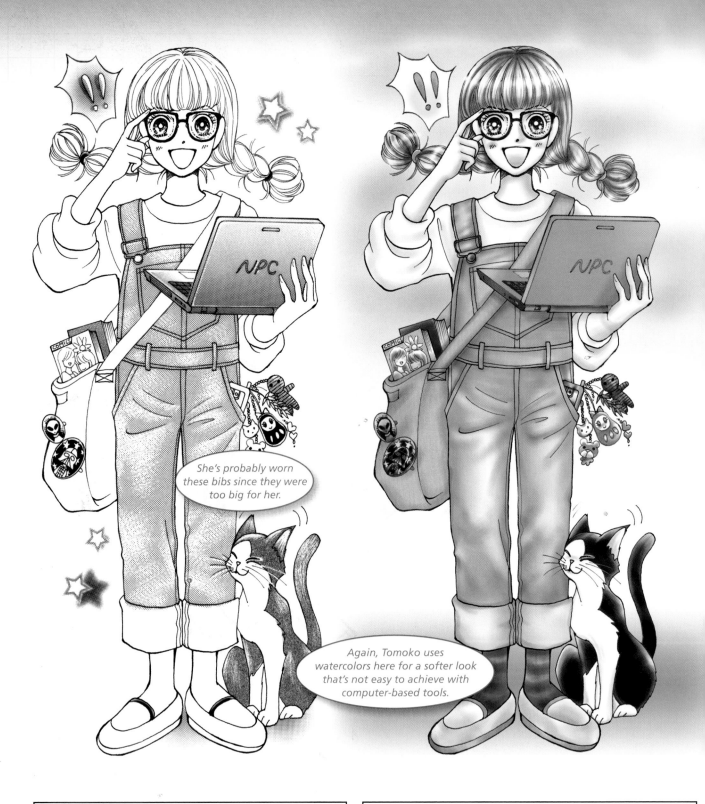

She's probably worn these bibs since they were too big for her.

Again, Tomoko uses watercolors here for a softer look that's not easy to achieve with computer-based tools.

7. Rough up the screen tones to show how rumpled the girl's overalls really are. This shows not only the highlights on the clothing but also how rough and worn it is. Tomoko adds some stars to the background to indicate how much whirls around in this girl's head.

8. Go back to your clean inks and add in colors. Choose what you like, but a few feminine touches—like a pink computer—can emphasize that this girl isn't oblivious to her gender. The pink shirt helps with that, too.

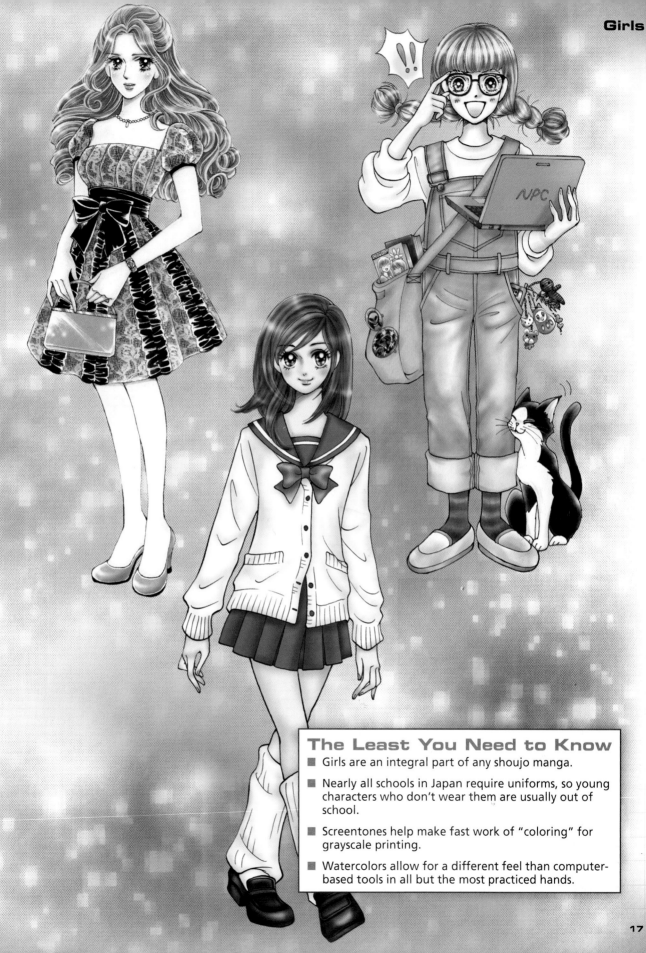

The Least You Need to Know

■ Girls are an integral part of any shoujo manga.

■ Nearly all schools in Japan require uniforms, so young characters who don't wear them are usually out of school.

■ Screentones help make fast work of "coloring" for grayscale printing.

■ Watercolors allow for a different feel than computer-based tools in all but the most practiced hands.

Boys:
Objects of Affection

In This Chapter

- The boy you meet at school

- The bad boy with the good heart

- The boy with all the brains

While shoujo manga is for girls, it often concerns something girls like to think about a lot: boys. It's only natural for girls to be curious about romantic figures in their lives and to wonder how to relate to them as they grow older. Shoujo can show girls examples of all sorts of different ways to connect.

Most schoolgirls know schoolboys of all types, so we start there. The schoolboy is the kind of boy a girl might have grown up with, but as they get older they start to become interesting to each other in brand-new ways. Sometimes the schoolboys seem too familiar to a girl, but that's not always a bad thing.

After that, we rough up the bad boy, the kind of tough guy many schoolgirls might find mysterious, with just a hint of danger. His reputation may be far worse than he really is, or it may be just a hint as to the troubles that follow him around.

From there, we tackle the smart boy. He's wealthy and wise, although he may be a bit clueless about things like fashion or even good manners. He sometimes has his head in a cloud, a computer, or a book, but he's a fine-enough friend if you can coax him out of his shell.

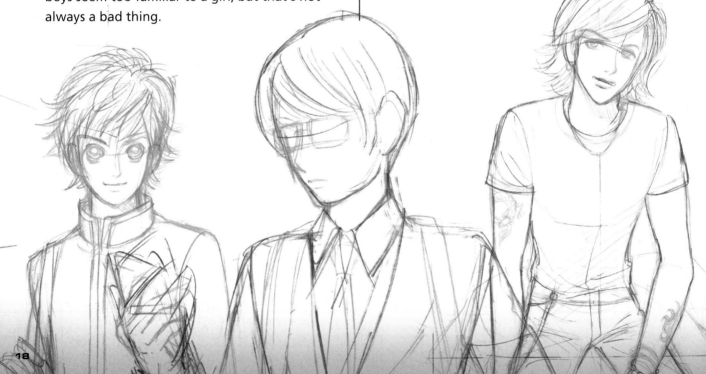

The Schoolboy

The schoolboy is the counterpart of the school-girl. He's a staple of shoujo manga, and also is the sort of guy that most shoujo readers are familiar with. He's often idealized, a figure who the heroine has known forever but just doesn't see as a romantic interest, at least at first.

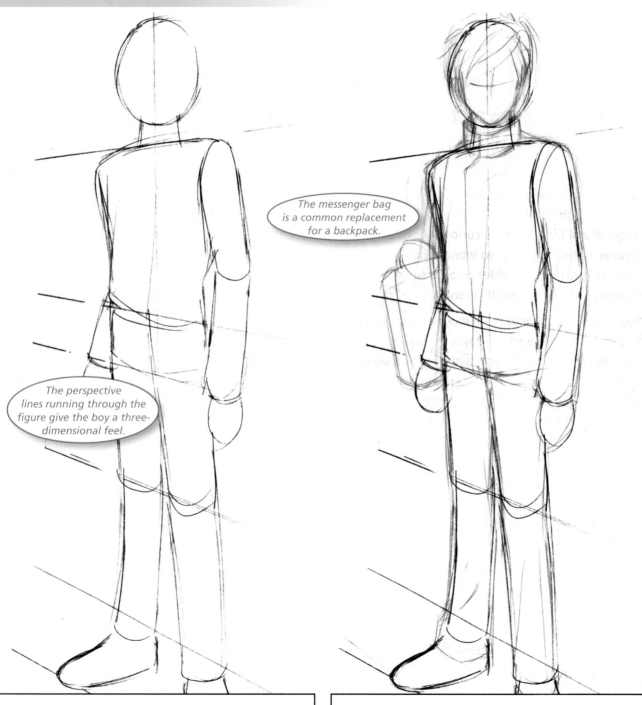

The messenger bag is a common replacement for a backpack.

The perspective lines running through the figure give the boy a three-dimensional feel.

1. Break down the figure into its component shapes. It should look a lot like a mannequin. Notice the confident stance.

2. Sketch in the schoolboy's clothing and hair. Notice that Tomoko has given him a messenger bag and has moved his right arm up for a natural-looking hold on it.

Artists use perspective lines to keep them on track when trying to make a two-dimensional representation (a drawing) of something three-dimensional (like a person). They help the artist make the drawing look natural and real. You can use several sets of perspective lines in a drawing, but it's best to stick with one or two at first.

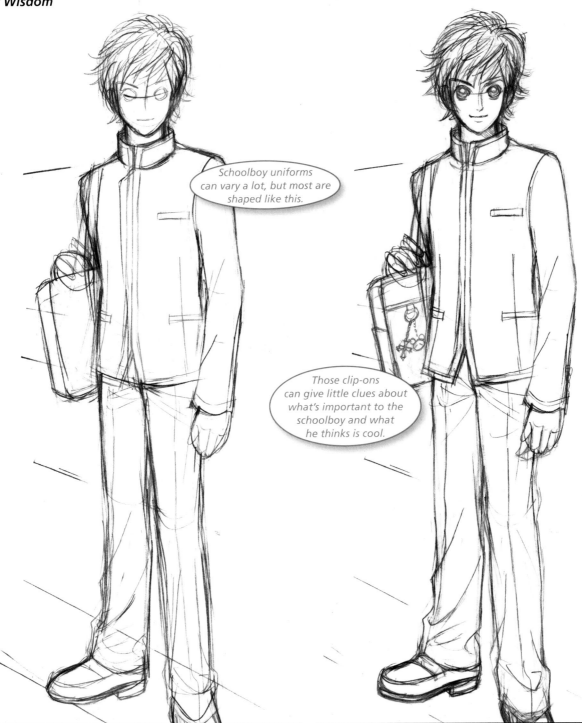

Schoolboy uniforms can vary a lot, but most are shaped like this.

Those clip-ons can give little clues about what's important to the schoolboy and what he thinks is cool.

3. Rough up the hair a bit and draw in the eyes. Add some details to the school uniform here, like piping on the hems and pockets.

4. Work in more details here. Add wrinkles to the pants, showing how they drape on the boy. The coat is pressed and made of thicker material, and should remain smooth. Add some clip-on decorations to the messenger bag if you like.

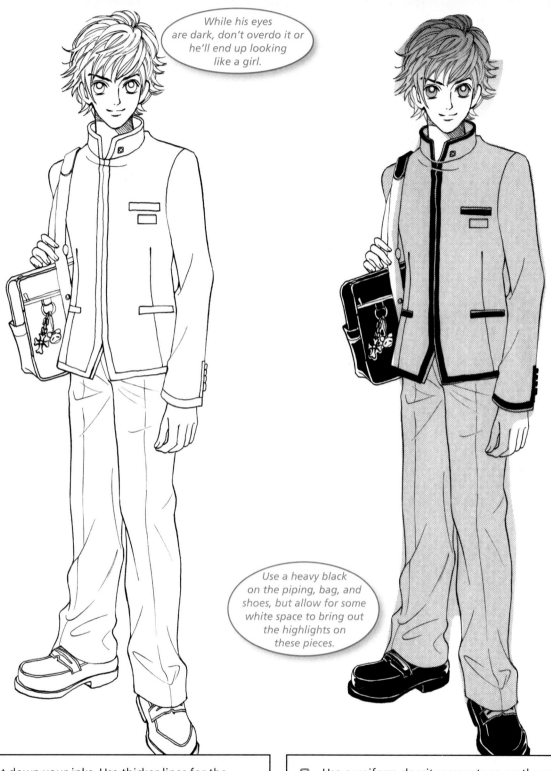

While his eyes are dark, don't overdo it or he'll end up looking like a girl.

Use a heavy black on the piping, bag, and shoes, but allow for some white space to bring out the highlights on these pieces.

5. Set down your inks. Use thicker lines for the edges and for his eyes. Thick lines around the shoes make him feel solid and grounded, too.

6. Use a uniform-density screentone on the schoolboy's clothes. Work with a gradated version for his hair, leaving it lighter underneath. This implies lighting from below and nicely frames his eyes.

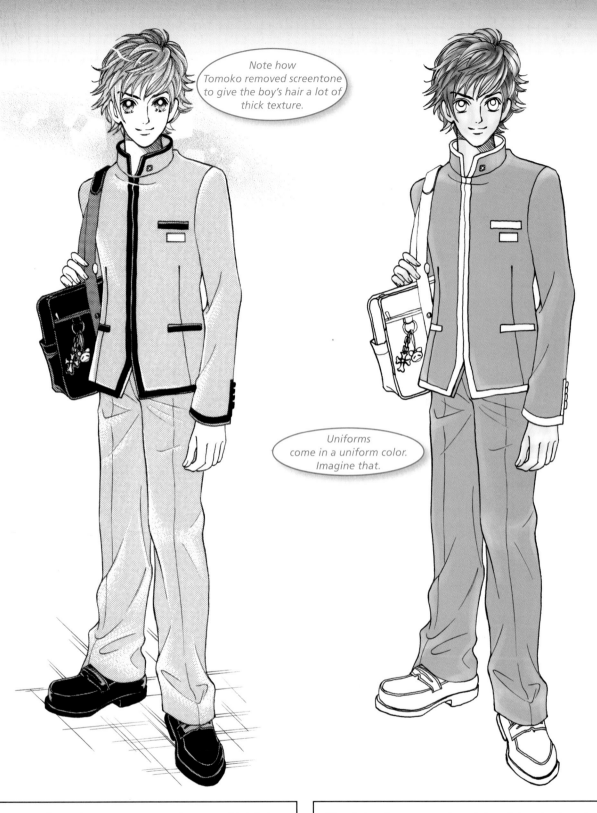

7. Rough up the screentone to give some highlights to the boy's clothes. This especially helps with the wrinkles on his pants. Add some clouds in the background, behind his shoulders, to lend some depth. A hint of flooring keeps him on the ground.

8. Going from your clean inks, pick a single color for the uniform and a standard color for the boy's hair.

Manga-nese

Shonen stands for both boys and the comics they read. It's the opposite of shoujo, and it tends to focus on action and adventure rather than relationships. Boys and girls can read both shonen and shoujo manga, of course, but shonen is made for boys, just the way shoujo is made for girls.

Examine the difference between the shoes here and in the finished monochrome version. This shows you two ways to add detail.

9. Tomoko goes with purple piping, and she makes the bag a matching color. The shoes are black, but they aren't as solid of a color, so that she can show details with black lines. Maybe he has some *shonen* manga in that bag.

The Bad Boy

The bad boy isn't always bad, especially from a girl's point of view. He's the kind of guy your parents wouldn't like you to bring home, though, and is the definition of the wrong crowd. Maybe that's what makes him so intriguing.

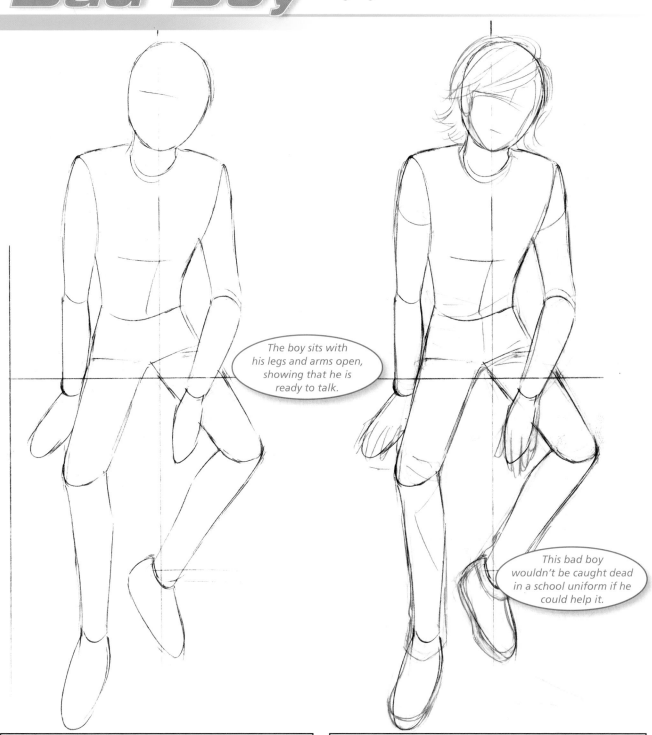

The boy sits with his legs and arms open, showing that he is ready to talk.

This bad boy wouldn't be caught dead in a school uniform if he could help it.

1. Break down the figure. Tomoko chooses to seat him on a low wall or bench, sitting comfortably, almost slouching.

2. Sketch in the hair and the edges of the boy's clothing. Draw him wearing long pants (maybe jeans) and a T-shirt.

Chimeric Koans

In shoujo manga, the bad boy is usually the object of the heroine's desire. He's someone new and mysterious and maybe just a bit frightening. Figuring out his secrets plays a big part in the story.

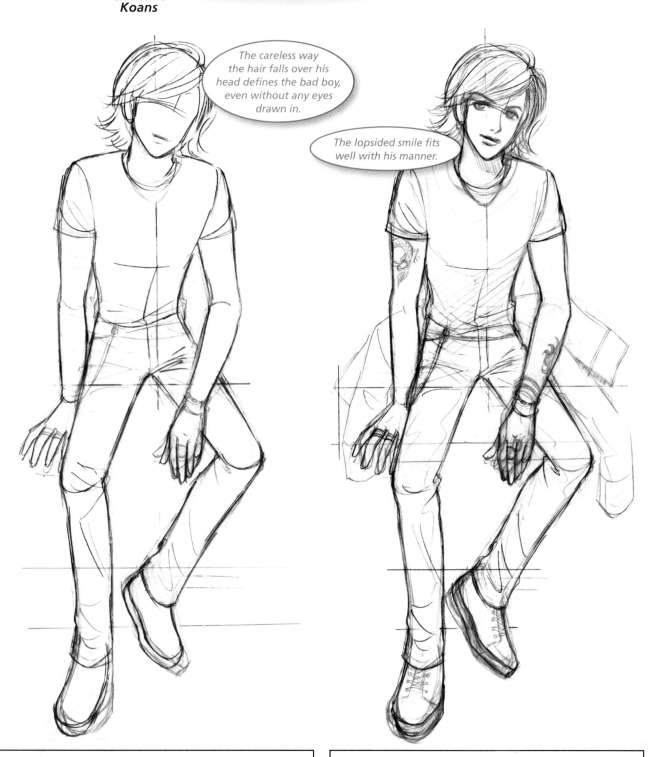

The careless way the hair falls over his head defines the bad boy, even without any eyes drawn in.

The lopsided smile fits well with his manner.

3. Pick out some more details, like the bracelet on his wrist, the rings on his fingers, and the chain that runs to his wallet. Add some wrinkles to his clothes and rough in the edges of the wall.

4. Put in the final details, including the eyes and nose. Add some tattoos on the arms and toss a jacket in behind him. Put a necklace around his neck.

The lines of the low wall on which the bad boy sits not only give him a strong foundation but also show you how to draw him. Without those lines of the wall, the boy would seem like he was squatting in empty space, but they help show the foreshortening of his thighs as they point toward the viewer.

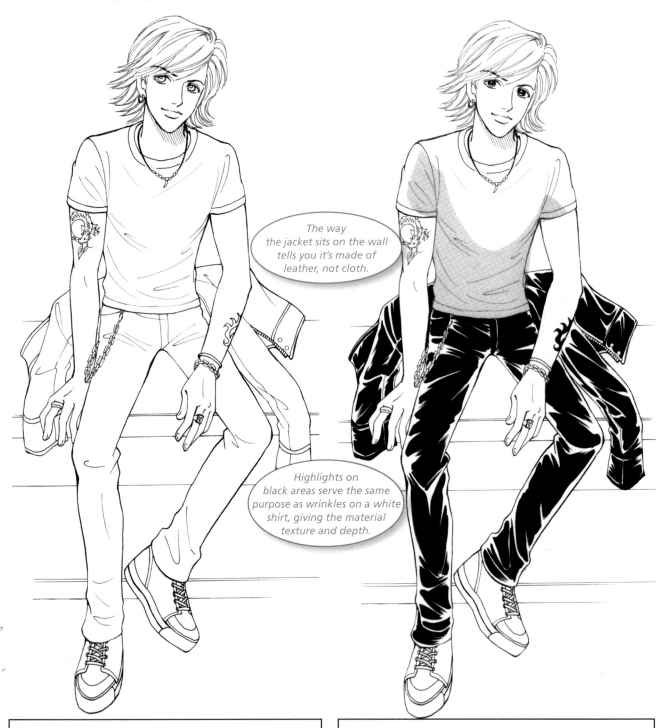

*The way
the jacket sits on the wall
tells you it's made of
leather, not cloth.*

*Highlights on
black areas serve the same
purpose as wrinkles on a white
shirt, giving the material
texture and depth.*

5. Adding in the inks can make a figure like the bad boy seem a bit too clean. Once you're through with your heavier inks, go back through and add in some wrinkle lines to his clothing with a finer touch.

6. Bad boys wear black, and this one is no exception. Blacken his jeans and coat, but take care to leave white space to show the highlights here. Add some screentone to the shirt and under the neck to show shadows from the light overhead.

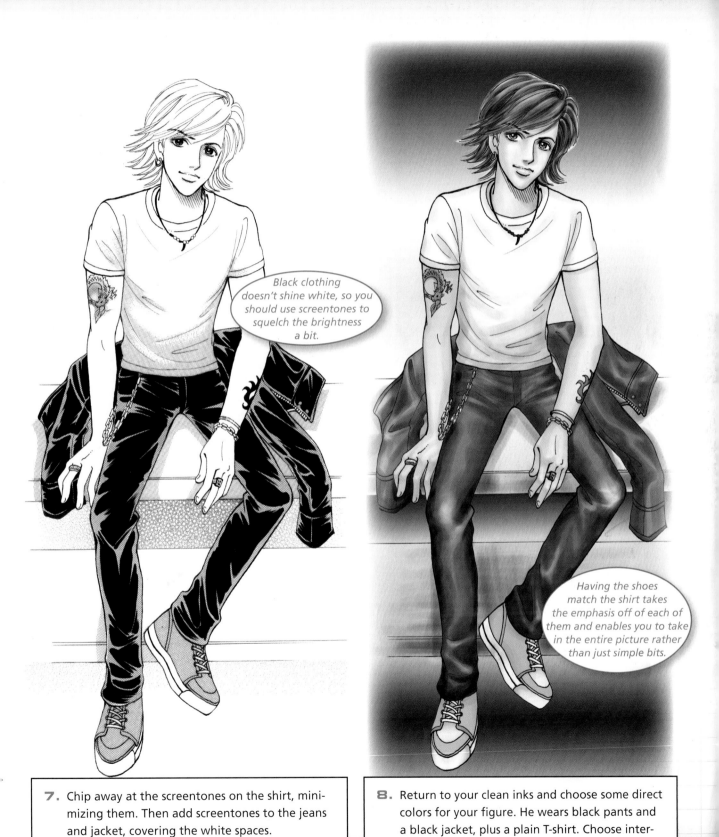

Black clothing doesn't shine white, so you should use screentones to squelch the brightness a bit.

Having the shoes match the shirt takes the emphasis off of each of them and enables you to take in the entire picture rather than just simple bits.

7. Chip away at the screentones on the shirt, minimizing them. Then add screentones to the jeans and jacket, covering the white spaces.

8. Return to your clean inks and choose some direct colors for your figure. He wears black pants and a black jacket, plus a plain T-shirt. Choose interesting colors for his tattoos and his hair.

The Smart Boy

In shoujo manga, the nerd is rarely the object of affection. However, just because a boy is smart doesn't mean he's nerdy. Think of a smart, wealthy boy, but perhaps not too stylish, and you have our smart boy.

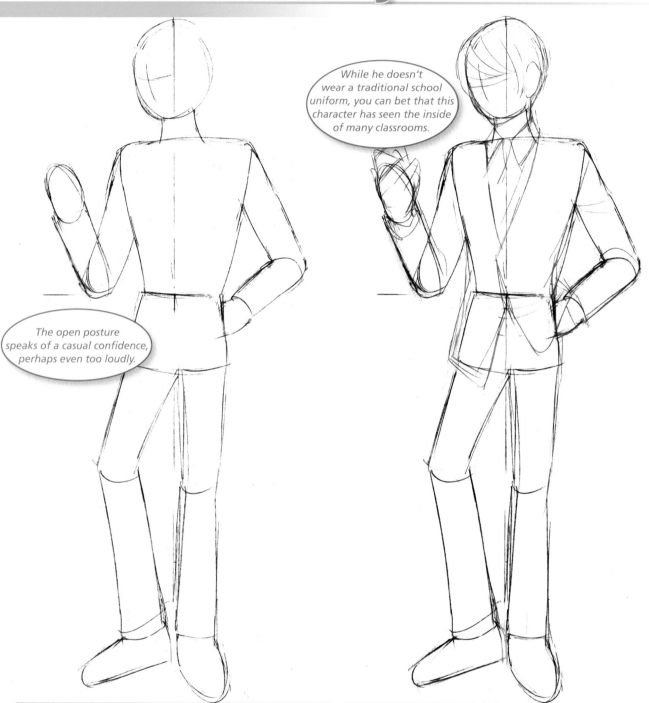

While he doesn't wear a traditional school uniform, you can bet that this character has seen the inside of many classrooms.

The open posture speaks of a casual confidence, perhaps even too loudly.

1. Break down the smart boy's body shape. The hand on the hip and the other hand bent in the air almost puts him in a teaching pose.

2. Sketch in the hair and the clothes. Put him in a jacket and a tie. Have him reading something from a gadget in his hand.

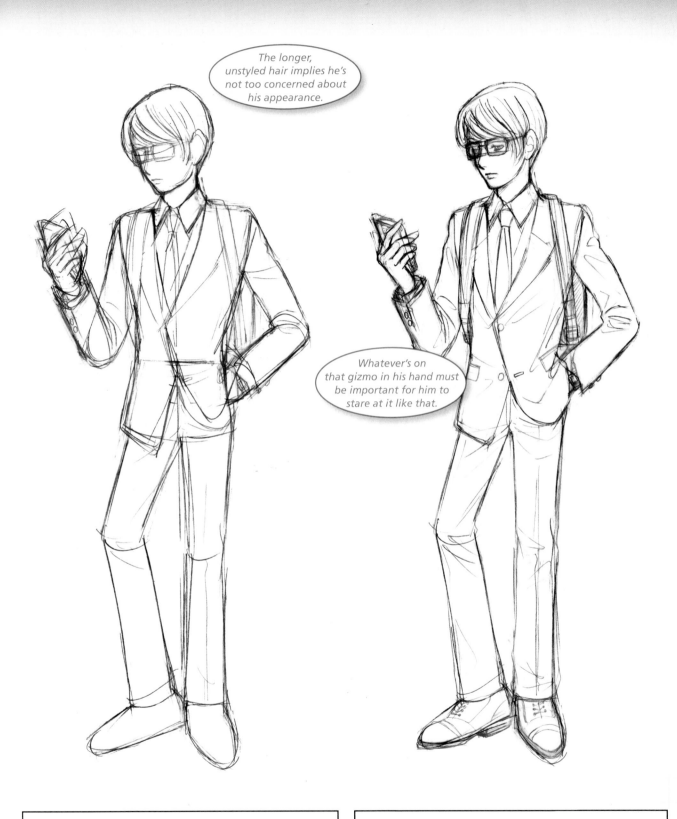

3. Add a backpack, and put glasses on the boy's face. Details like the shape of his cuffs work well here.

4. Put some eyes behind those glasses, and add pockets and crease-lines to his suit. A few more lines can add some texture to his hair. Laces and lines on the shoes make them dressier.

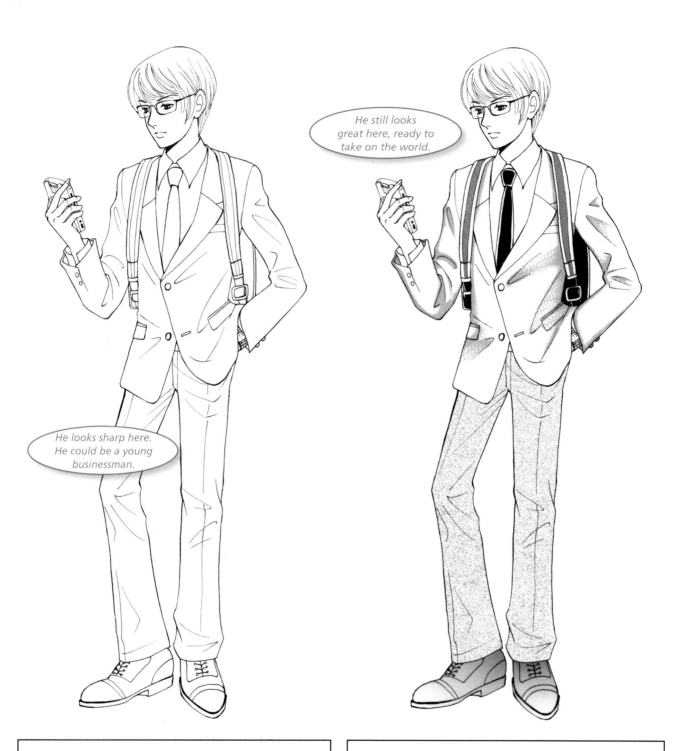

He looks sharp here. He could be a young businessman.

He still looks great here, ready to take on the world.

5. Use strong inks on the edges of the smart boy's silhouette, but use lighter inks just about everywhere else. This is a complex and interesting boy, and his inks should reflect that.

6. Use a solid screentone on his pants and the straps of his backpack. Use gradated screentones to fill in the wrinkles on his jacket and give the fabric some real texture. The gradation on the shoes shows the direction of the perceived light source.

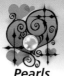

Pearls of Wisdom

Choosing strange or different colors or patterns changes the way the viewer thinks about the character. Imagine the smart boy in a dark suit instead of green or plaid, or with blond hair instead of green. He'd look like someone else entirely.

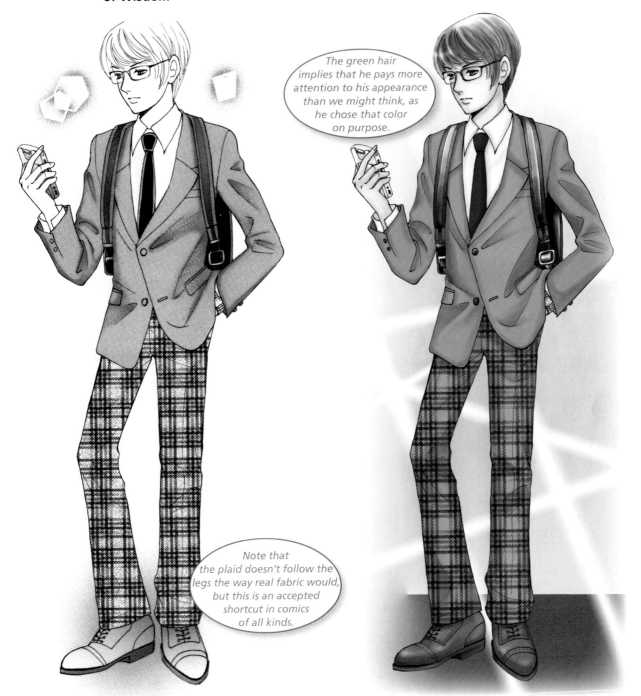

The green hair implies that he pays more attention to his appearance than we might think, as he chose that color on purpose.

Note that the plaid doesn't follow the legs the way real fabric would, but this is an accepted shortcut in comics of all kinds.

7. Tomoko uses a solid screentone over the bits she's already used on the jacket. This gives it all a very natural feel. To counter that polished look, she uses plaid on the pants.

8. Check back to your clean inks and then color in the figure as you like. Tomoko uses the plaid screentone and then adds some wrinkles under that with her colors. She replicates the effect of the gradated screentones on the wrinkles of the jacket, too.

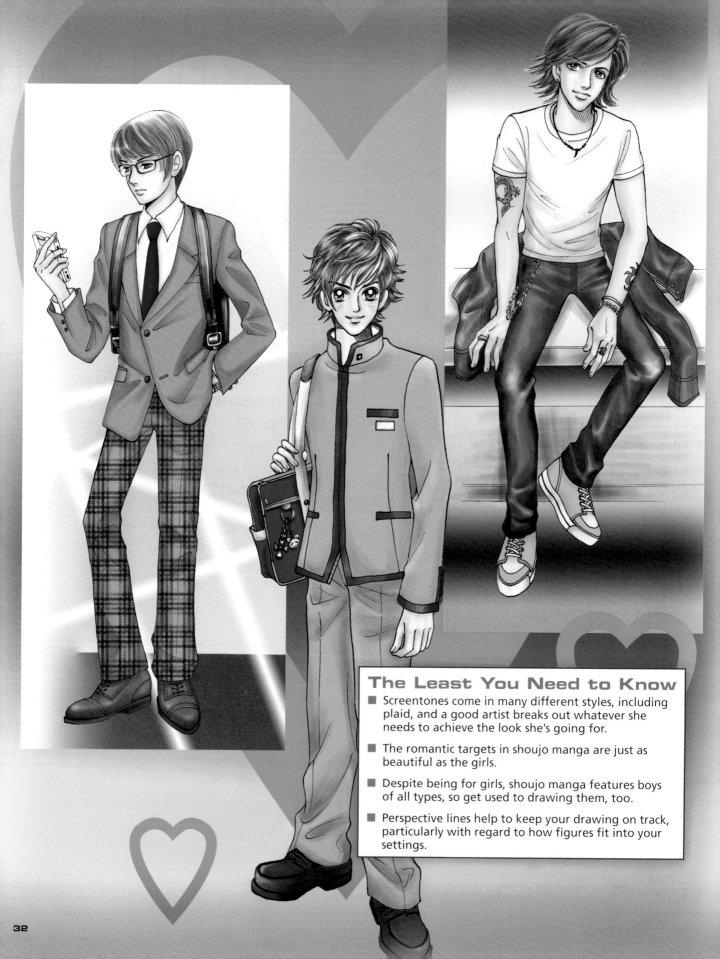

The Least You Need to Know

■ Screentones come in many different styles, including plaid, and a good artist breaks out whatever she needs to achieve the look she's going for.

■ The romantic targets in shoujo manga are just as beautiful as the girls.

■ Despite being for girls, shoujo manga features boys of all types, so get used to drawing them, too.

■ Perspective lines help to keep your drawing on track, particularly with regard to how figures fit into your settings.

Women:
Even Young Heroines Grow Up

In This Chapter

- The mother who knows more than you think
- The mentor who shows what you can become
- The rivals who think they're better than you

While shoujo manga is meant for girls, no one remains a girl forever. Eventually, those young ladies grow up into women, some of whom continue to read shoujo manga, of course. For our purposes, we'll tackle three different kinds of women.

First, we approach the lady who means more than anyone else in a young girl's life: the mother. While all sorts of mothers in Japan work outside the home and wear business clothes, we examine a mother in traditional dress.

From there, we move on to the mentor. This is the accomplished young woman many girls would like to grow up to be like. She is sharp, smart, and stylish, but she still has time to talk to younger girls and give them advice.

We wrap up the chapter with a study of the rival. While she may be just a bit older than the girls shoujo manga targets, she acts even less mature, picking on the heroine and making her life miserable. Every good story needs a villain, and much of shoujo manga finds her here.

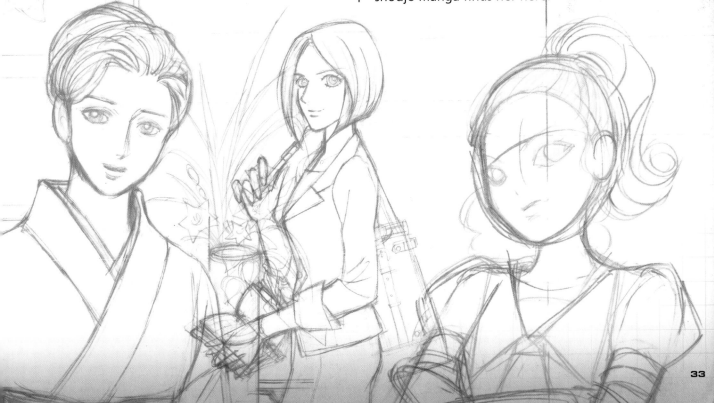

The Mother

The mother for this picture is an older woman, probably in her late 40s or early 50s. She is the rock of her family and a role model for her daughter, although perhaps one that the girl rebels against. To represent this, we show her at home in a traditional kimono.

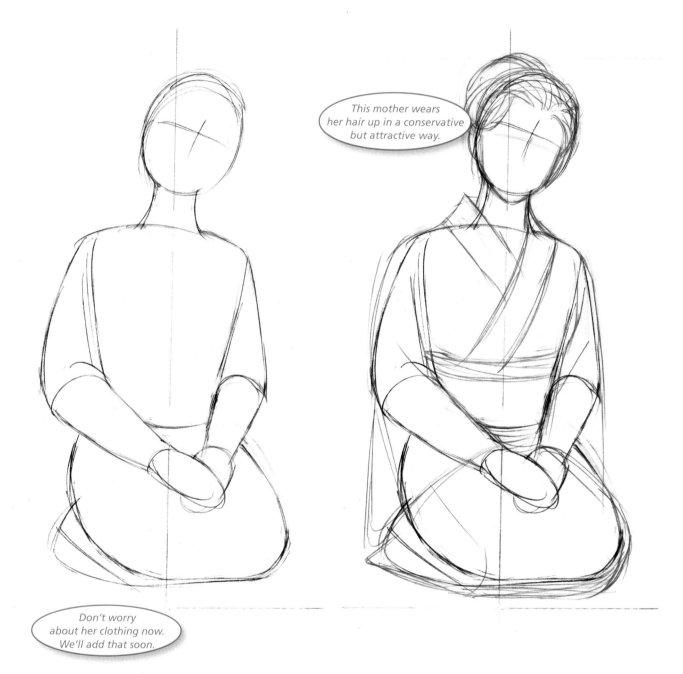

This mother wears her hair up in a conservative but attractive way.

Don't worry about her clothing now. We'll add that soon.

1. Here we tackle the basic shapes. We show the mother sitting on the floor, Japanese style, her hands folded in front of her. She tilts her head to the side to look at the viewer in a kindly way.

2. Work in the outlines of her clothing. Note how the sleeves of the kimono drape from her arms.

In Japan, the left side of the kimono is worn over the right. This is inverted when dressing the dead for burial. In translated manga that reads left to right (rather than the Japanese way, right to left), the artwork is often reversed, making it seem like the living are wearing the clothes of the dead.

Pearls of Wisdom

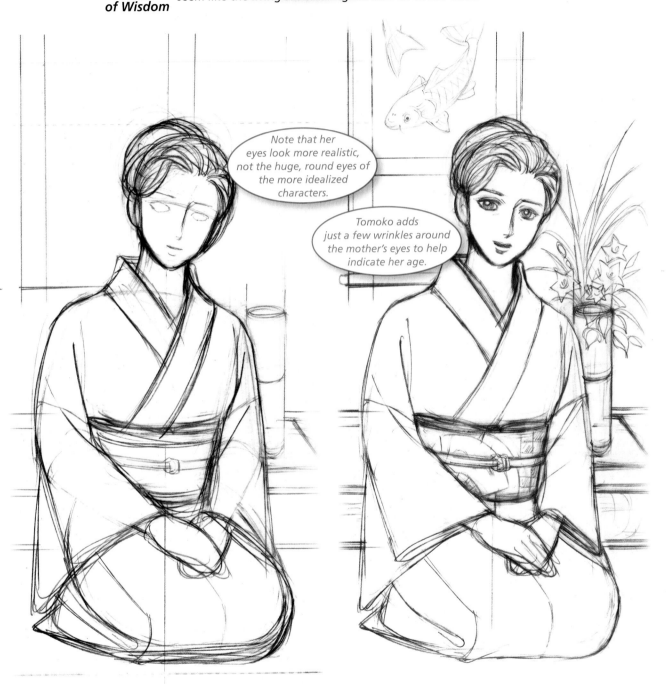

Note that her eyes look more realistic, not the huge, round eyes of the more idealized characters.

Tomoko adds just a few wrinkles around the mother's eyes to help indicate her age.

3. Add in some background details, and define the hair and clothing better. She sits on the floor of a traditional Japanese home. Work in the details of her face.

4. Add more detail to the mother's eyes and face. Decorate the room around her tastefully. Add some flowers to the vase behind her.

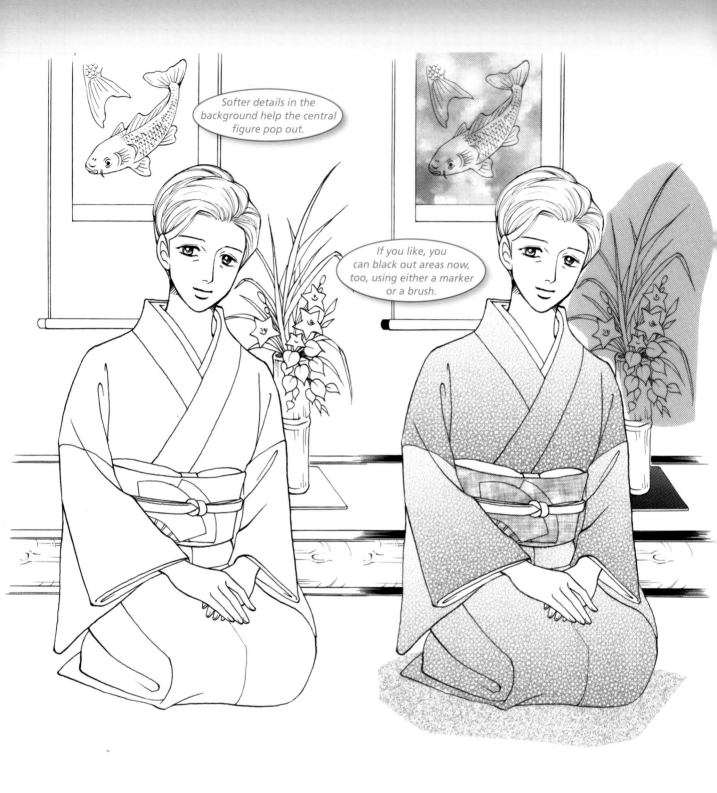

5. Lay down your inks here. For most of this drawing, Tomoko uses even lines. See how the lines are just a bit thicker around the mother's hair and face and the outline of her kimono, helping her stand out from the background.

6. Break out the screentones and go wild. Tomoko uses a single pattern on the kimono, but notice how it fades as it moves upward in three different levels, hinting at the lighting in the room. She also uses different patterns for the flowers, the painting, and the kimono's belt.

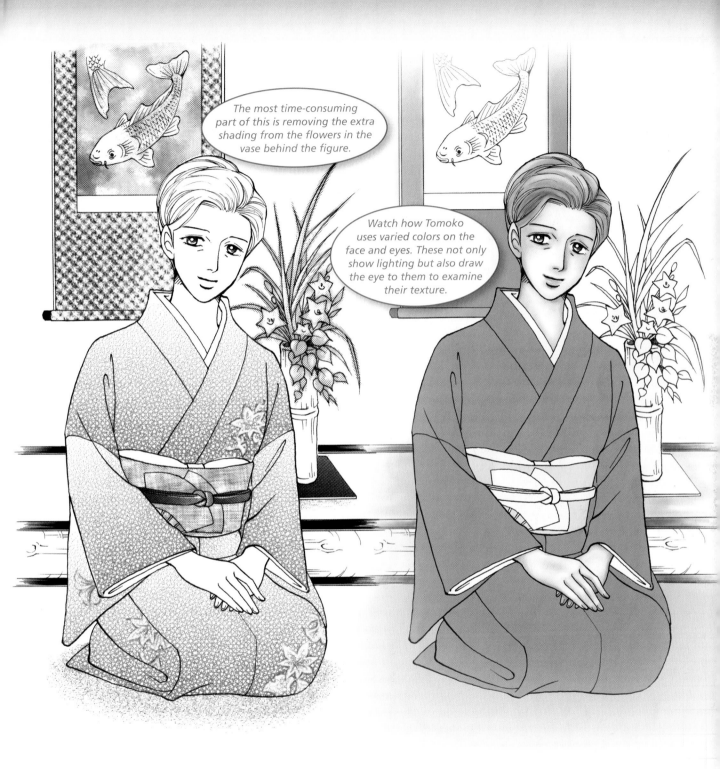

7. Add in more details with other patterns, like the flowers that decorate the kimono or the bare scroll on which the painting on the wall sits.

8. Pick soft and pleasing colors here. The mother represents both home and tranquility. The yellow, light green, and lavender all signify that.

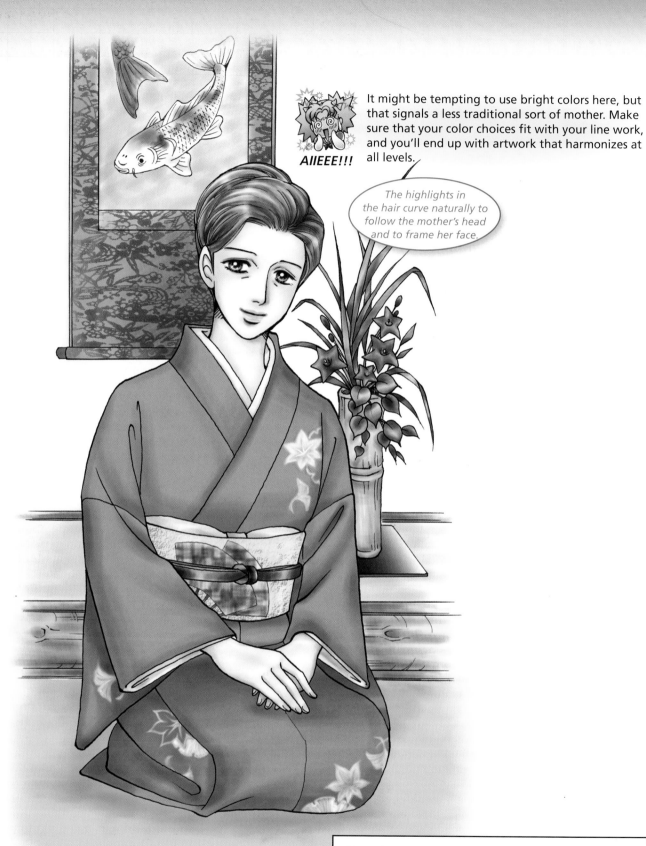

It might be tempting to use bright colors here, but that signals a less traditional sort of mother. Make sure that your color choices fit with your line work, and you'll end up with artwork that harmonizes at all levels.

AIIEEE!!!

The highlights in the hair curve naturally to follow the mother's head and to frame her face.

9. Add depth to the mother's clothing by varying the tone of the clothes. Add highlights to her hair, and place textures on the scroll work, floor, and belt.

The Mentor

The mentor is a sharp, stylish woman who knows what she wants and works hard to get it. She's already accomplished so much, but there are always new horizons ahead for such women. In the meantime, though, she's happy to share what she knows.

She will clearly be carrying something in her left hand, but what?

The short skirt makes her a modern woman for sure.

1. We start with a breakdown of the figure. Note that she is slim, confident, and pretty. Her feet are crossed and seem high up, but we'll add shoes to her soon.

2. Work in the clothing, and add a purse and shoes. The addition of her right arm (previously hidden) holding a pencil, and her bobbed hair, give her a smart, thoughtful look.

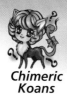

Chimeric Koans

Before WWII, women in Japan had few rights and could not, for instance, vote. From 100,000 to 400,000 women were even forced to serve as sex slaves for the Japanese military during the war. They have come a long way in the past 60 years, and matters continue to improve for them.

She seems like she just had a great idea and needs to write it down.

The darkening around the eyes makes her seem more human.

3. Work in some more details on her hair and clothing. The shoes look fashionable but comfortable. A jacket over her blouse makes her more businesslike than ever. Again, her eyes seem more realistic and serious than those of a girl.

4. Sharpen up everything: hair, eyes, and clothing. Add details to the purse and the book in the woman's hand.

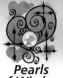

Pearls of Wisdom

See the arcing line that connects the two knees? That helps you make sure the character looks balanced, not like she might tip over at any moment. You should erase it when you get to the inking stage, but while you're working with pencils it helps keep you on track.

The deep blacks on the mentor's eyes make them pop right out at you, as if she's looking right through you.

The lines below the mentor's feet imply a reflection on a shiny floor without your having to actually draw a fully reflected image.

5. This is where the mentor comes together. Every line here should be as polished as she is. Use thicker lines for her exposed skin and for the edges of her clothing. Use softer lines for the interiors and for things like the details on her purse or the writing in the book.

6. Time for screentones and heavy blacks. Take the time to add in a floor and back wall. Note the way the screen runs from light to dark, going left to right. This gives the impression that the mentor is facing the light source.

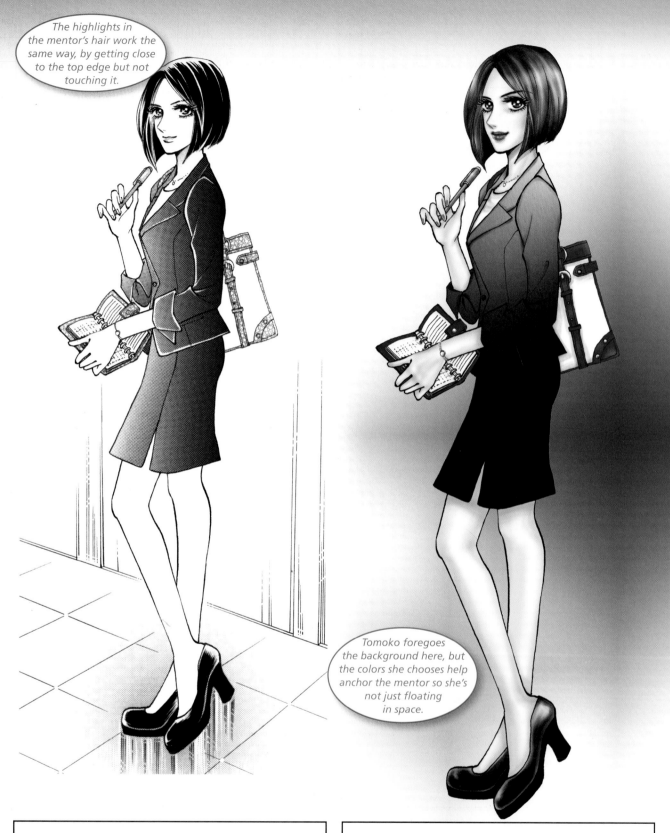

The highlights in the mentor's hair work the same way, by getting close to the top edge but not touching it.

Tomoko foregoes the background here, but the colors she chooses help anchor the mentor so she's not just floating in space.

7. Add in some more screentones on the jacket. Notice how Tomoko trims the screentone from the edges that face the light source. This implies that the jacket is made from a slicker material, and it really lifts it off the page.

8. Go back to your pure inks and color the figure without the textures. Notice here how Tomoko assumes a stronger light source from the top, perhaps angled toward the viewer. The strong light from the front is gone.

The Rival

For some serious conflict in your stories, the rival has to not only be as good as your heroine, but better. Older, smarter, and craftier rivals may make your heroine feel frustrated and powerless, but that's the source of great conflict. The heroines who can overcome such rivals are the ones worth reading about.

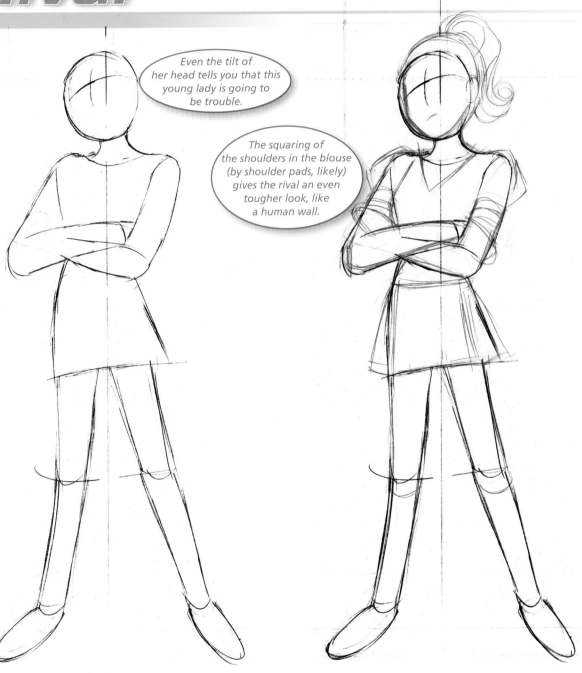

Even the tilt of her head tells you that this young lady is going to be trouble.

The squaring of the shoulders in the blouse (by shoulder pads, likely) gives the rival an even tougher look, like a human wall.

1. Break down the rival's form. Note the body language of the strong, defiant stance and the arms defensively crossed over the body.

2. Rough in the hair, which is up in a sassy ponytail. The clothes are short and stylish, too, with more than a touch of defiance.

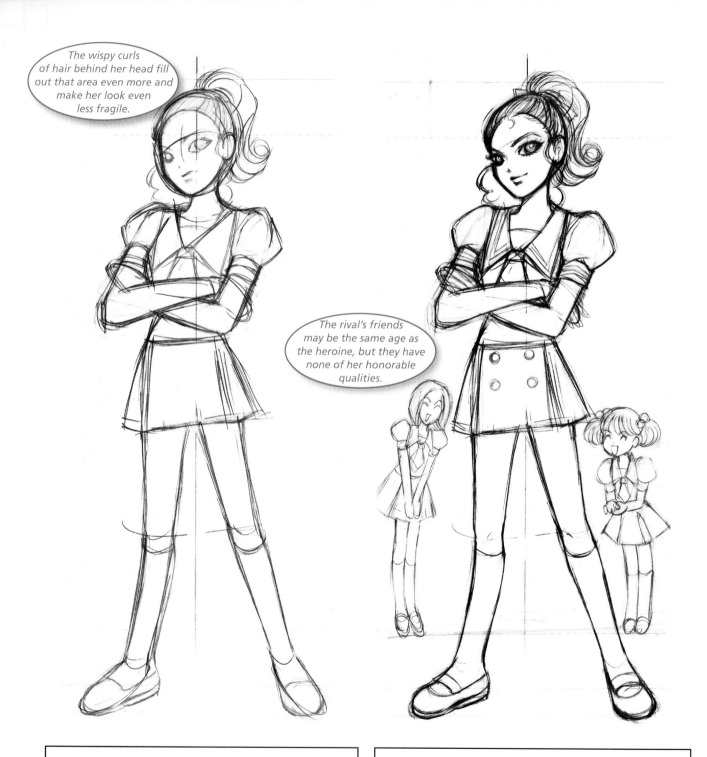

The wispy curls of hair behind her head fill out that area even more and make her look even less fragile.

The rival's friends may be the same age as the heroine, but they have none of her honorable qualities.

3. Sketch in the rest of the hair, the face, and the outfit. You can see now from the shoes and knee socks that this is a schoolgirl, albeit an older, tougher one than the heroine.

4. Add in the details in the rival's hair and clothes. Tomoko takes it a step further and puts two of the rival's friends in the frame. She forces the perspective to make them look small and mean. This also makes the rival look that much more powerful.

Pearls of Wisdom

Figures in the background don't require nearly as much detail as the main figure in the foreground. Paying as much attention to them with your pencil distracts the viewer from the character up front. You can get away with less polished drawings in the background, and for the good of your drawing you should.

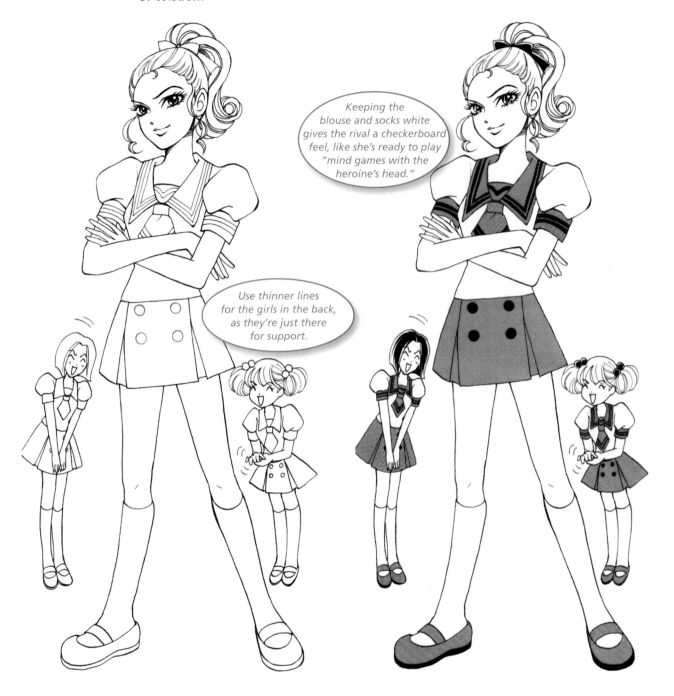

Keeping the blouse and socks white gives the rival a checkerboard feel, like she's ready to play "mind games with the heroine's head."

Use thinner lines for the girls in the back, as they're just there for support.

5. Use strong inks for most of the rival's lines. She is a strong character, and she should pop off the page at you. Notice that while her eyes aren't huge, they're larger than the ones of the other two figures in this chapter, and the heavy blacks around them make them leap off the page.

6. Use solid screentones throughout. Ignore the subtleties of lighting for the moment. The flat, ungradated texture gives the girls a very solid feel, one more thing that makes them like a wall in the heroine's way.

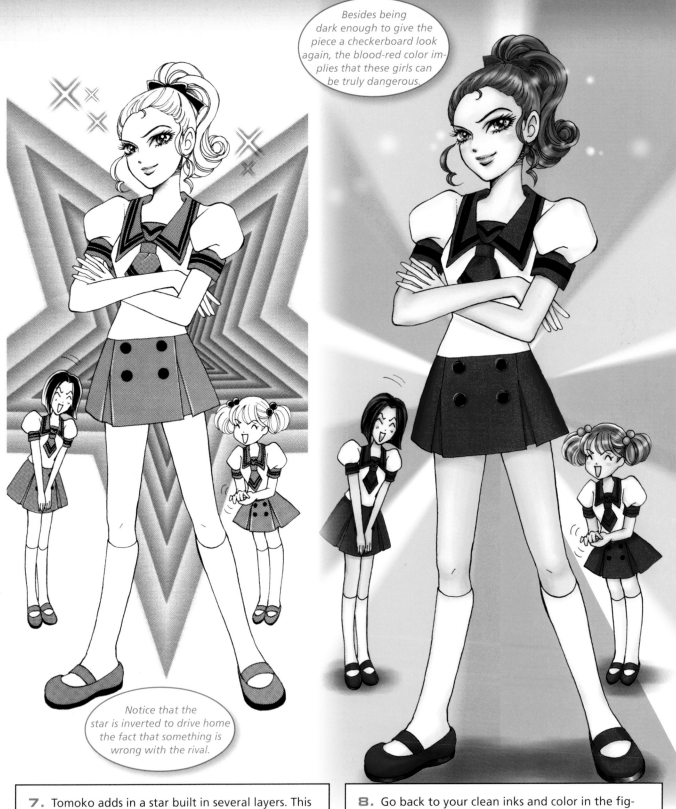

Besides being dark enough to give the piece a checkerboard look again, the blood-red color implies that these girls can be truly dangerous.

Notice that the star is inverted to drive home the fact that something is wrong with the rival.

7. Tomoko adds in a star built in several layers. This gives more depth to the image and centers your eyes on the rival rather than on the other girls. The way it's darker in the middle and lighter on the edges implies that the center is farther away, almost as if the rival shot out of it to stand right here.

8. Go back to your clean inks and color in the figures instead. Tomoko uses essentially the same coloration scheme as she did with the screentones, only she uses a blood red in place of the gray. She also loses the star in favor of a bursting pattern of orange and yellow.

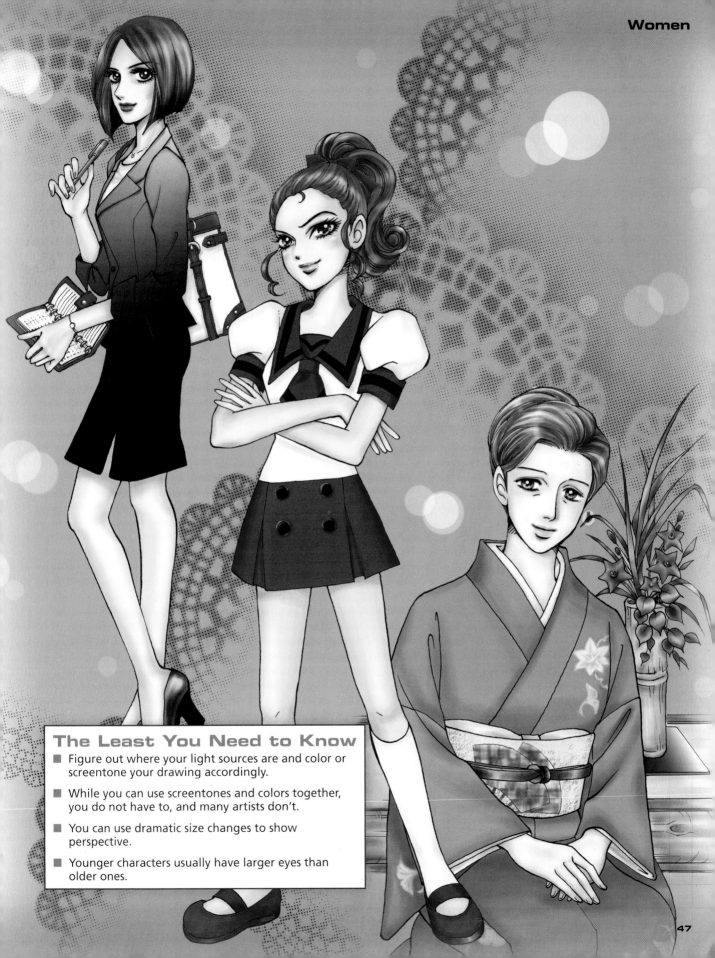

The Least You Need to Know

■ Figure out where your light sources are and color or screentone your drawing accordingly.

■ While you can use screentones and colors together, you do not have to, and many artists don't.

■ You can use dramatic size changes to show perspective.

■ Younger characters usually have larger eyes than older ones.

Men:
Boy-Toys Don't Stay Boys

4

In This Chapter

- ■ The father of the heroine
- ■ The wise grandfather at home
- ■ The stalker whose attentions aren't welcome

Men play many roles in shoujo manga. They represent the future for many of their readers, in the form of husbands or boyfriends when they are old enough to have them. They also stand for the past: fathers, uncles, grandfathers, and the like, who look over them and try to protect them, sometimes a bit too aggressively.

Every girl has a father, after all, even if the traditional salaryman (white-collar worker) is often busy and distant. Japanese men generally work long days and leave the child-rearing to their wives. This is changing as the years go on, but it puts fathers in a tough position between their demanding jobs and the families with whom they'd like to spend more time.

Grandfathers tend to have more time to talk and wisdom to share, especially if they are retired, but sometimes their respect for tradition makes them just as hard to speak with. In their day, girls had very clear roles in society, and it can be hard for them to watch these roles change, especially when it comes to the grandchildren they love dearly.

Then there are the stalkers, predators who can't seem to figure out where the boundaries between men and girls should be. Experienced men can intrigue innocent girls, but those girls should be careful to not let older men lead them into trouble.

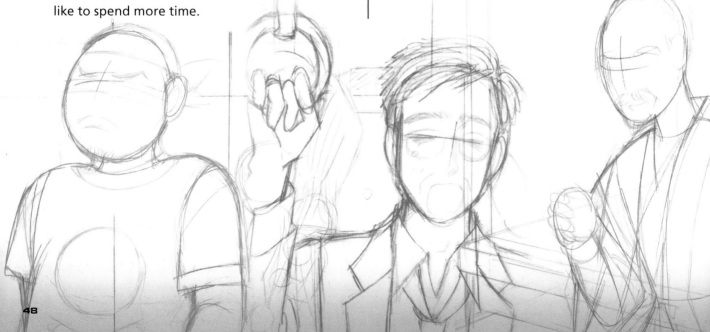

The Father

The usual Japanese father today is a salaryman, who works long hours and so rarely is able to spend much time with his family. He loves his family, but he knows that he must work hard to feed, house, and clothe his wife and children. Even though more wives work today than ever before in Japan, the pressures on men continue to build.

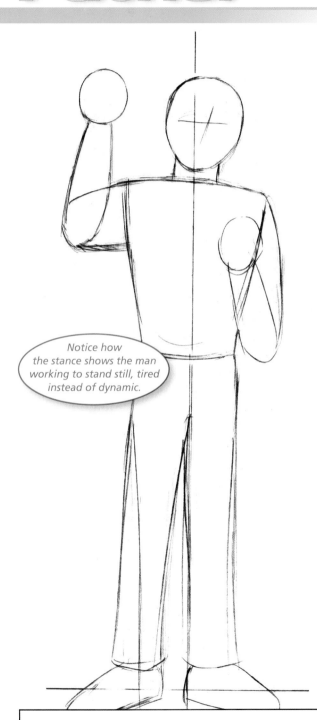

Notice how the stance shows the man working to stand still, tired instead of dynamic.

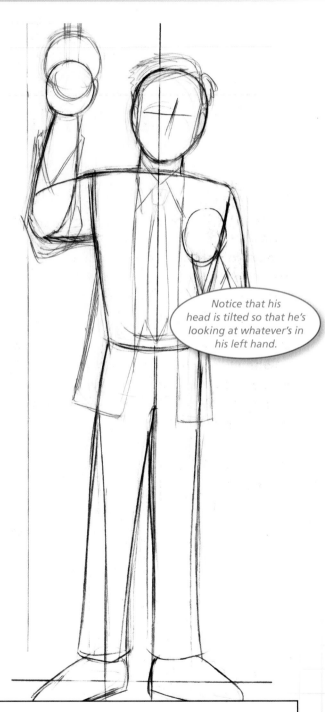

Notice that his head is tilted so that he's looking at whatever's in his left hand.

1. Break down the figure into its component shapes. Tomoko chose to show him in a typical environment (the subway) doing many things at once.

2. Sketch in the father's clothing (a suit, of course) and hair. Show that he's holding a ring hanging from the ceiling of the subway.

It's important to choose the right setting for your figures. A father relaxing on the beach makes for a far different story than the same man sitting in a cubicle or standing on a subway. Think about your character's surroundings and what they might say about your story or his life.

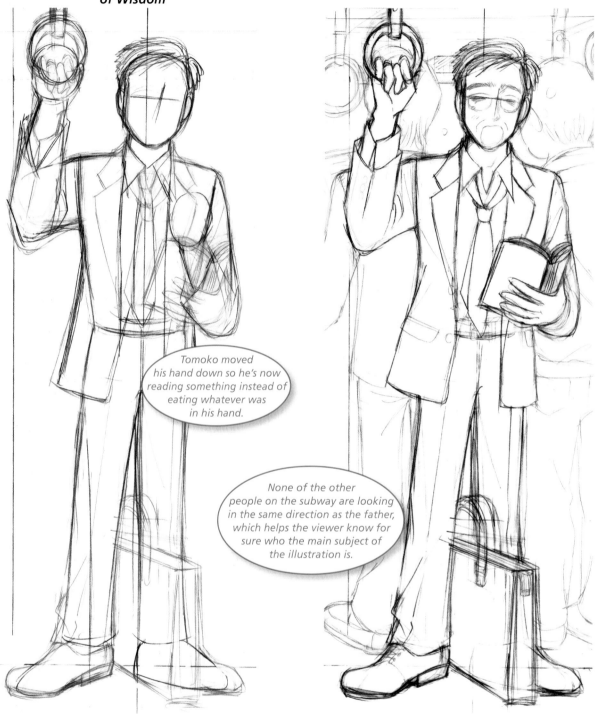

Tomoko moved his hand down so he's now reading something instead of eating whatever was in his hand.

None of the other people on the subway are looking in the same direction as the father, which helps the viewer know for sure who the main subject of the illustration is.

3. Add in some more details. Put a book in this left hand. Tuck a briefcase between his feet.

4. Put some other people in the background to show that the subway is crowded. Work on the father's face. Tomoko has him munching on a roll stuffed into his mouth.

Pearls of Wisdom

Artists use perspective lines to keep them on track when trying to make a two-dimensional representation (a drawing) of something three-dimensional (like a person). They help the artist make the drawing look natural and real. You can use several sets of perspective lines in a drawing, but it's best to stick with one or two at first.

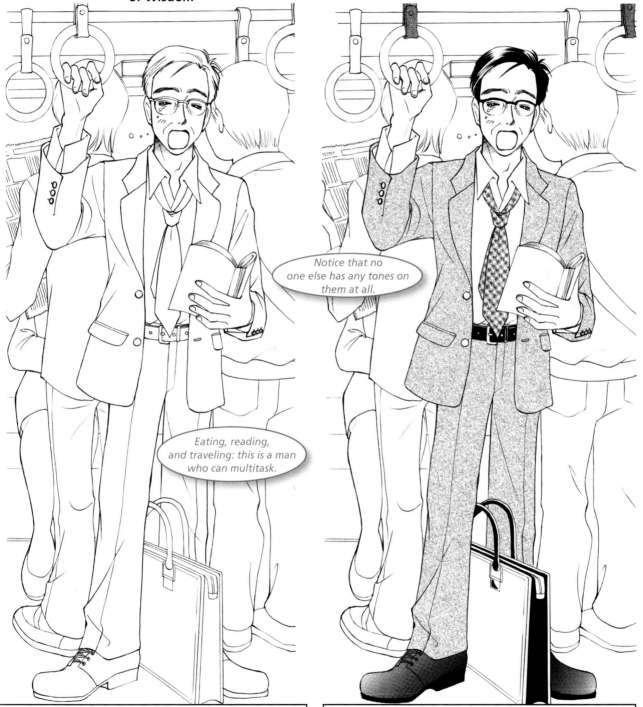

> Notice that no one else has any tones on them at all.

> Eating, reading, and traveling: this is a man who can multitask.

5. Lay down those inks. Notice how Tomoko uses stronger inks on the father's upper body, while the lines on his legs are the same weight as those of the figures around him. This makes him look like he's leaning forward and helps lift him off the page.

6. Use a nongradated screentone on the father's suit. A light gray works as an extremely neutral color. Gradated screentones on the shoes imply scuffs and wear toward the toes. A patterned screentone works wonderfully for the tie, too.

Manga-nese

Seinen is manga for men. **Josei** is manga for women. People of all ages and both genders read manga in Japan, and it comes in all sorts of different categories based on age, gender, and taste.

The glasses form another barrier between him and the world, and the smaller eyes emphasize that.

Wonder what kind of manga he's reading there?

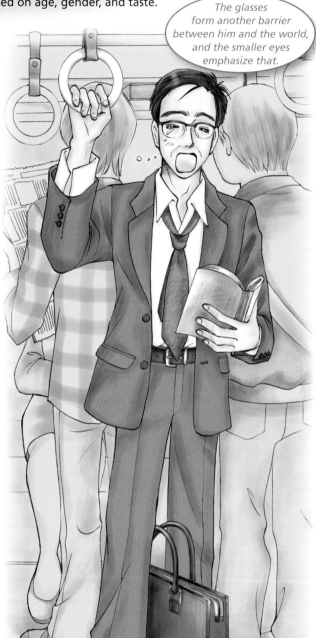

7. Add in some wisps of smoke to show how close and polluted the subway is. Pass these behind the father to help separate him from the figures behind him. Add a texture to the book's cover (use a *seinen*-style drawing if you like, not *josei*) and the outside of the briefcase, too.

8. Going to your clean inks, pick a single neutral color for the father's suit. Use a gently contrasting color for everything else in the background he's not touching. Pick the same dull and worn brown for his shoes and briefcase.

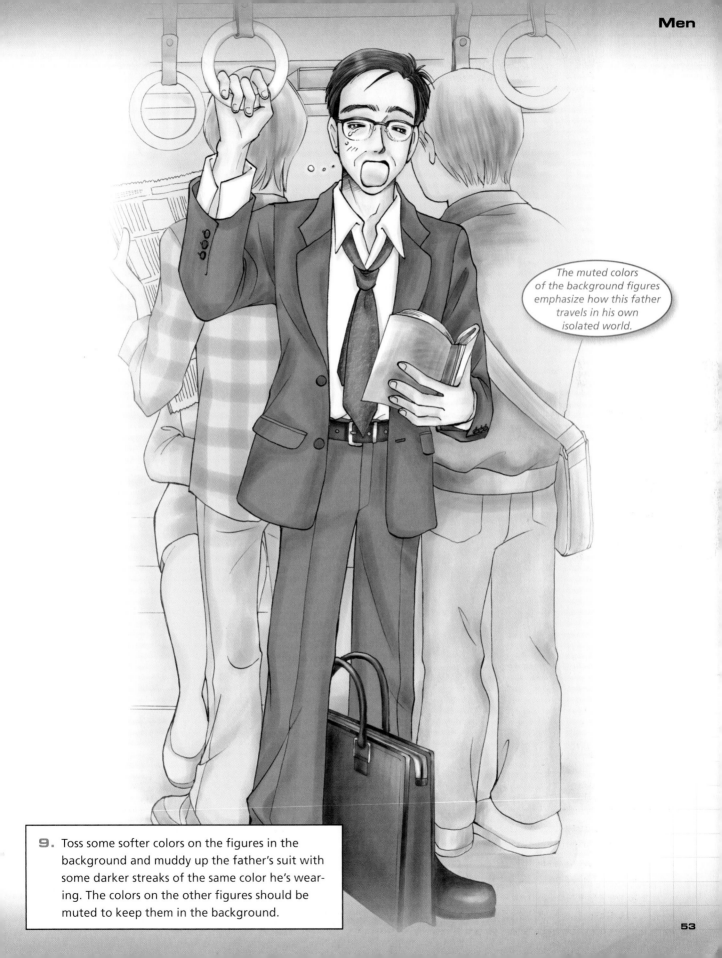

The muted colors of the background figures emphasize how this father travels in his own isolated world.

9. Toss some softer colors on the figures in the background and muddy up the father's suit with some darker streaks of the same color he's wearing. The colors on the other figures should be muted to keep them in the background.

The Grandfather

For this image, we'll show a kindly old grandfather having tea in a room open to the world beyond. This makes for a strong contrast with the image of the father and shows the kind of tranquility the salaryman may aspire to reach.

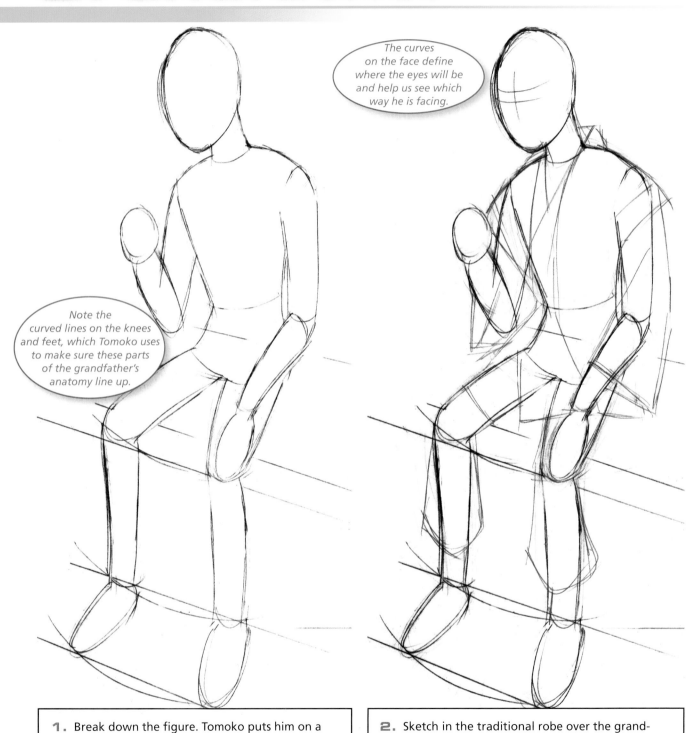

The curves on the face define where the eyes will be and help us see which way he is facing.

Note the curved lines on the knees and feet, which Tomoko uses to make sure these parts of the grandfather's anatomy line up.

1. Break down the figure. Tomoko puts him on a bench. He is relaxed, his back slightly bent to show his great age.

2. Sketch in the traditional robe over the grandfather's frame. As with the mother's kimono in Chapter 3, it should be worn with the left side over the right.

Chimeric Koans

The grandfather here is the man that the heroine hopes her father grows up to be: a sedate and gentle man with whom she can spend some time. While the generation gap may cause some friction between grandfather and granddaughter, usually their affection for each other can overcome that, at least in the long run.

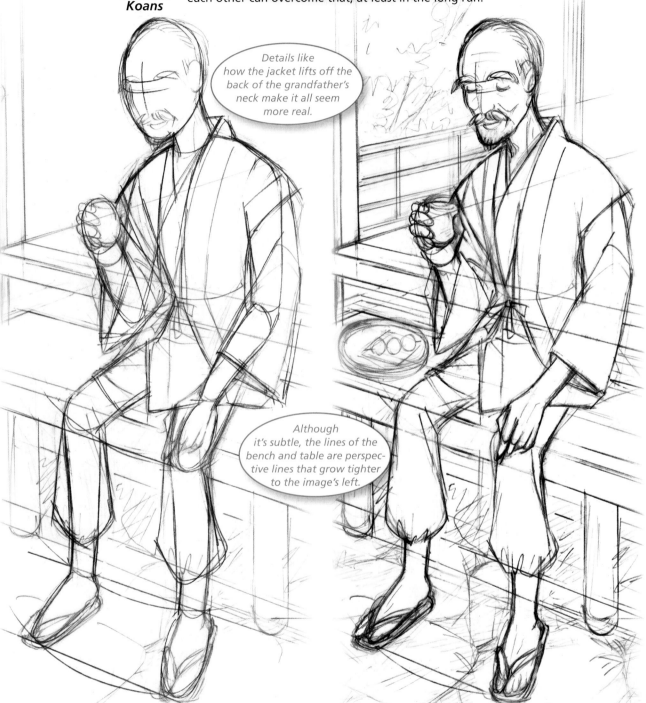

Details like how the jacket lifts off the back of the grandfather's neck make it all seem more real.

Although it's subtle, the lines of the bench and table are perspective lines that grow tighter to the image's left.

3. Work in some more details. He sits on a wooden bench with his back to a low table. He has little hair, and he wears sandals that resemble flip-flops. He has a jacket over his shirt.

4. Go nuts with the details. Put a plate of food next to him and work some trees into the background. A rock floor speaks of his solidity. Bushy eyebrows and mustache emphasize his age and make for a stark contrast with the clean-shaven salaryman.

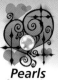

Notice how Tomoko draws lines through the grandfather to make sure everything matches up. She'll remove these after inking. Nothing is set in stone in the penciling stage. Use as many guidelines as you like, and then remove them with the artist's best friend: the eraser.

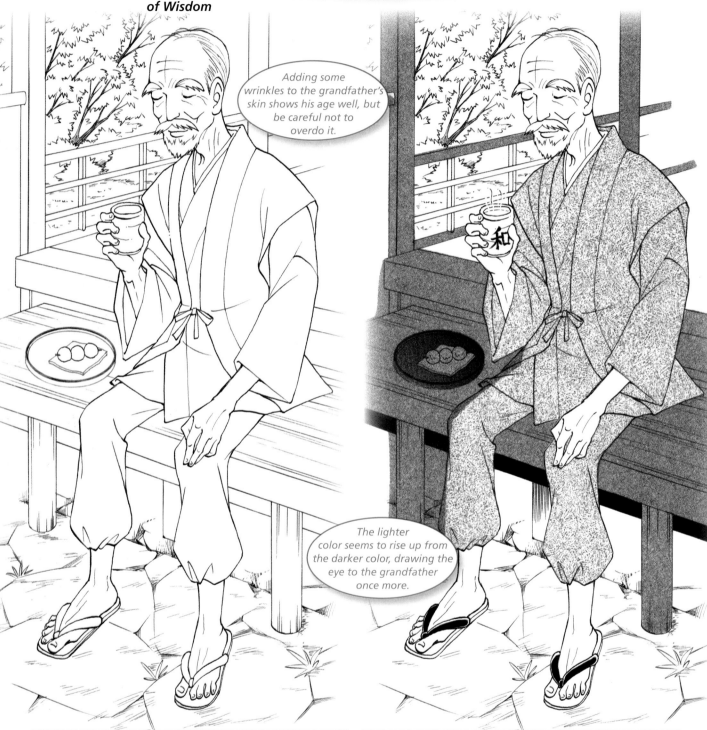

Adding some wrinkles to the grandfather's skin shows his age well, but be careful not to overdo it.

The lighter color seems to rise up from the darker color, drawing the eye to the grandfather once more.

5. Lay in your inks. The lines surrounding the grandfather should be stronger than the rest. Don't crosshatch his clothing much. Save those little strokes for the background or the bench, and his simplicity makes him pop out better.

6. Use a dark, uniform gray for the wooden pieces in the room. Use a lighter gray (which speaks of age and wear) on the grandfather's clothes.

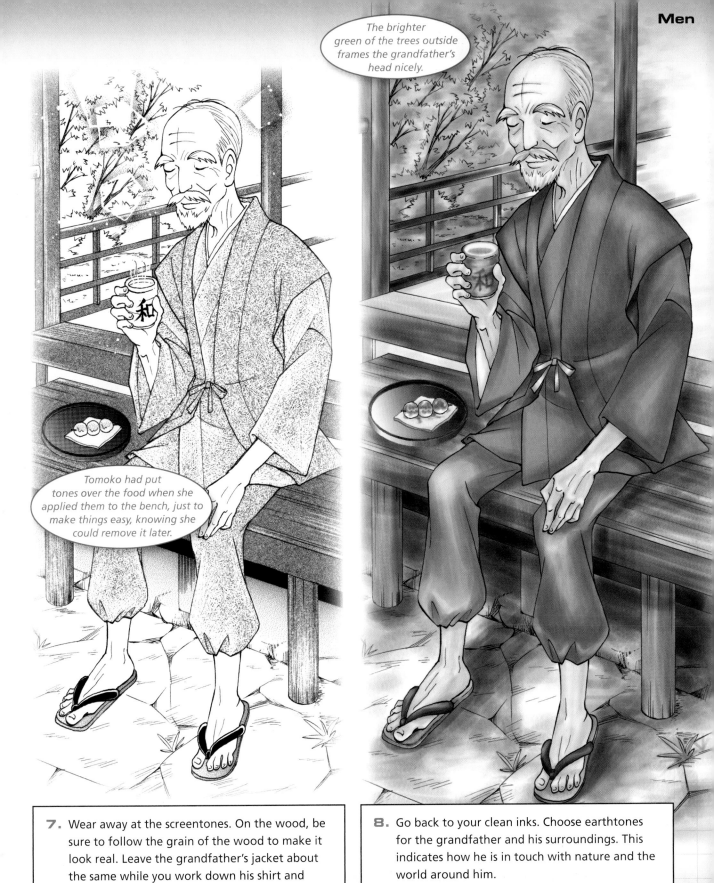

The brighter green of the trees outside frames the grandfather's head nicely.

Tomoko had put tones over the food when she applied them to the bench, just to make things easy, knowing she could remove it later.

7. Wear away at the screentones. On the wood, be sure to follow the grain of the wood to make it look real. Leave the grandfather's jacket about the same while you work down his shirt and pants. This helps the viewer see the different layers he wears.

8. Go back to your clean inks. Choose earthtones for the grandfather and his surroundings. This indicates how he is in touch with nature and the world around him.

The Stalker

Because the stalker's attentions are unwanted, we need to make him unattractive. We don't have to work too hard at this because the objects of romance in shoujo manga are so idealized that even an ordinary-looking person seems out of place.

T-shirts and shorts are wonderful clothes, but in the idealized world of shoujo manga, they're not what most romantic interests wear.

The box behind the stalker represents the wall and gives him something to lean on for now.

1. Tomoko decides to depict the stalker hiding behind a pole. Break down his figure there, showing him crouching. Unlike the boys in Chapter 2, or even the other men in this chapter, he is heavier. Use rounded shapes to emphasize this.

2. Sketch in the details. Notice how Tomoko decides to raise his shoulders, putting him harder against the wall and making him seem even more anxious. He wears unstylish clothes, making him less idealized, too.

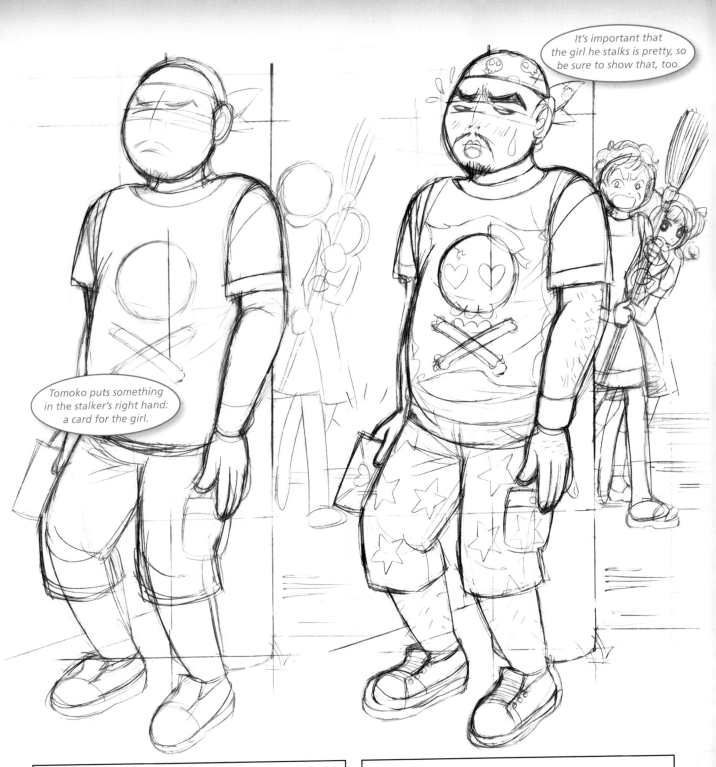

It's important that the girl he stalks is pretty, so be sure to show that, too.

Tomoko puts something in the stalker's right hand: a card for the girl.

3. Work in more details. Grunge out the clothes. Top the man's head with a do-rag. Add a pair of figures in the background: the shoujo heroine and the mother who's there to protect her.

4. Add some more details to the stalker's clothes. This is a man who dresses like a child. Put hair on his face, legs, and arms to show he's nothing like a child, though. Sweat on his face shows how scared he is. Showing that it's a woman with a broom who frightens him off makes him look as pathetic as he is.

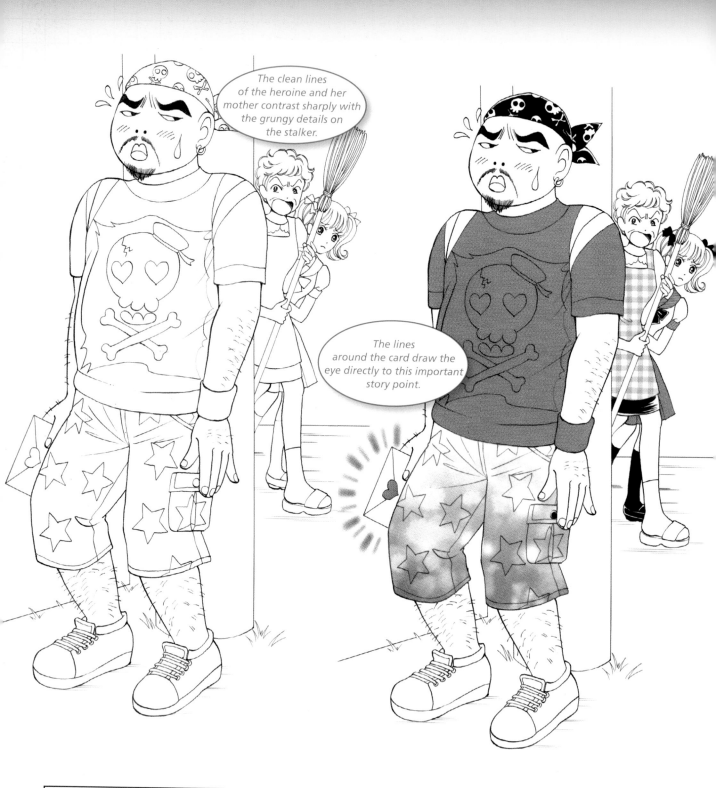

5. Use strong inks on the stalker's face. Unlike in the picture of the father, you want to use strong inks on the characters in the background, too, as they form an integral part of the story.

6. Use a solid screentone on the stalker's shirt, and use solid black on his do-rag. A muddy texture on the shorts emphasizes his dirty nature. Be sparing with the textures on the figures in the background, helping them look clean and sharp.

AIIEEE!!!

Color choices with wavy lines are important. A dark color and curly shape, like we saw on the monochrome version of the stalker, can indicate smelliness. However, similar lines colored blue in the colored version show the mother's wrath. Take care not to confuse the two.

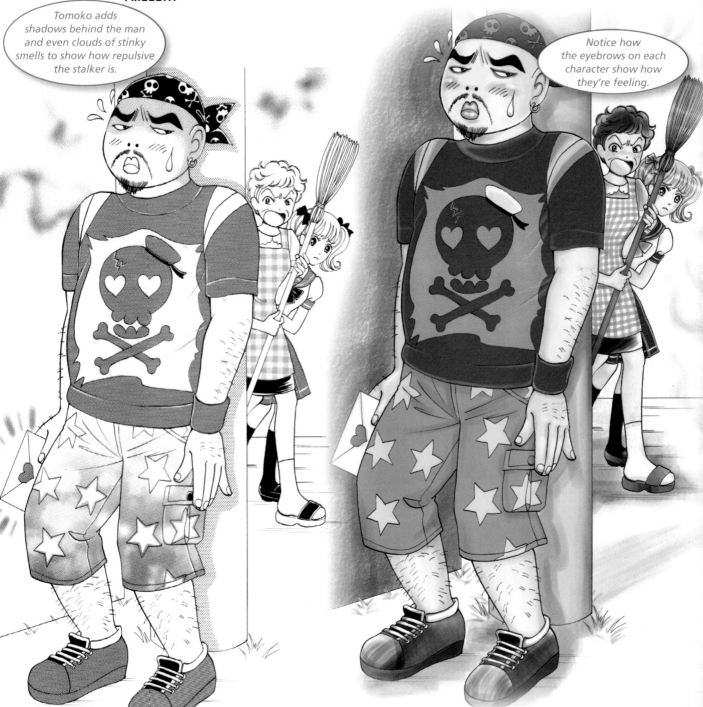

Tomoko adds shadows behind the man and even clouds of stinky smells to show how repulsive the stalker is.

Notice how the eyebrows on each character show how they're feeling.

7. Tomoko removes much of the screentone on the stalker's shirt to emphasize the skull there, just as she has on his do-rag. The hearts in the skull's eyes indicate a dangerous affection, and it even looks like the heart on the card might have been pulled from the stalker's shirt.

8. Go back to your clean inks and then color the figure in. Use awful, unmatching colors for the stalker, showing that he's clueless when it comes to matters of looking decent. This contrasts well with the simple, clean colors of the mother and the heroine.

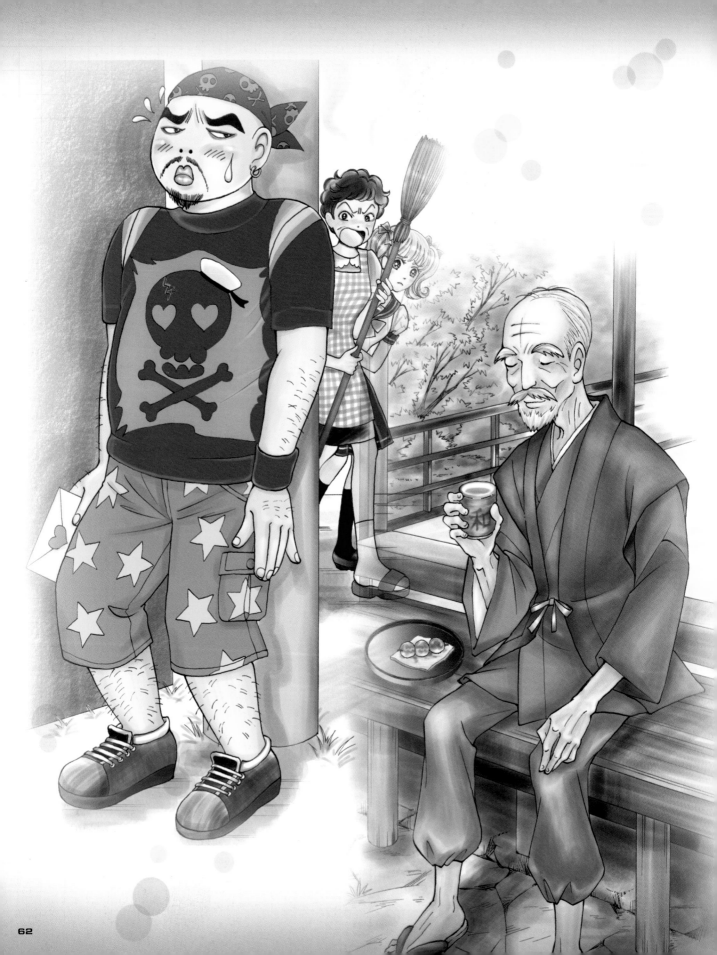

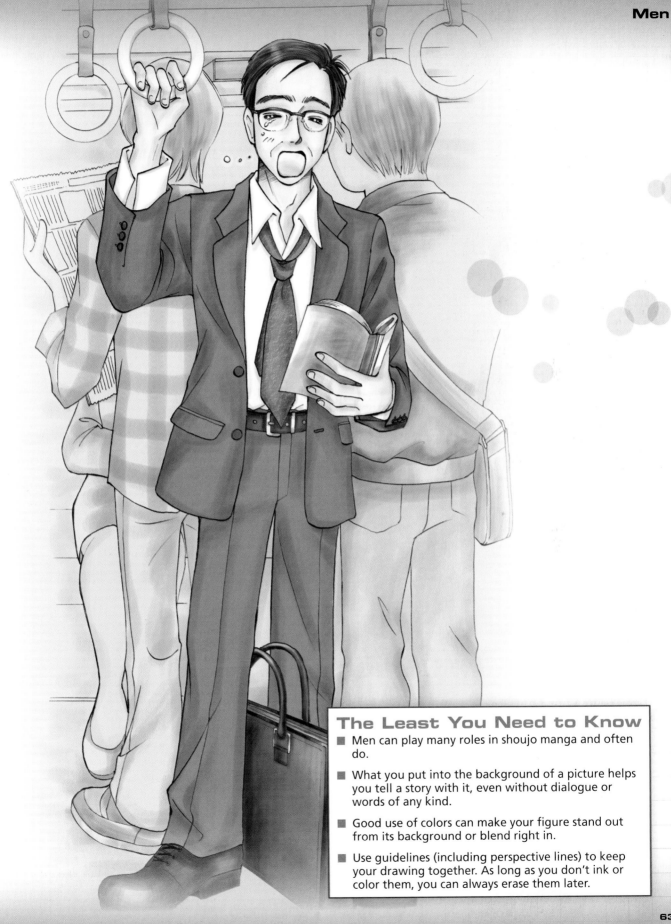

The Least You Need to Know

- Men can play many roles in shoujo manga and often do.

- What you put into the background of a picture helps you tell a story with it, even without dialogue or words of any kind.

- Good use of colors can make your figure stand out from its background or blend right in.

- Use guidelines (including perspective lines) to keep your drawing together. As long as you don't ink or color them, you can always erase them later.

Part 2
Settings

Once you have characters, you have to have a place or time in which their stories can happen. In this part, we venture into four different types of settings and explore their usefulness for various kinds of stories.

As broad and inclusive as manga is, it's difficult to pin it down at all. Manga stories take place in any time or place, including many settings made up just for that story alone. Still, some types of settings are more popular than others, and we'll try to concentrate on those.

Many stories take place in modern times, all around the globe. Others transpire in a recognizable future that sometimes seems all too close. Beyond that lies fancy, the stories that happen in the distant future, far past what we can really understand or see. On the flipside, history gives us endless eras from which we can choose settings for our tales.

We explore various types of characters from each of these times and places, one or more at a time. When you're done, you'll have a better idea of the breadth of settings available to shoujo storytellers like you.

Modern Times: **5**
Wandering the World

In This Chapter

- Tokyo Gal living in the big city
- The young man in New York
- The farmer's daughter in the country

Now that we've covered the basic characters, it's time to think a bit about the settings for your tales and the different kinds of people who live in them. For now, we'll stick with modern times and consider some interesting characters who live in very different worlds.

Tokyo, Japan's capital and largest city, features countless types of subcultures. For girls alone, the variety boggles the mind. We'll study a pair of GALs first to show you some of the ones who stick out the most.

They say there are eight million stories in New York City, so we'll stop there for a bit, too. We examine a young man, perhaps a romantic interest, in a hurry here. We also look at how to place him dramatically among the city's massive skyscrapers.

Then we try something completely different and travel to Hokkaido to look at a young lady who lives on a farm. Far from the bustling city streets, she has a story and style all her own. It may not be as glamorous, but it can be just as interesting.

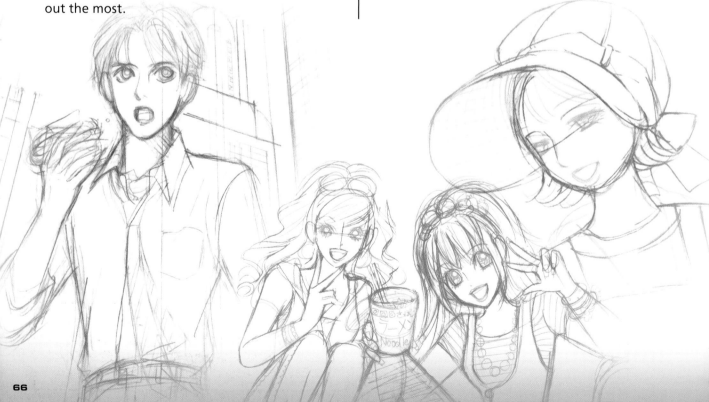

Tokyo is the home of *GAL* culture, so let's take a shot at drawing a couple of the members of that flashy, bling-bling society. We'll start with a single figure and work the other in later.

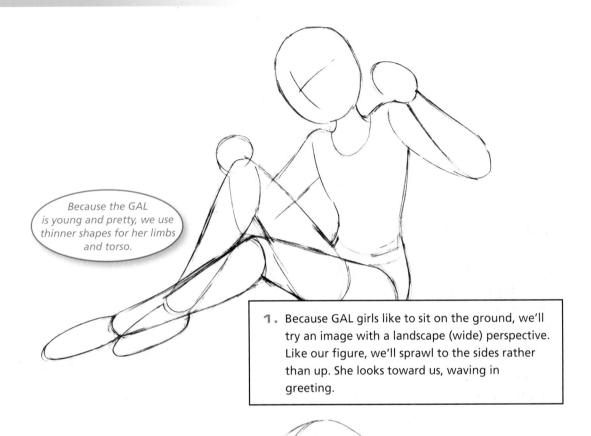

Because the GAL is young and pretty, we use thinner shapes for her limbs and torso.

1. Because GAL girls like to sit on the ground, we'll try an image with a landscape (wide) perspective. Like our figure, we'll sprawl to the sides rather than up. She looks toward us, waving in greeting.

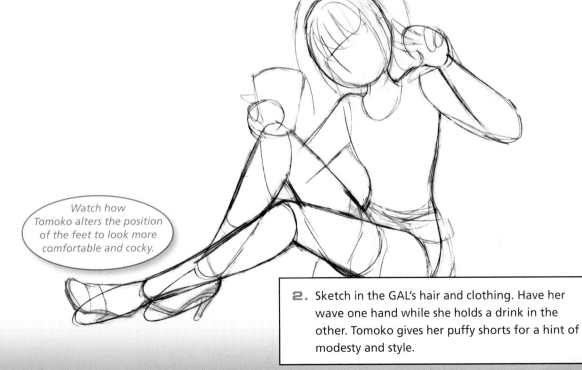

Watch how Tomoko alters the position of the feet to look more comfortable and cocky.

2. Sketch in the GAL's hair and clothing. Have her wave one hand while she holds a drink in the other. Tomoko gives her puffy shorts for a hint of modesty and style.

GAL culture involves girls and young women who wear outlandish and expensive makeup and clothing that run against typical Japanese standards of beauty. Stereotypically, they don't bother to bathe often, nor do they mind sitting right on the streets, so many outsiders think of them as dirty. They are also called *gyaru*, which is a transliteration of the English word "gal." There are over a dozen different types of GAL subcultures, with more cropping up every year.

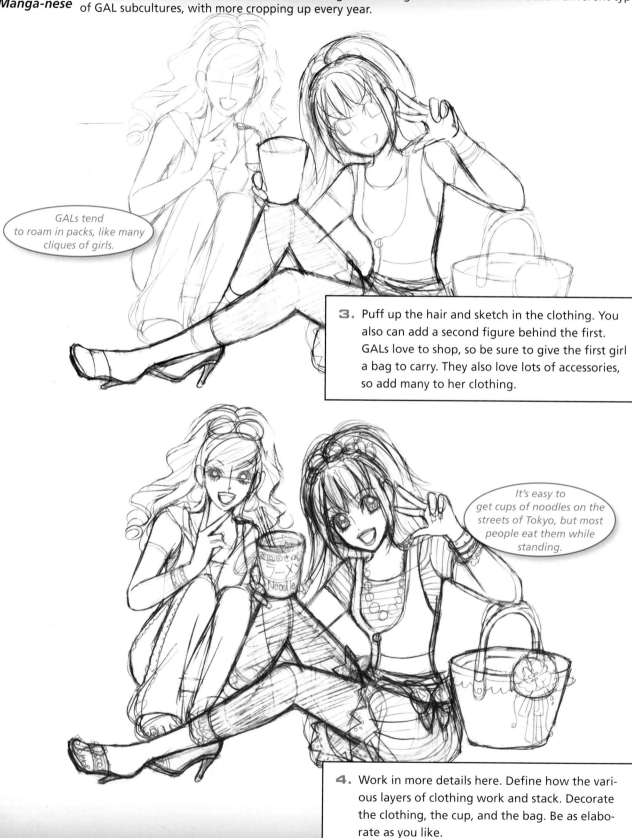

GALs tend to roam in packs, like many cliques of girls.

3. Puff up the hair and sketch in the clothing. You also can add a second figure behind the first. GALs love to shop, so be sure to give the first girl a bag to carry. They also love lots of accessories, so add many to her clothing.

It's easy to get cups of noodles on the streets of Tokyo, but most people eat them while standing.

4. Work in more details here. Define how the various layers of clothing work and stack. Decorate the clothing, the cup, and the bag. Be as elaborate as you like.

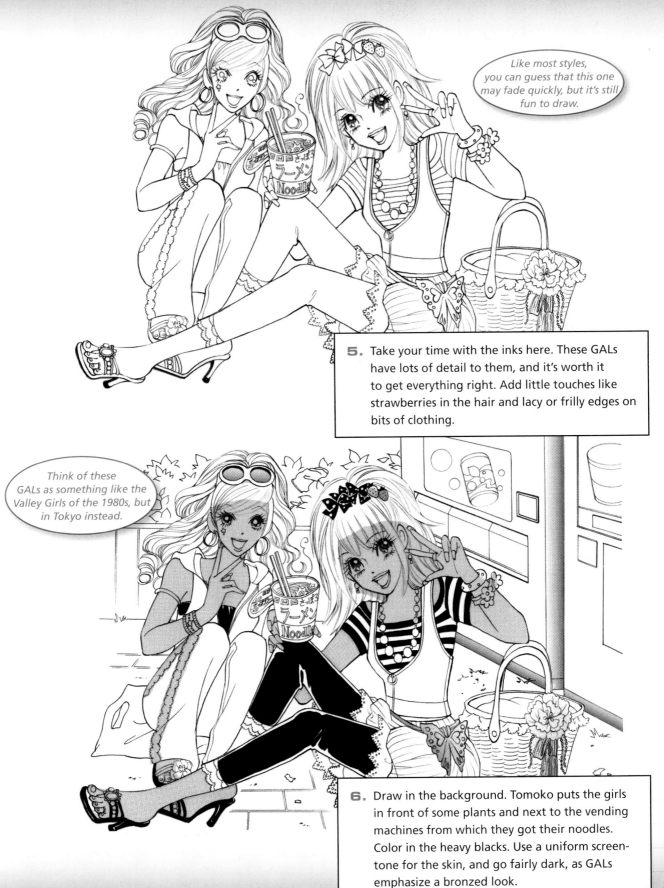

Like most styles, you can guess that this one may fade quickly, but it's still fun to draw.

5. Take your time with the inks here. These GALs have lots of detail to them, and it's worth it to get everything right. Add little touches like strawberries in the hair and lacy or frilly edges on bits of clothing.

Think of these GALs as something like the Valley Girls of the 1980s, but in Tokyo instead.

6. Draw in the background. Tomoko puts the girls in front of some plants and next to the vending machines from which they got their noodles. Color in the heavy blacks. Use a uniform screentone for the skin, and go fairly dark, as GALs emphasize a bronzed look.

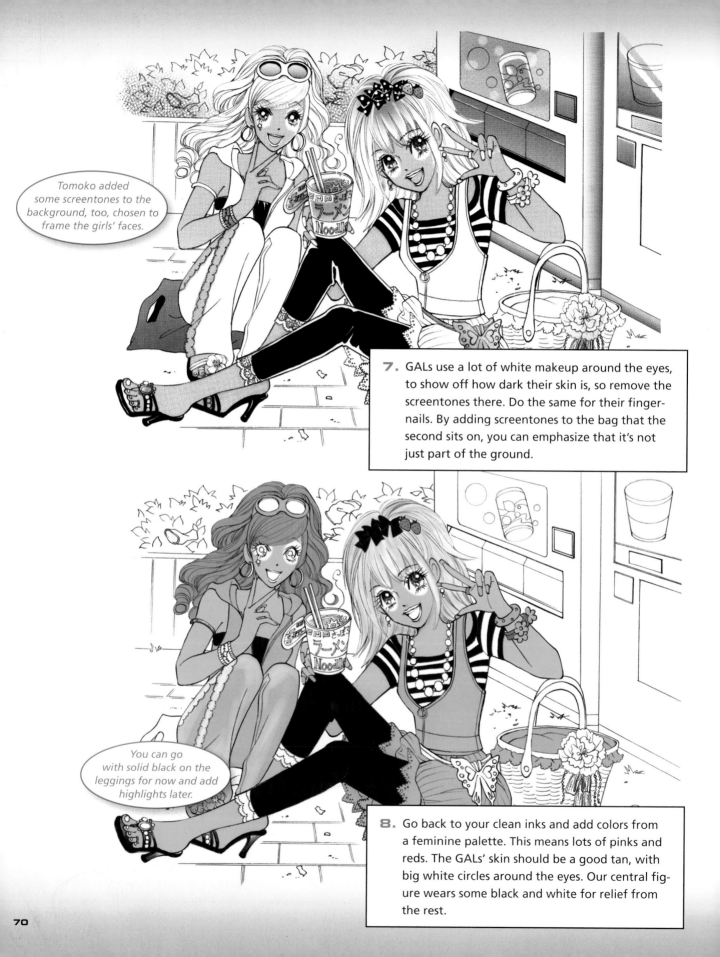

Tomoko added some screentones to the background, too, chosen to frame the girls' faces.

7. GALs use a lot of white makeup around the eyes, to show off how dark their skin is, so remove the screentones there. Do the same for their fingernails. By adding screentones to the bag that the second sits on, you can emphasize that it's not just part of the ground.

You can go with solid black on the leggings for now and add highlights later.

8. Go back to your clean inks and add colors from a feminine palette. This means lots of pinks and reds. The GALs' skin should be a good tan, with big white circles around the eyes. Our central figure wears some black and white for relief from the rest.

Pearls of Wisdom

Working in color versus black and white is very different, as the first GAL's pants show. In a monochrome version, they need highlights to give them and the picture more life. In the color version, though, it's fine to leave them solidly one color, as there's already plenty going on in the picture, and this looks more realistic. They also draw the eye to them by standing out from the more rendered bits.

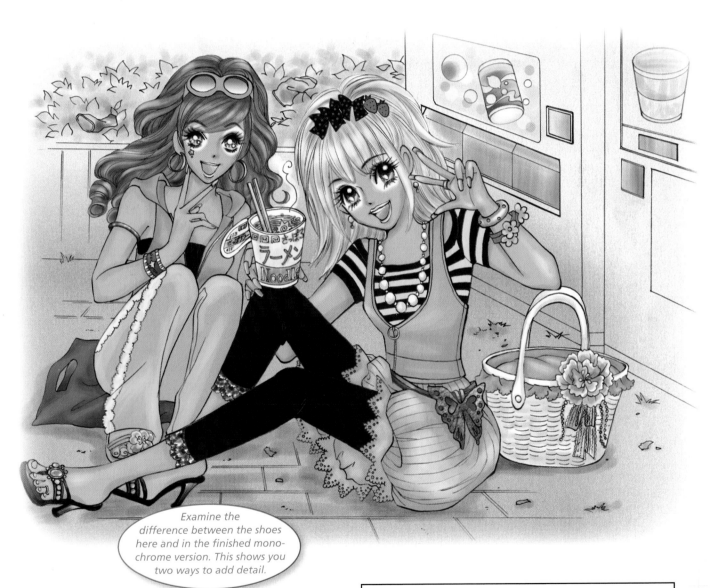

Examine the difference between the shoes here and in the finished monochrome version. This shows you two ways to add detail.

9. Color in everything else and add highlights and shadows as you like. Note that Tomoko leaves the blacks with a matte (dull) finish. She also goes with faint colors, almost light pastels, for the background to help make the GALs stand out.

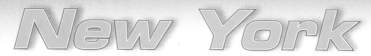

New York

Ask any New Yorker, and he or she will tell you that New York is the greatest city on Earth. As the song goes, if you can make it there, you can make it any-where, and thousands of people arrive to give it a shot every day. Let's examine one such young man in our next illustration.

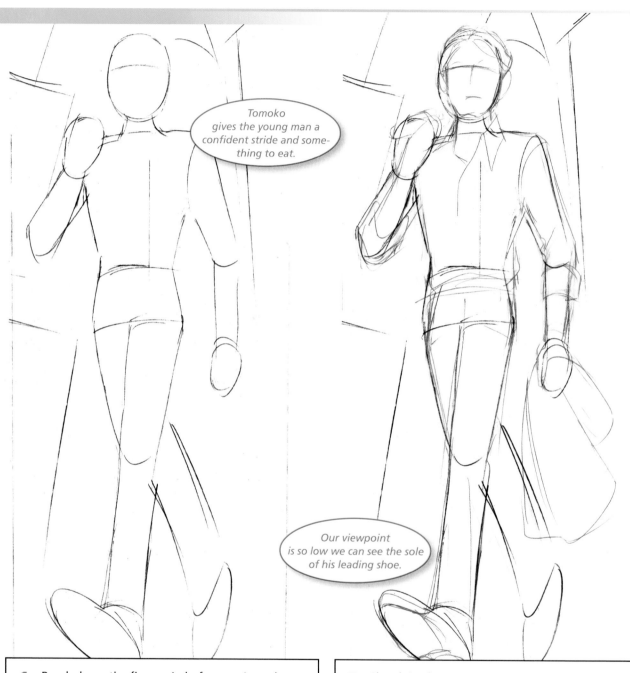

Tomoko gives the young man a confident stride and some-thing to eat.

Our viewpoint is so low we can see the sole of his leading shoe.

1. Break down the figure. As before, we're going to try something a little different with the angle and perspective. This time, we're going to set the viewer at a worm's-eye angle. This gives us a dynamic way to look at the figure and also show off the buildings in Manhattan, the central part of New York City.

2. Sketch in the young man's hair and clothes. He wears a button-down shirt and carries his jacket in his free hand. He's rolled up his sleeves so he can enjoy the spring weather.

Chimeric Koans

New York is still the hometown of Marvel and DC Comics, the two giants of the American comic book industry. While they were built on the backs of their spandex-clad superheroes, even they have begun to make inroads into the styles popularized by manga publishers, in both Japan and the United States. In many ways, the home of comic books of all kinds is right here in the Big Apple.

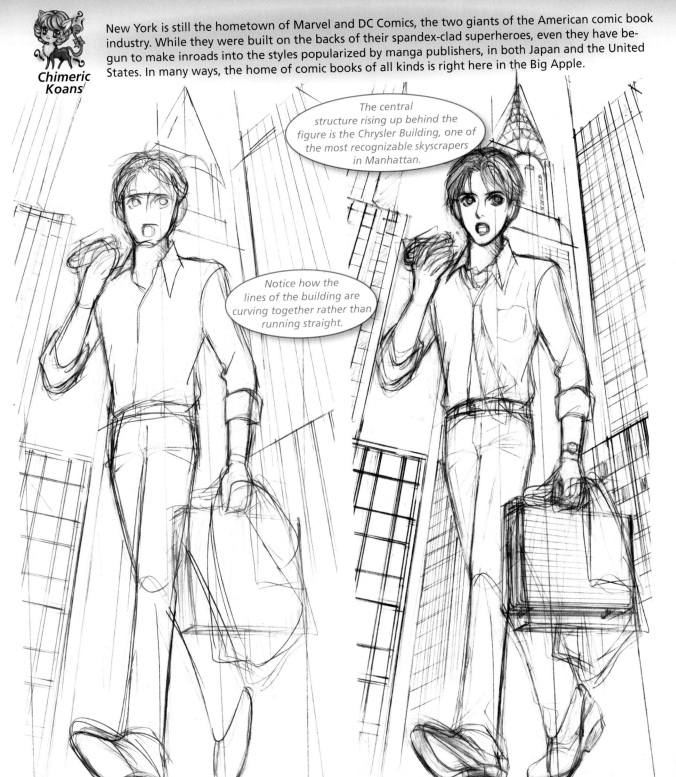

The central structure rising up behind the figure is the Chrysler Building, one of the most recognizable skyscrapers in Manhattan.

Notice how the lines of the building are curving together rather than running straight.

3. Work in some more details. Tomoko switched out the jacket for a briefcase with a jacket draped over it. Develop the buildings a little more, too.

4. Draw in the final details. Add a tie to the young man's shirt, but make it sway in the wind, showing the speed of his movement. Define the hot dog, the briefcase, and the buildings better. Put a pocket on the shirt and refine the figure's features.

Manga-nese

Curvilinear perspective is a system of drawing that uses five vanishing points and takes into account the natural curve that a lens imparts to a long, straight line. The perspective lines curve together rather than just running together. This makes for a more natural and dramatic feel, although it's tougher to pull off.

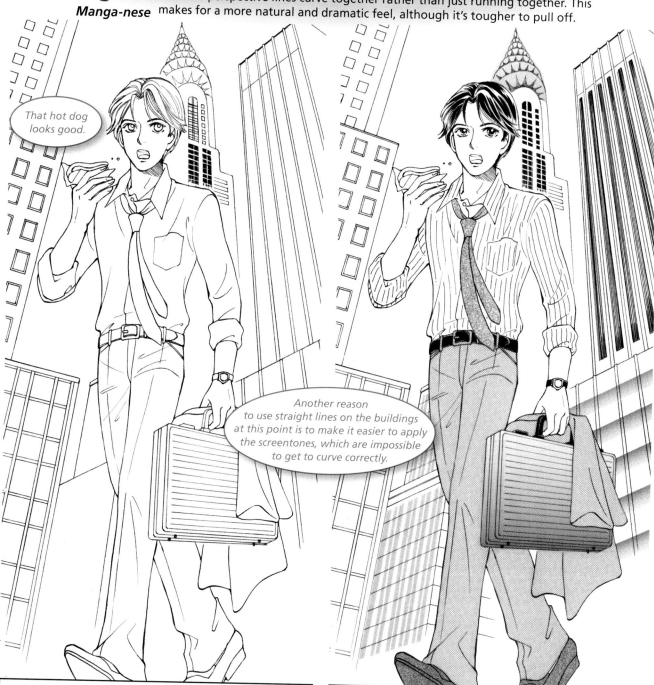

5. Time to lay down the inks. Use thicker lines for the outlines of the young man. A bit of shadow under his shoe helps ground him, too. Tomoko uses a straight edge here to ink the lines of the buildings. It's a fair compromise between keeping to the strict *curvilinear perspective* and making the drawing look sharp and clean, as getting all those curves exactly right in such a dramatic drawing can be tricky and time-consuming.

6. Add in screentones on the pants, shoes, and briefcase. You can even use them for the reflections on skyscraper windows if you like. Tomoko also takes the time to ink in the lines on the young man's shirt by hand rather than using a pattern, giving it a natural, realistic look.

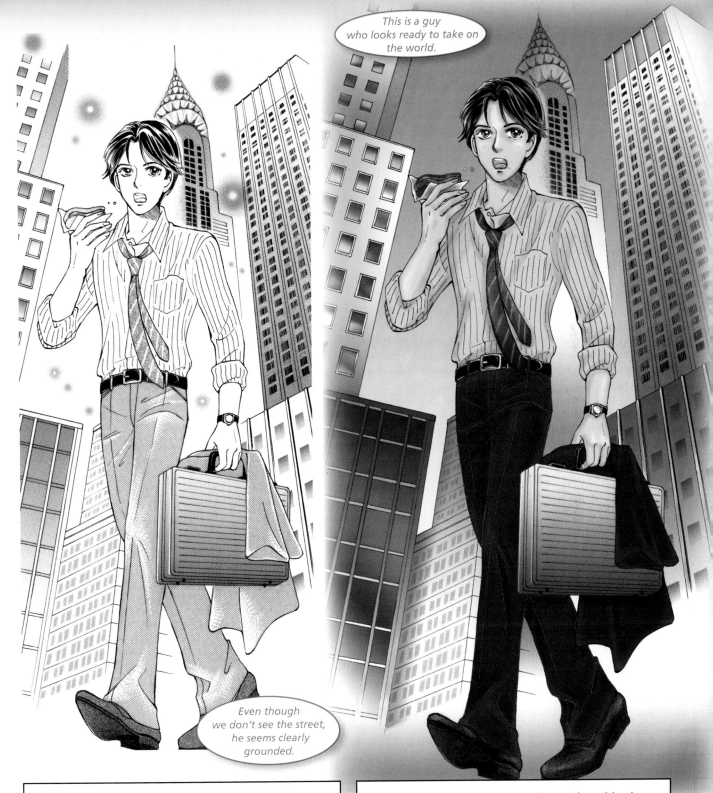

7. Wear away at the screentones on the young man's pants to give them highlights. Run more screentones on the building faces to show shadows and lights.

8. Rather than going to your clean inks, add color over the screentones. This mixed use gives the illustration a grittier feel than you might be able to achieve with either alone.

The Country

Despite what the people in the big cities of the world might tell you, life looms beyond their well-lit borders. People have lived in the country since long before there were cities, and they're still there now, growing the food that the rest of us eat. Let's try a study of a girl in a country field to see a bit more of this.

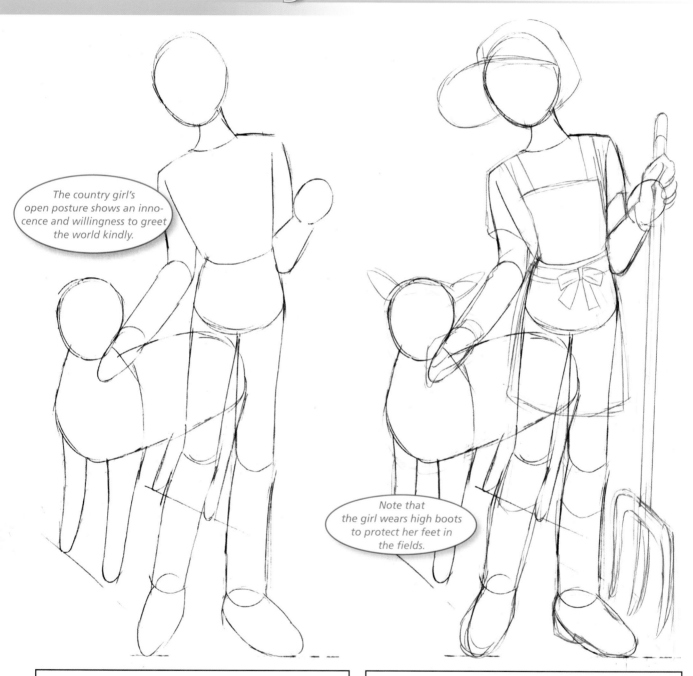

The country girl's open posture shows an innocence and willingness to greet the world kindly.

Note that the girl wears high boots to protect her feet in the fields.

1. Break down the body shape. Tomoko starts with a young girl, a farmer's daughter, perhaps, tending a young calf in the fields of Hokkaido. Her stance shows that she cares for the creature. Similarly, it does not shy away from her.

2. Give the girl a traditional bonnet and clothes, and put a pitchfork in her hand. Notice that she wears a type of apron for her work. Put some ears on the calf so you can tell which way it's facing.

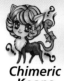

Chimeric Koans

Hokkaido is the mostly rural island north of Honshu, the largest, most populated island in the country. It produces more rice and fish than any other region in the nation. While it has a long history of agriculture, it has developed a strong tourism industry, too. It's also the land where Tomoko was born.

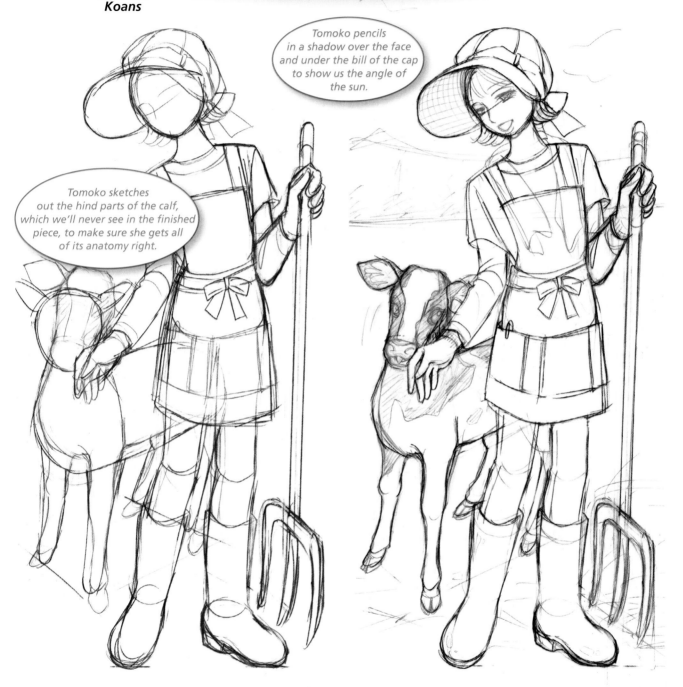

Tomoko pencils in a shadow over the face and under the bill of the cap to show us the angle of the sun.

Tomoko sketches out the hind parts of the calf, which we'll never see in the finished piece, to make sure she gets all of its anatomy right.

3. Rough in the calf's head a bit better. Now we can see that the girl is not petting it but letting it nuzzle her hand. Add some more details to the girl's clothes, like pockets on the apron and gloves on her hands.

4. Focus on the girl's face, filling out her hair and showing her eyes. She doesn't have the wide eyes of a GAL, but she's pretty and wholesome. Add some coloring to the calf's coat, and drape a rag or towel over the girl's shoulders. Sketch in some background details.

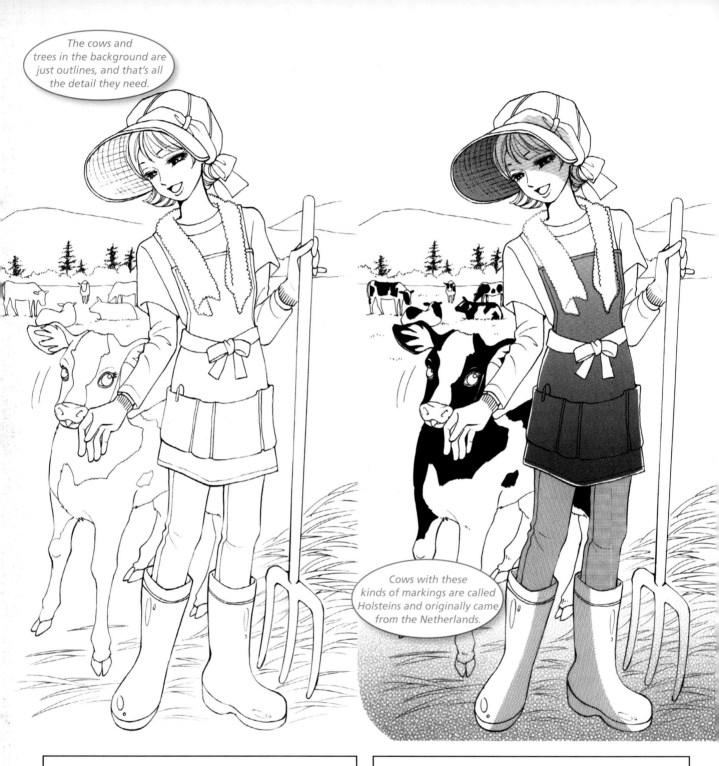

The cows and trees in the background are just outlines, and that's all the detail they need.

Cows with these kinds of markings are called Holsteins and originally came from the Netherlands.

5. Lay down your inks. Use stronger lines on the girl and the calf and weaker ones for the background. The hand-done texture inside the bill of the cap gives it a look that no screentone could mimic. Add some hay under the pitchfork and throw a few other cows into the background.

6. Add screentones to the girl's apron and pants. Also shade over her eyes and under her bonnet's bill. Black shapes on the cows make them easily identifiable at any distance. Use a gradated screentone on the hay to establish the ground more strongly.

It's a beautiful scene, reminiscent of home.

Tomoko also adds screentone to the calf's eyes and nose to give it a bit more life.

7. A gradated screentone works well on the mountains in the distance, but make sure it's lighter than what you use in the foreground. Work the screentone on the face to make it lighter and more varied. Chew up the knees of the pants to show natural wear. Pick out the apron's pockets in white.

8. Return to your clean inks. Because this is a pastoral scene, use bright, natural tones: vibrant green grass, blue sky, white clouds, and so on. Tomoko chooses dark colors for the girl's clothes for their practicality in such settings. She also scatters transparent circles around the place, which resemble lens flares, optical artifacts found on photographs taken in bright light.

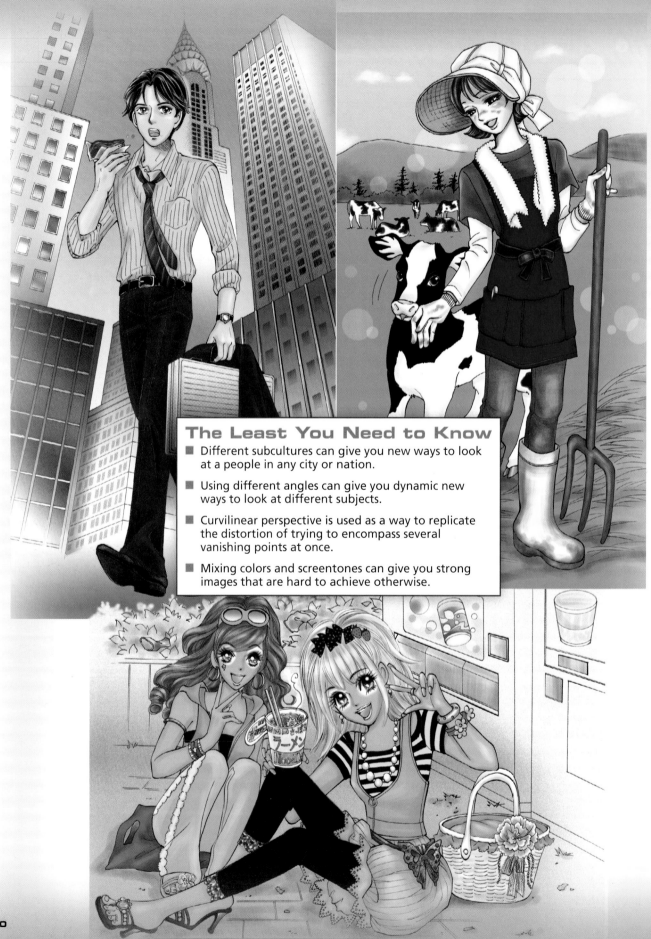

The Least You Need to Know

■ Different subcultures can give you new ways to look at a people in any city or nation.

■ Using different angles can give you dynamic new ways to look at different subjects.

■ Curvilinear perspective is used as a way to replicate the distortion of trying to encompass several vanishing points at once.

■ Mixing colors and screentones can give you strong images that are hard to achieve otherwise.

Near Future: 6
Dancing on the Bleeding Edge

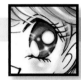
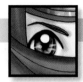

Having wandered around today's world for a bit, it's time to explore the near future, bits of fantasy that flit close enough to the edges of our reality that you could confuse them with our own world. Lots of manga takes place in this nether place between reality and the science-fiction of the far future. Other times it might be called cyberpunk or post-singularity, but either way, it's near enough that you can feel the cutting edge right against your skin.

First we indulge in a bit of whimsy and tackle the popular subgenre of the magic girl. This constitutes a good chunk of shoujo manga in which a young girl has superhuman powers, fights evil from beyond, and has a secret identity she must protect. Think of it as superheroes for young girls.

Next we attack a young ninja trained to fight in the streets of Tokyo or beyond. Ninjas have been part of legend for centuries, but they're almost always adults. Here, in post-modern shoujo, we can find them at nearly any age.

From there, we examine a young soldier of fortune, a mercenary outfitted in the latest and greatest combat gear and trained to make the fullest use of every bit of it. In many ways, this figure is the mirror opposite of the magic girl, a hard-edged version of the future that's already here.

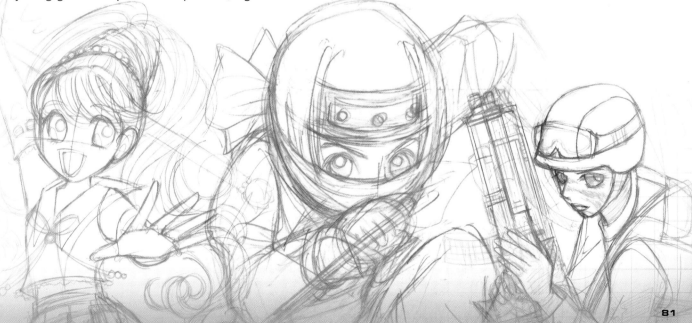

Magic Girl

The magic girl, or *maho shoujo*, is the ultimate power fantasy of many shoujo readers. While on the surface she seems just like the average shoujo manga fan, she is secretly a person granted great magical powers with which she is to play a major role in the salvation of the planet or universe. In our case, we're going to produce a super-cute young heroine with the ability to do just that.

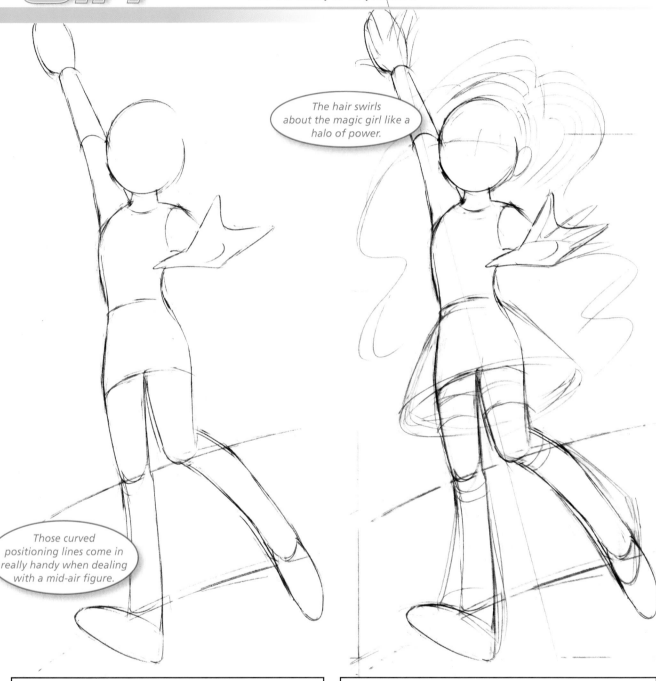

The hair swirls about the magic girl like a halo of power.

Those curved positioning lines come in really handy when dealing with a mid-air figure.

1. For a figure who's essentially a superhero, we need something dramatic and dynamic. Here, break down the figure as a flying girl, hanging from something in her right hand. Notice the foreshortening of the left arm as she points it toward the viewer.

2. Sketch in the girl's clothing and hair. Go wild here, especially with the hair. From the angle we have, we end up looking up her skirt, which is a bit suggestive for a young girl. However, a pair of shorts and long leggings make it nothing more than that.

Manga-nese

Maho shoujo is the Japanese term for "magic girl," and it's one of the most popular forms of shoujo manga. The most popular examples in the United States spring from the *Sailor Moon* series, in which the heroines transform into magic girls named after different heavenly bodies: Sailor Moon, Sailor Venus, Sailor Mars, and so on.

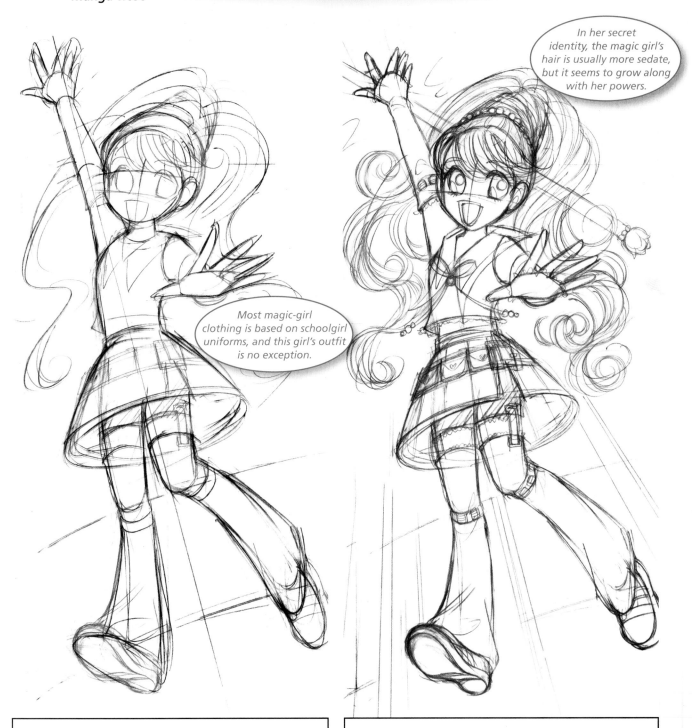

In her secret identity, the magic girl's hair is usually more sedate, but it seems to grow along with her powers.

Most magic-girl clothing is based on schoolgirl uniforms, and this girl's outfit is no exception.

3. Add in more details. Figure out the placement of the hands, and watch the foreshortening of the fingers as they splay out before the viewer. The leggings end up like stylish bell-bottoms here. Rough in the eyes and the details of the outfit, too.

4. Finish off the hair, and go as elaborate as you can. Put a baton in her hand, the totem of her power. Give her wide, stylized eyes, and you can even put a crown of some sort in her hair. Rough in the motion lines to show that she's flying into the air.

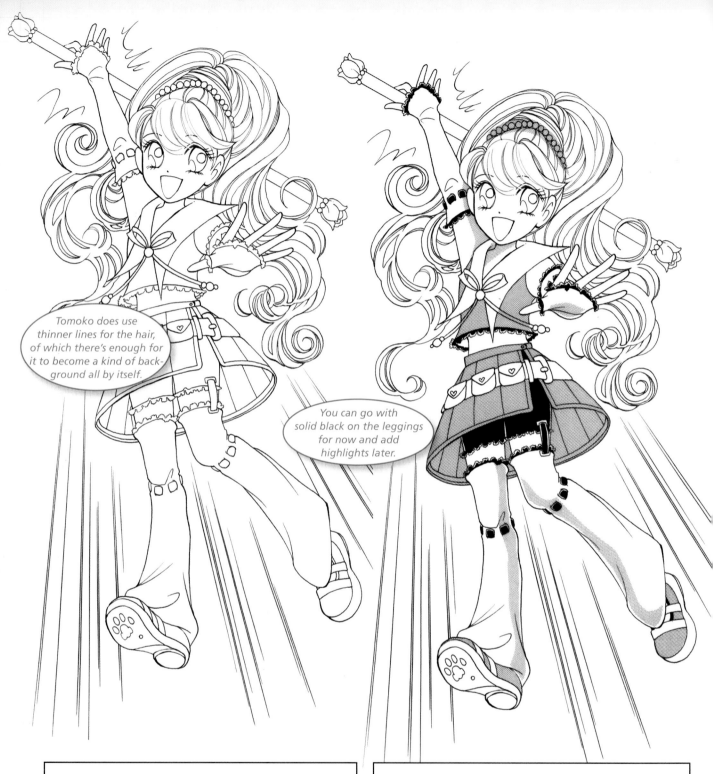

Tomoko does use thinner lines for the hair, of which there's enough for it to become a kind of background all by itself.

You can go with solid black on the leggings for now and add highlights later.

5. Use inks of uniform thickness through most of this drawing. The exceptions are the figure's eyes. For everything else, rely on the strength of your drawing and presentation. We don't have a background here, so there's no need for a strong contrast (or any, really) against it.

6. Magic girls tend to be bright and shiny, so go easy on the shading here. Tomoko only applies solid tones to the girl's shirt and skirt. However, she also adds some shading to her limbs to show shadows from the light source.

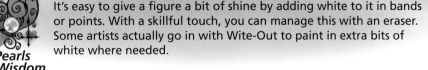

It's easy to give a figure a bit of shine by adding white to it in bands or points. With a skillful touch, you can manage this with an eraser. Some artists actually go in with Wite-Out to paint in extra bits of white where needed.

*Pearls
of Wisdom*

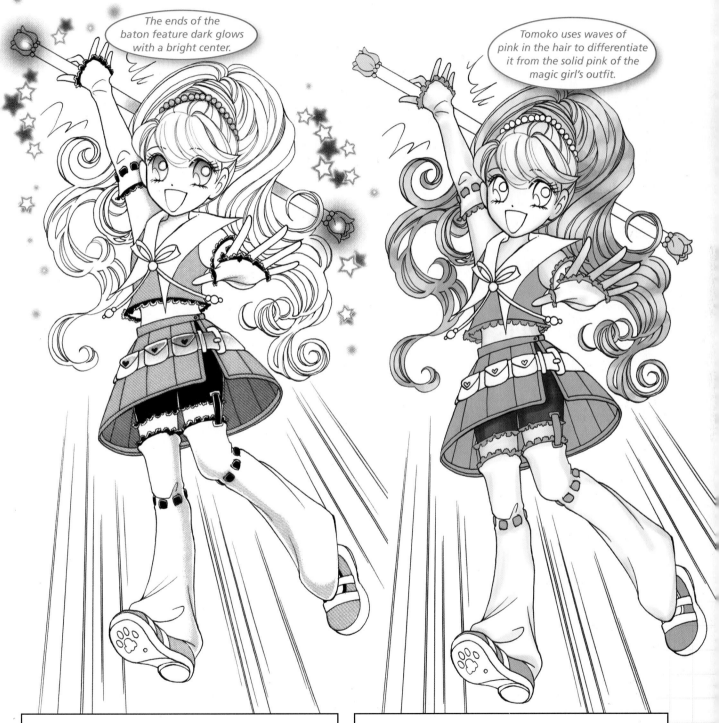

The ends of the baton feature dark glows with a bright center.

Tomoko uses waves of pink in the hair to differentiate it from the solid pink of the magic girl's outfit.

7. Go back to your clean inks and choose a super-feminine palette. The magic girl wears only pink and white, with the exception of dark-purple shorts.

8. Go back to your clean inks. Use only a pale pink or salmon color for most of the colors. A dark purple works well for the undershorts, and blue highlights on the gloves and leggings make them pop.

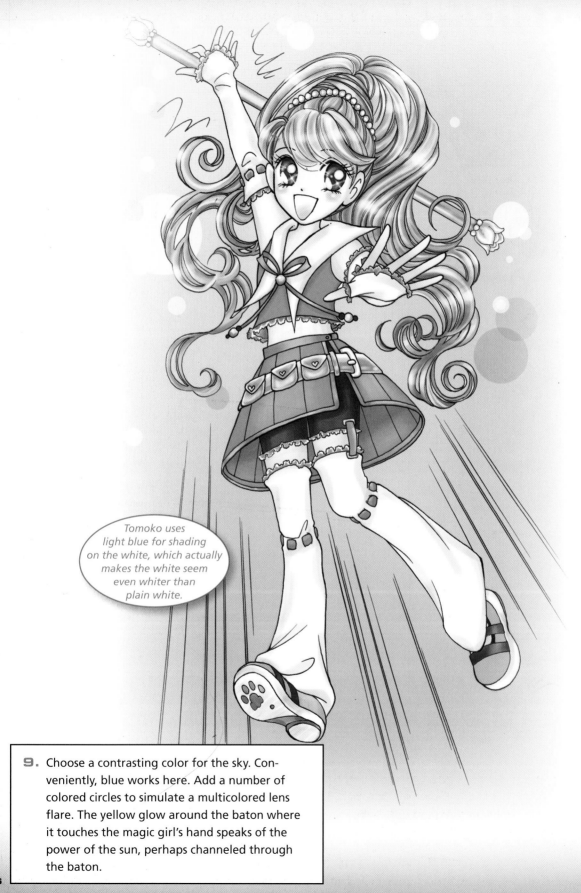

Tomoko uses light blue for shading on the white, which actually makes the white seem even whiter than plain white.

9. Choose a contrasting color for the sky. Conveniently, blue works here. Add a number of colored circles to simulate a multicolored lens flare. The yellow glow around the baton where it touches the magic girl's hand speaks of the power of the sun, perhaps channeled through the baton.

For our next subject, we have a young girl who is a student by day and secretly a *ninja* by night. To juxtapose these two parts of her life, Tomoko has decided to show the girl in her everyday clothes, with her ninja alter ego leaping up behind her, a transparent figure from her imagination.

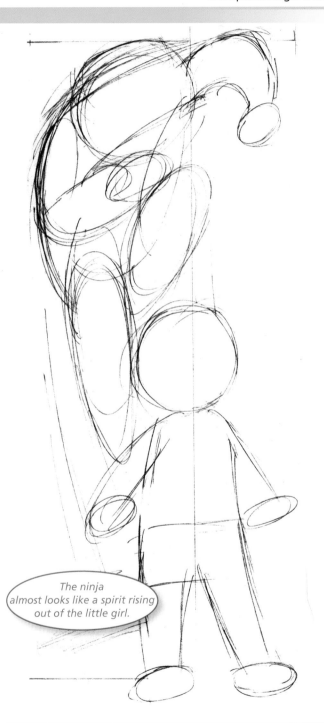

The ninja almost looks like a spirit rising out of the little girl.

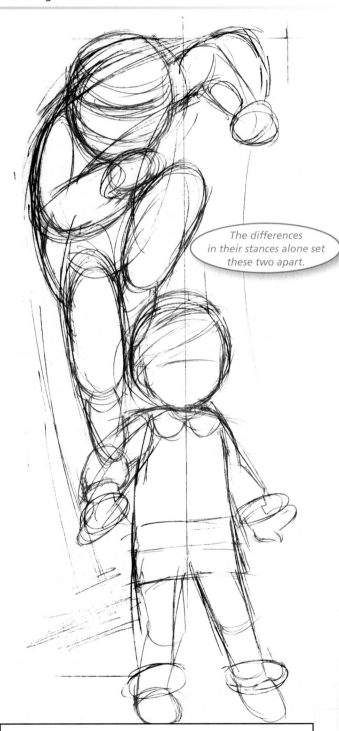

The differences in their stances alone set these two apart.

1. This time, we break down two figures. The lower one is the little girl. Use shorter limbs and torso to indicate her tiny height. For the ninja, be far more dramatic. Hurl her into the air and use looser limbs.

2. Sketch in more of the two figures. Show the location of the ninja's mask and add some movement lines, showing her rise into the air. Tomoko repositions the girl's feet and bends her right knee to show her taken aback just a bit.

Manga-nese

Ninja have been with us since fourteenth-century Japan as stealth troops trained to carry out the dishonorable kinds of jobs that samurai, with their strict code of honor (*bushido*), could not. In modern stories, they usually wear outfits all of black, that cover everything but their eyes. They are assassins of the highest order.

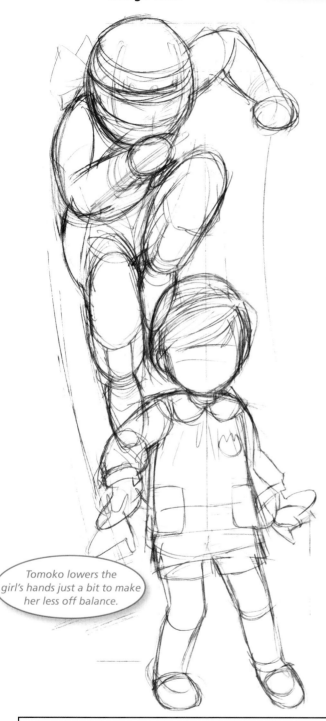

Tomoko lowers the girl's hands just a bit to make her less off balance.

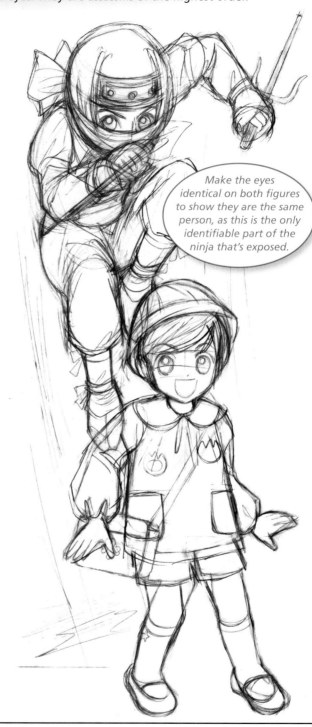

Make the eyes identical on both figures to show they are the same person, as this is the only identifiable part of the ninja that's exposed.

3. Refine things further. Work in the details of the girl's outfit, which is a loose blouse over shorts. The ninja's clothes are baggy to allow for a wide range of movement without being hampered.

4. Go nuts with the details. Add weaponry (these daggers are called *sai*) and a headband to the ninja. Wrap the baggy pants around the ankles. Put a purse on the girl and work up the details on her face.

Don't be afraid to change things around in your drawing, especially in the pencil stage. Inks may be permanent, but you have an eraser to handle all those pencil marks if need be.

Pearls of Wisdom

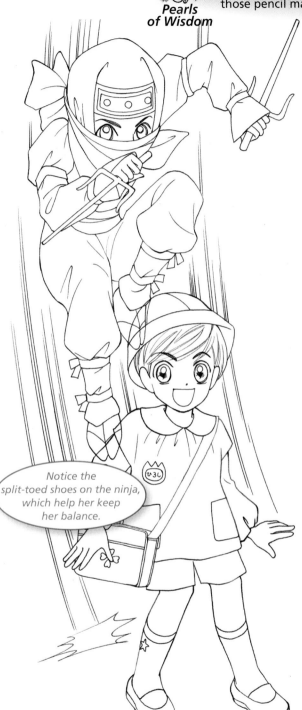

Notice the split-toed shoes on the ninja, which help her keep her balance.

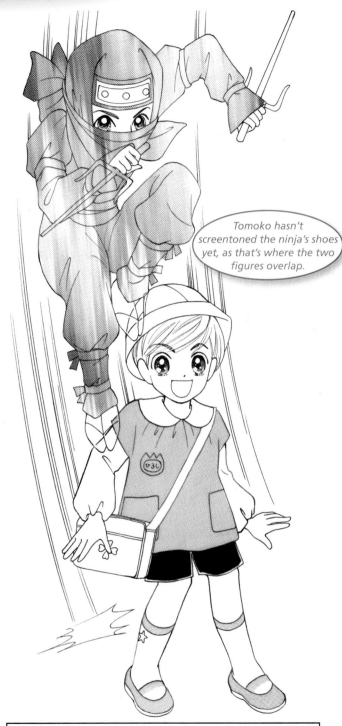

Tomoko hasn't screentoned the ninja's shoes yet, as that's where the two figures overlap.

5. Lay down the inks. Again, you can use mostly uniform lines here. Use fainter ones for the motion lines and for the wrinkles on clothing. Use clean lines for the girl and rumpled ones on the ninja. Notice how you can see the ninja's feet through the little girl.

6. Cover every bit of the ninja's outfit in screentones. Scrape it in the direction of the motion lines to make it seem like it's moving even faster. Also apply screentones to the girl's outfit, including her shoes and the tops of her socks, and black out her shorts.

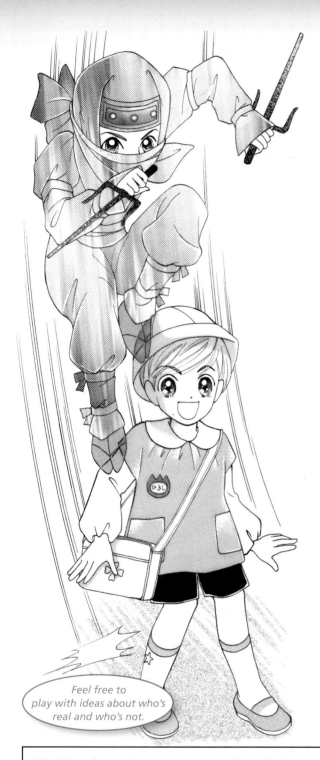

Feel free to play with ideas about who's real and who's not.

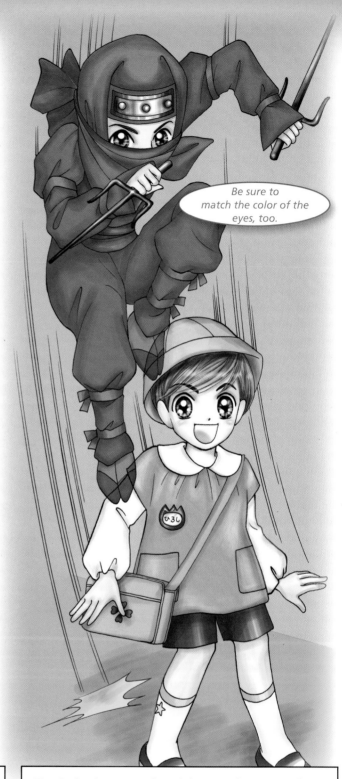

Be sure to match the color of the eyes, too.

7. Wear down the screentones on the girl's dress to give it some highlights. Add a bit of shadow to the ground to make it solid. Screentone the ninja's shoes with care to show the overlap. Now it looks like the ninja is real and the girl is the imaginary part.

8. Go back to your clean inks. Tomoko goes with purple for the ninja's outfit because it's more girlish and is actually harder to spot at night than pure black. For the girl, she goes with yellow for the hat and bag, blue for the shirt, and purple for the shorts and shoes. A dull green wall and salmon-colored floor give a simple background more life.

The Soldier

Throughout human history, there has always been war, and there's no reason to think that fact will change any time soon. More and more women have become soldiers over the past few decades, and it's not impossible for girls to wonder what it might be like to be a soldier of fortune, a trained mercenary selling her skills and abilities to the highest bidder. Sometimes these "mercenaries" are used by their own government to provide it with a way to cut them loose if caught. In such cases, these soldiers are truly on their own.

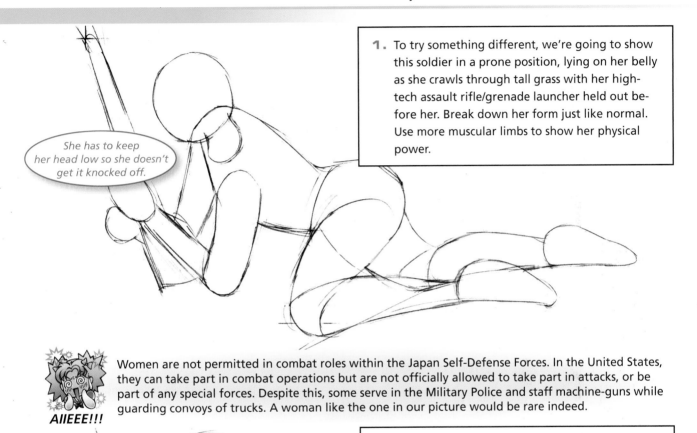

1. To try something different, we're going to show this soldier in a prone position, lying on her belly as she crawls through tall grass with her high-tech assault rifle/grenade launcher held out before her. Break down her form just like normal. Use more muscular limbs to show her physical power.

She has to keep her head low so she doesn't get it knocked off.

AIIEEE!!!

Women are not permitted in combat roles within the Japan Self-Defense Forces. In the United States, they can take part in combat operations but are not officially allowed to take part in attacks, or be part of any special forces. Despite this, some serve in the Military Police and staff machine-guns while guarding convoys of trucks. A woman like the one in our picture would be rare indeed.

2. Put a helmet on the solider and arrange supply packs on the belt around her waist. Place tall bits of grass around her for concealment from her foes. Work out the details of the weapon a bit more.

Very little of her skin should be exposed, so keep that in mind as you arrange her clothing.

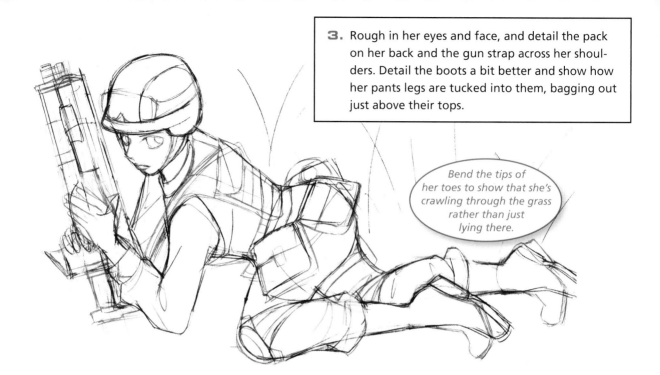

3. Rough in her eyes and face, and detail the pack on her back and the gun strap across her shoulders. Detail the boots a bit better and show how her pants legs are tucked into them, bagging out just above their tops.

Bend the tips of her toes to show that she's crawling through the grass rather than just lying there.

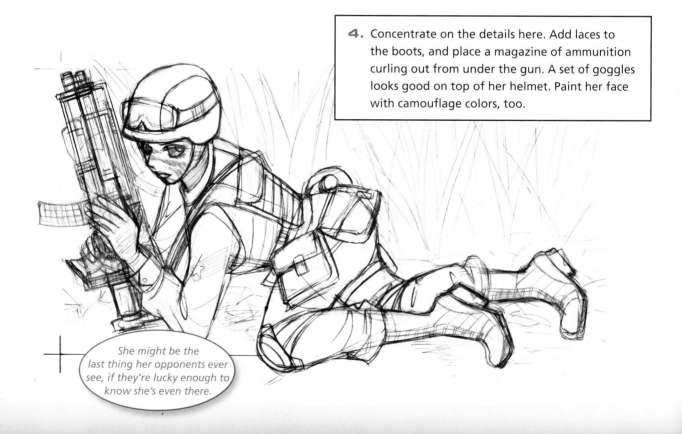

4. Concentrate on the details here. Add laces to the boots, and place a magazine of ammunition curling out from under the gun. A set of goggles looks good on top of her helmet. Paint her face with camouflage colors, too.

She might be the last thing her opponents ever see, if they're lucky enough to know she's even there.

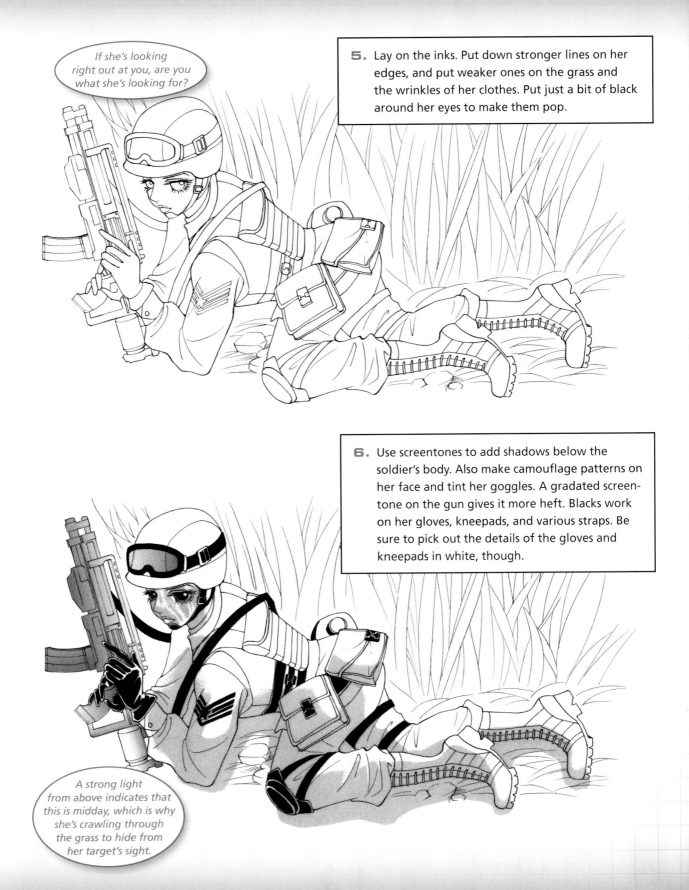

If she's looking right out at you, are you what she's looking for?

5. Lay on the inks. Put down stronger lines on her edges, and put weaker ones on the grass and the wrinkles of her clothes. Put just a bit of black around her eyes to make them pop.

6. Use screentones to add shadows below the soldier's body. Also make camouflage patterns on her face and tint her goggles. A gradated screentone on the gun gives it more heft. Blacks work on her gloves, kneepads, and various straps. Be sure to pick out the details of the gloves and kneepads in white, though.

A strong light from above indicates that this is midday, which is why she's crawling through the grass to hide from her target's sight.

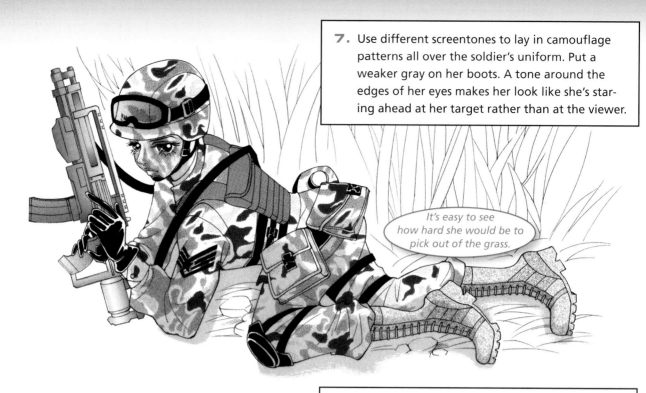

7. Use different screentones to lay in camouflage patterns all over the soldier's uniform. Put a weaker gray on her boots. A tone around the edges of her eyes makes her look like she's staring ahead at her target rather than at the viewer.

It's easy to see how hard she would be to pick out of the grass.

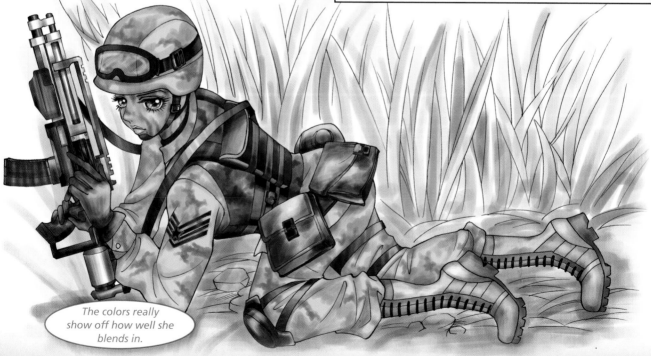

8. Go back to your clean inks. Choose a color for the grass and the ground, and start with those first. Then use similar colors for the soldier's camouflage patterns. Use dull blacks on the gun and straps. Nothing on her should shine. That would attract attention, which is the last thing she wants.

The colors really show off how well she blends in.

The Least You Need to Know

■ There are many different subgenres of shoujo manga, including maho shoujo ("magic girl").

■ It's okay to use two versions of the same character in an image to show how they relate to and differ from each other.

■ Don't let reality get in your way when choosing your subjects for your near-future shoujo manga.

■ Ninja do not exist, except when they do.

Far Future:
On the Edge of Time

In This Chapter

■ **Supergirls make great heroes**

■ **Cybergirls go past punk**

■ **Girls with designer genes**

Now that we've poked our noses into the future, it's time to dive into the deep end, feet first. While the far future isn't a common setting for shoujo, when it comes up, you'll want some ideas for how to handle it. Here are three solid examples.

First we examine a supergirl from the future. She flies, she's tough as nails, and she has powers far beyond those of normal women. We don't know if they come from magic, technology, or some odd mix of the two, but she saves the world and looks great doing it.

Then we examine a girl who's embraced technology to the fullest, or perhaps it's embraced her! This cybergirl puts the Bionic Woman to shame and comes fitted with all the latest in techno-gear. The trick, though, is to look for and find the girl in the machine.

Strange superpowers and technological leaps aren't everything, though. For an example, we examine a girl who's been genetically manipulated into something resembling a modern mermaid. And best of all, no batteries are required.

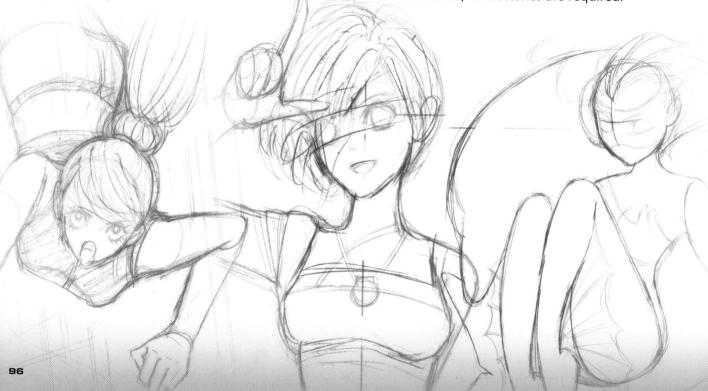

The Super-heroine

In the far future, scientists will have the means to grant people of all ages powers far beyond those of mortals, or so the theory goes. When the world stands on that cusp, a select few will be given the powers with which they can be trusted. The rest of us will have to stay on the ground and watch them fly overhead.

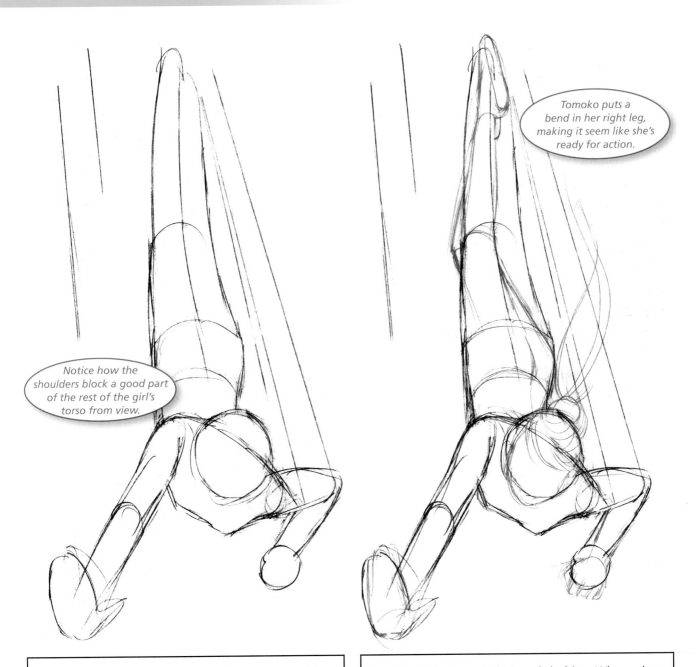

Notice how the shoulders block a good part of the rest of the girl's torso from view.

Tomoko puts a bend in her right leg, making it seem like she's ready for action.

1. Because this is a superheroine, let's try something entirely different. Instead of showing her rising into the sky, she dives toward the viewer, her hand extended, almost like a shield. Use basic shapes to break down the pose and add motion lines to give her a sense of movement.

2. Sketch in the girl's hair and clothing. When using long hair, make sure it sweeps back behind her in the wind made by the speed of her passage.

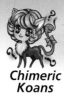

Chimeric Koans

While most readers of superhero manga realize that the tenets underlying it are nonsense, it's the creator's responsibility to come up with some sort of plausible-sounding reasoning behind any superhero's powers. Often this comes in the form of a strange origin story designed to help suspend the reader's disbelief. Most of the time, though, it's just another form of technobabble.

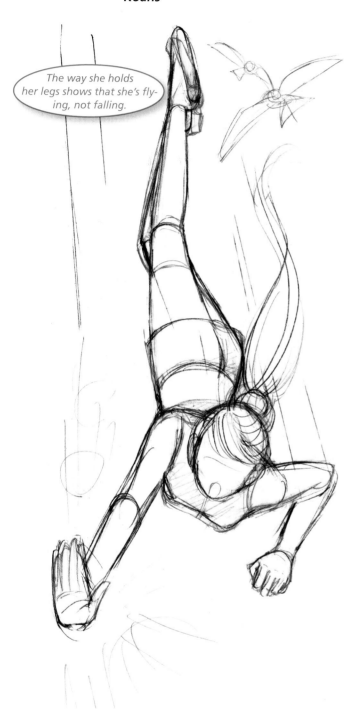

The way she holds her legs shows that she's flying, not falling.

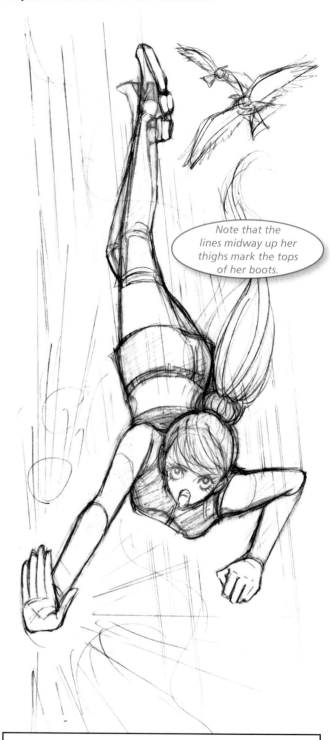

Note that the lines midway up her thighs mark the tops of her boots.

3. Rough in more details. Position her mouth. Add some birds in the background to help show that she's plunging down out of the sky.

4. Finish the face and hair. Add heels to the shoes. Work in more motion lines and show that she's firing or shining something out of her hand.

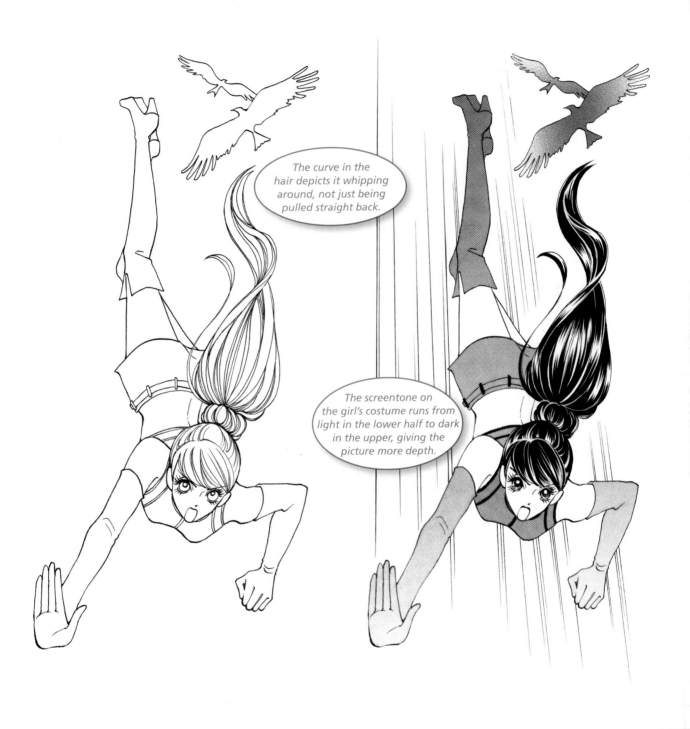

The curve in the hair depicts it whipping around, not just being pulled straight back.

The screentone on the girl's costume runs from light in the lower half to dark in the upper, giving the picture more depth.

5. For most of the figure, you can use a uniform line. The perspective used here matters more than the depth of line. The only large exception is her hair, which uses thinner lines to give it less weight and let it flow in the air.

6. Use blacks on the hair to set the heroine off from the blankness of the sky around her. Notice how Tomoko leaves a pattern of white through the streaks of black to show the highlights in the girl's hair.

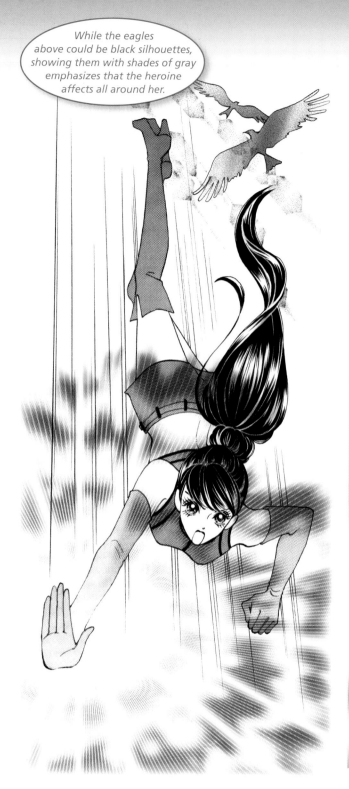

While the eagles above could be black silhouettes, showing them with shades of gray emphasizes that the heroine affects all around her.

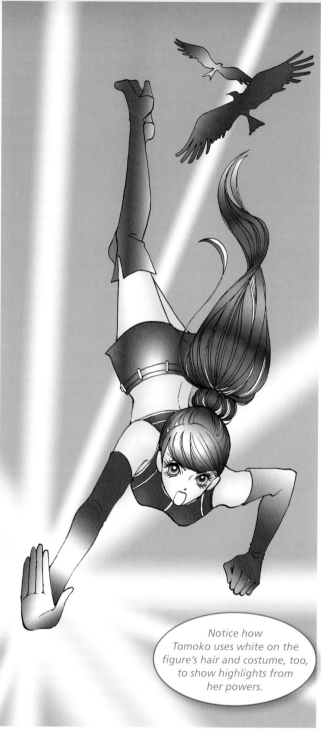

Notice how Tomoko uses white on the figure's hair and costume, too, to show highlights from her powers.

7. Rough up a burst pattern around the superheroine's hand. Overlay it atop the figure. This shows the power surging from her hand. The crystal figures in the top of the illustration mimic a type of lens flare and show the position of the sun.

8. Return to your clean inks. Go with a blue for the sky, working up to a truer blue at the top of the illustration. Red for the superheroine's costume and green for her hair give her a strong, primary-colors look. White streaks can show her power radiating from her hand.

Pearls of Wisdom

Computer coloring makes it easy to create brilliant whites in any piece. Here, Tomoko uses a gradient that faces to the surrounding colors, making the light seem more real and bright.

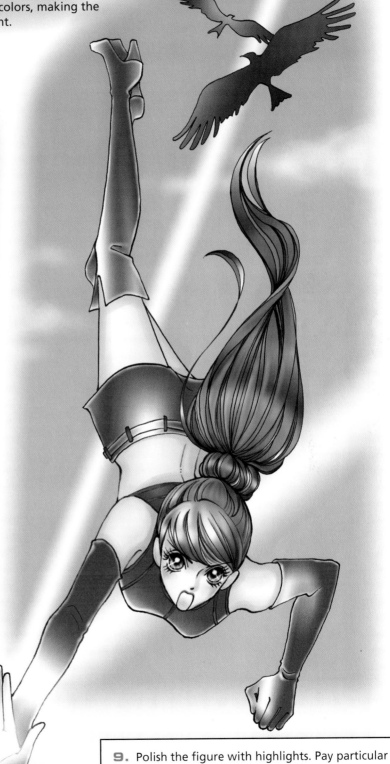

You can barely see the girl's hand for the power emanating from it.

9. Polish the figure with highlights. Pay particular attention to her hair. Add clouds in the background. Work some more blacks into the girl's hair to contrast sharply with the bright-white highlights.

Robo-Girl

Life sometimes takes a strange turn, and whether by choice or chance, this young woman has found herself on the receiving end of a large fortune in cybernetic replacements. While she was born human, the question now is whether she's become something less than that or something more.

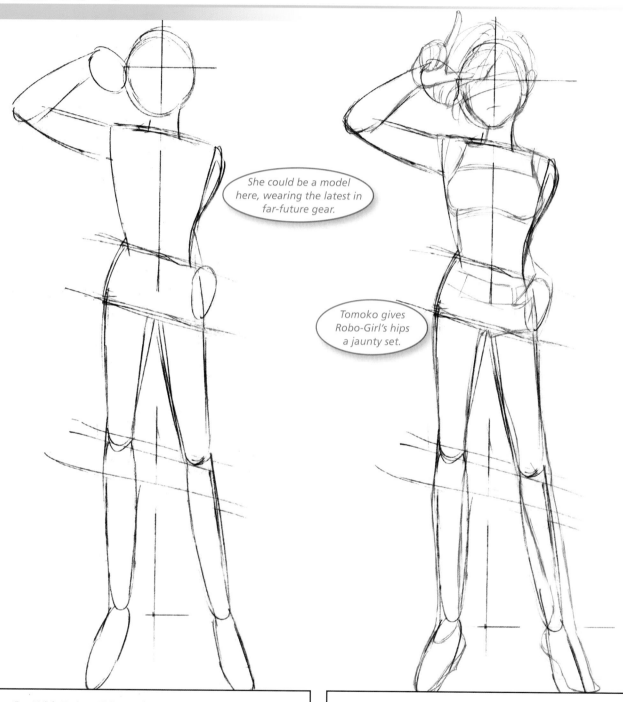

She could be a model here, wearing the latest in far-future gear.

Tomoko gives Robo-Girl's hips a jaunty set.

1. With Robo-Girl, we don't need any fancy poses. In fact, we should go with something standard. We're here to show off her hardware, not distract from it. Use simple shapes to break down a simple post.

2. Fill in a few more of the details. Right now, she still looks human, and we want to keep her that way. Her robot parts are subtle, not creepy or large. Add in her hair and show her fingers.

While characters like Robo-Girl may have a passing acquaintance with scientific reality, most creators don't limit themselves to the possible, instead going with what's coolest. To explain this away, they use *technobabble*, words that sound right but are really nonsense.

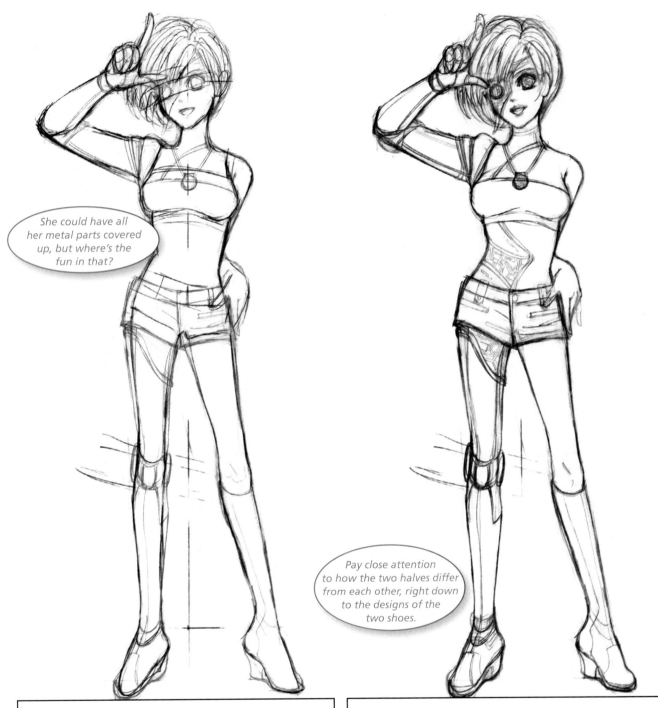

She could have all her metal parts covered up, but where's the fun in that?

Pay close attention to how the two halves differ from each other, right down to the designs of the two shoes.

3. Add in the eyes, show the clothes better, and then add the cybernetics. Robo-Girl's right half is mostly circuitry. Work metallic joints into her right arm and leg.

4. Add in more circuitry and metal. Stick mostly to her right half, but swing over to the left a bit in the middle, almost as if the metal is trying to swallow the rest of her. Be careful to use slightly harder lines for the metallic bits. Give them less subtle curves and bends.

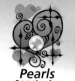

It's important to be able to think of things from your subject's point of view but not to confuse them with your own. In this picture, Robo-Girl's right is to your left.

Pearls of Wisdom

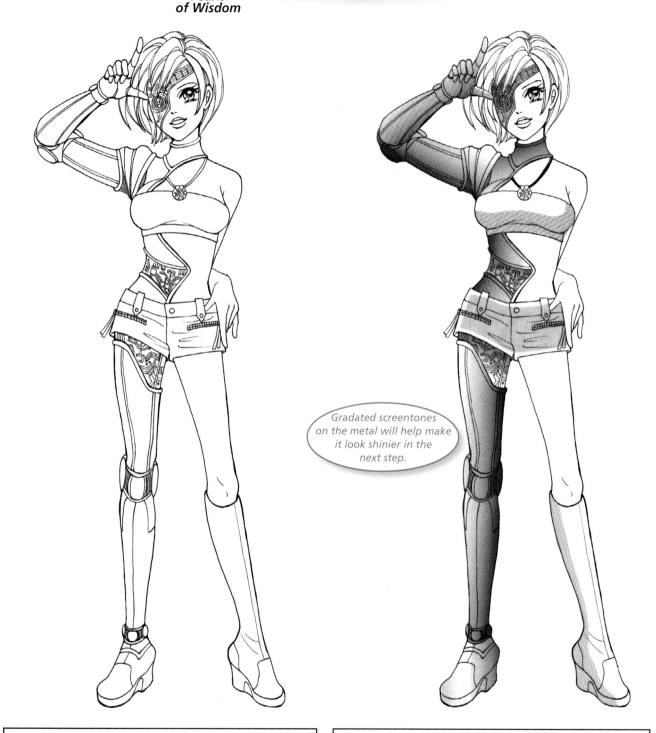

Gradated screentones on the metal will help make it look shinier in the next step.

5. Time for the inks. Use standard inking patterns here. Note that longer lines on the robot half are heavier, while circuitry is lighter. This emphasizes its miniaturized nature.

6. Cover the metallic parts in screentones. Also add shadows on the girl's shorts and boots. Notice how the curved shadows under Robo-Girl's breasts give them depth.

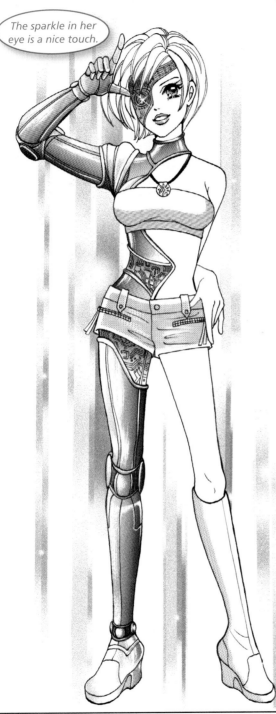

The sparkle in her eye is a nice touch.

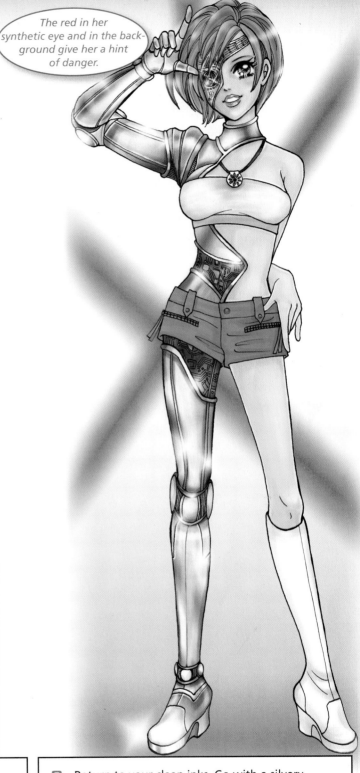

The red in her synthetic eye and in the background give her a hint of danger.

7. Strip out some of the screentones on the girl's metallic parts, thereby adding highlights. Adding broken streaks of gray to the background gives it a science-fiction look, almost as if she stands against a pixilated picture.

8. Return to your clean inks. Go with a silvery chrome for the metallic bits and circuit-board green for the exposed electronics. Matching this color with the girl's hair and shorts shows that she's embraced this new life of hers. The light green of her shirt and boot remind the viewer of a technician in a research lab.

Gene-Tech

In the far future, genetic manipulation will have as much impact as computers, if not far more. People will be able to remake themselves in any image they like and countless forms we haven't even thought of yet. For an excellent example, look no further than our Gene-Tech girl, the ultramodern image of a mermaid.

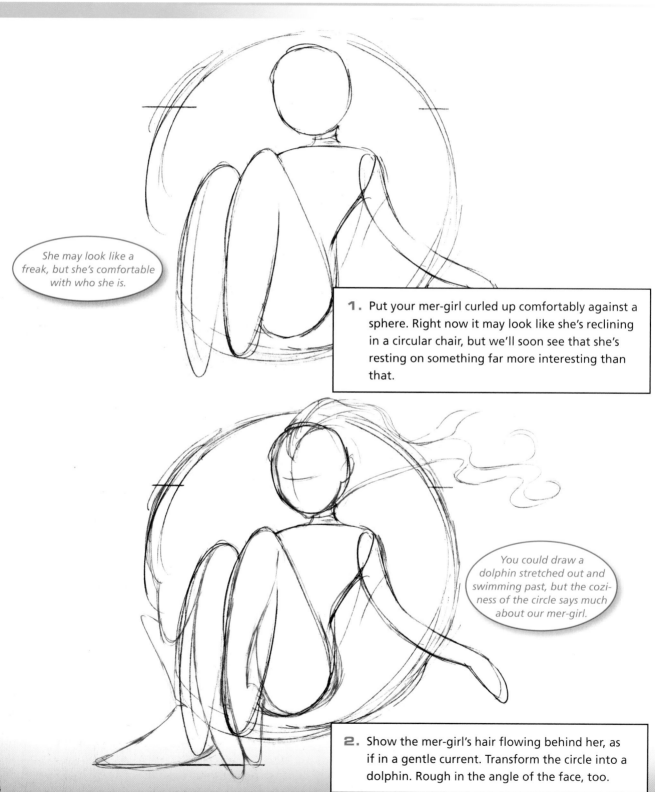

She may look like a freak, but she's comfortable with who she is.

1. Put your mer-girl curled up comfortably against a sphere. Right now it may look like she's reclining in a circular chair, but we'll soon see that she's resting on something far more interesting than that.

You could draw a dolphin stretched out and swimming past, but the coziness of the circle says much about our mer-girl.

2. Show the mer-girl's hair flowing behind her, as if in a gentle current. Transform the circle into a dolphin. Rough in the angle of the face, too.

AIIEEE!!!

There's a thin line between genetically manipulated cuties and monsters. You can go with either tone, but you should be aware of what you're shooting for before you begin. Otherwise, you could end up with a horrible beast in the center of your far-future romance, or an innocent beauty in the middle of a horrific tale.

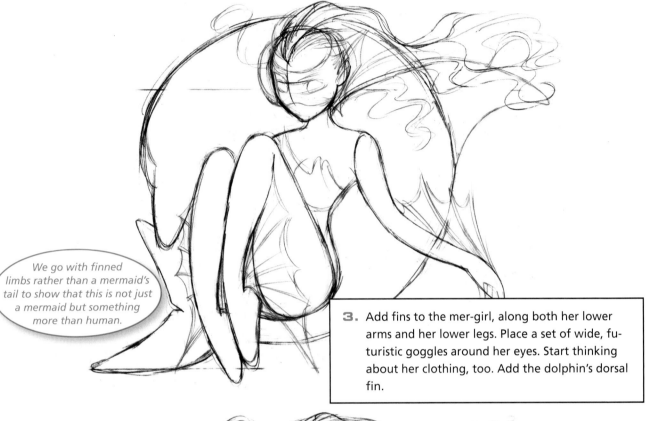

We go with finned limbs rather than a mermaid's tail to show that this is not just a mermaid but something more than human.

3. Add fins to the mer-girl, along both her lower arms and her lower legs. Place a set of wide, futuristic goggles around her eyes. Start thinking about her clothing, too. Add the dolphin's dorsal fin.

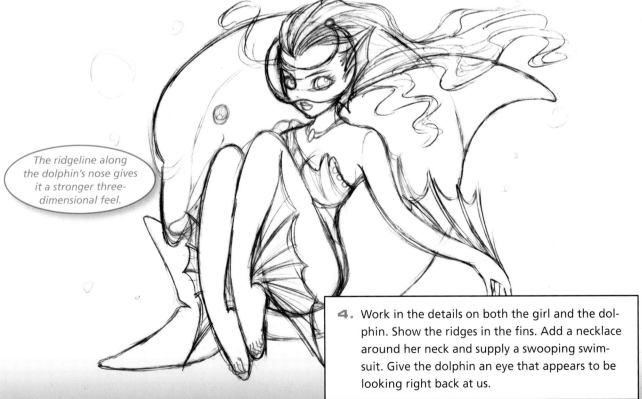

The ridgeline along the dolphin's nose gives it a stronger three-dimensional feel.

4. Work in the details on both the girl and the dolphin. Show the ridges in the fins. Add a necklace around her neck and supply a swooping swimsuit. Give the dolphin an eye that appears to be looking right back at us.

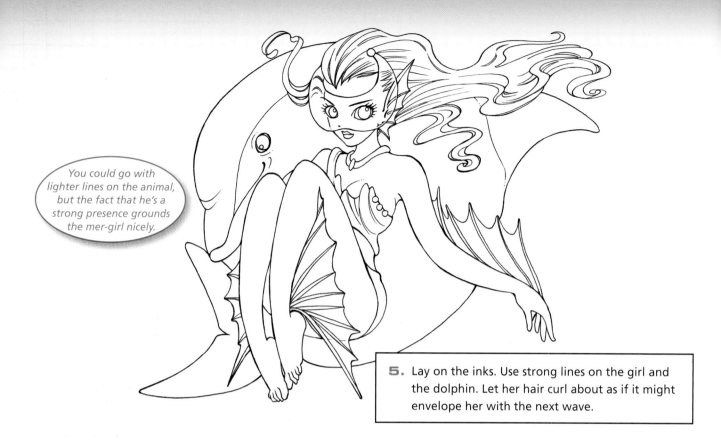

You could go with lighter lines on the animal, but the fact that he's a strong presence grounds the mer-girl nicely.

5. Lay on the inks. Use strong lines on the girl and the dolphin. Let her hair curl about as if it might envelope her with the next wave.

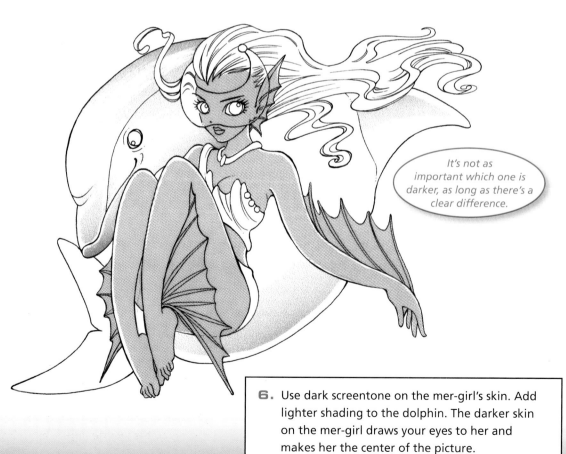

It's not as important which one is darker, as long as there's a clear difference.

6. Use dark screentone on the mer-girl's skin. Add lighter shading to the dolphin. The darker skin on the mer-girl draws your eyes to her and makes her the center of the picture.

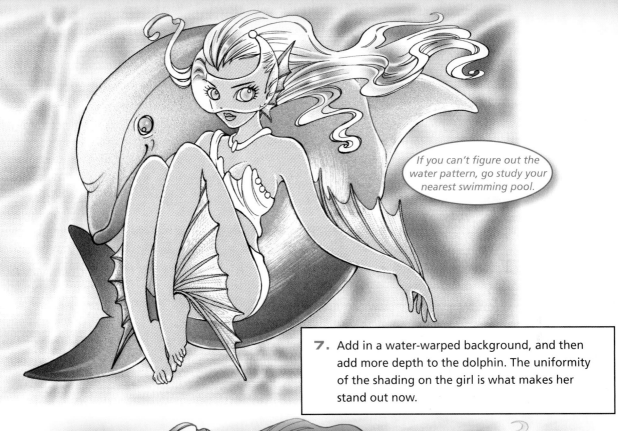

If you can't figure out the water pattern, go study your nearest swimming pool.

7. Add in a water-warped background, and then add more depth to the dolphin. The uniformity of the shading on the girl is what makes her stand out now.

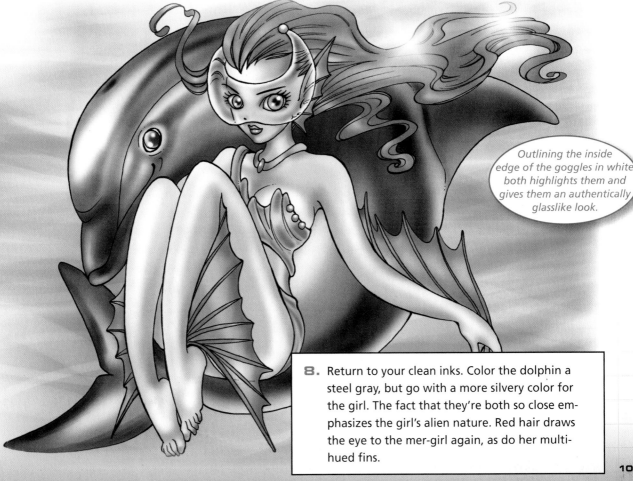

Outlining the inside edge of the goggles in white both highlights them and gives them an authentically glasslike look.

8. Return to your clean inks. Color the dolphin a steel gray, but go with a more silvery color for the girl. The fact that they're both so close emphasizes the girl's alien nature. Red hair draws the eye to the mer-girl again, as do her multi-hued fins.

The Least You Need to Know

- The future is full of as many different sorts of creatures as your imagination will allow.

- Computers make adding white to illustrations as easy as can be.

- Shapes of poses and of background elements can affect the tone of the illustration.

- Similar colors can link two or more elements in a simple and easy way.

Historical:
Doomed to Repeat

In This Chapter

- ■ Going medieval on your heroine
- ■ Prim and proper in Victoria's time
- ■ It's a mod, mod, mod, mod world

The future may be a sparkling lure, but history is wealthy with as many rich and wonderful settings, if not more. The best part about using a historical setting is you don't have to make the details up. You can look them up instead, and the resonance of realism this gives your tales can't be found anywhere else.

We start out in one of most popular eras of the past: medieval times. This is a time filled with royalty of all kinds, especially (for our purposes) princesses. While it was a dark and dangerous period, it forms the basis of an amazing body of fiction as well as the roots of fantasy literature.

From there we move on to the Victorian era. Many tales are set in this time, from moving romances to lurid tales of horror. Queen Victoria ruled over a world moving from the dark past into modern times, and it shows in the drama that springs from those years.

We wind up in the 1960s, a more carefree time filled with strange and outlandish styles. Still, it had a way all its own, something both darker and more innocent at the same time, making it fertile soil for rich characters and engaging stories.

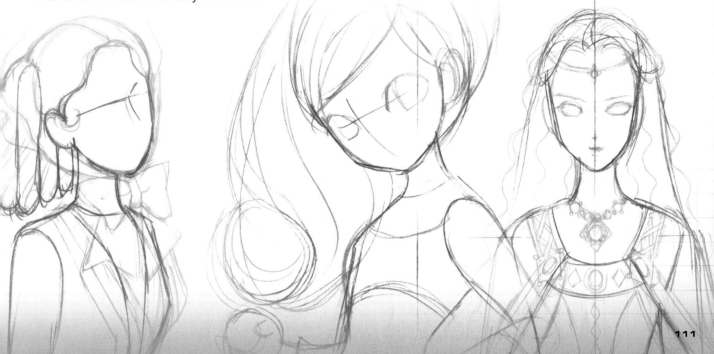

The Medieval

In the Middle Ages, which stretched roughly from the fifth to the fifteenth century C.E., civilization made its long, slow change from rural to urban culture. For our character, we'll pick a princess from medieval Europe, someone who likely lived in a castle and watched the world around her from the shelter of its towering walls. This is the time in which most fairy tales seem to be set, a golden-hued past filled with great heroes and horrible villains.

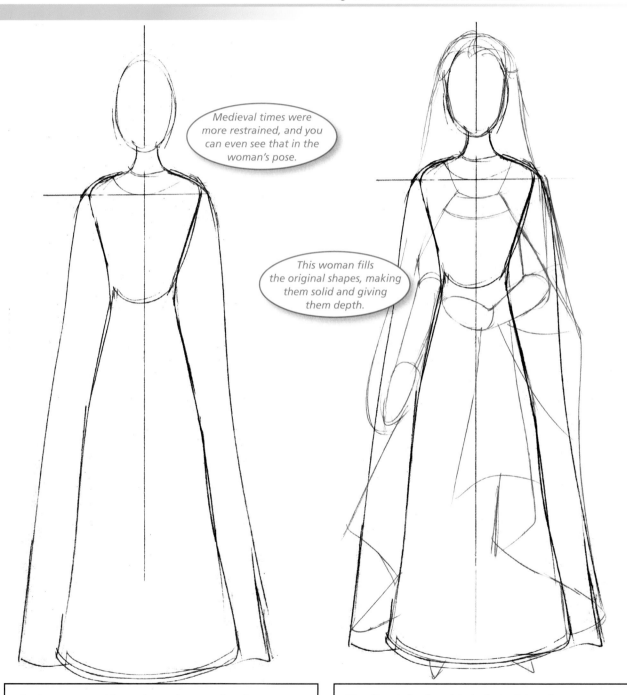

Medieval times were more restrained, and you can even see that in the woman's pose.

This woman fills the original shapes, making them solid and giving them depth.

1. Let's start with a princess in a medieval gown. Use basic shapes to define her. Notice the hourglass figure of her dress and the draping of her robe.

2. Sketch in the girl's hair. Position the arms, and show more of how her robe drapes around her. Take care to make realistic folds in the cloth or you may end up with a mess.

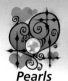

Pearls of Wisdom

Most fantasy stories are set in a strange version of medieval times in which magic works and monsters of all kinds roam the earth. While these are clearly not real, a solid knowledge of medieval styles and architecture can give your stories the kind of grounding they need to feel real.

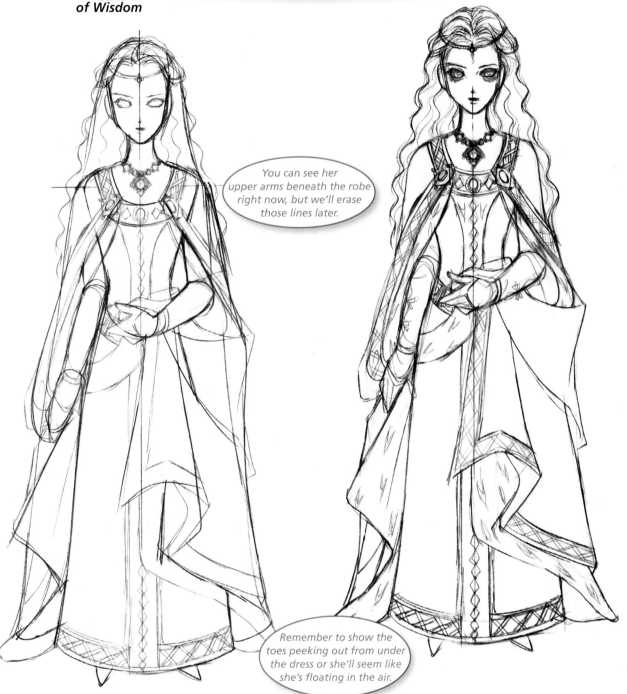

You can see her upper arms beneath the robe right now, but we'll erase those lines later.

Remember to show the toes peeking out from under the dress or she'll seem like she's floating in the air.

3. Work intricate designs along the fringes of her clothing. Position the eyes, and crown her with a golden circlet. String a necklace around her, using elements that recall the details on her clothing.

4. Differentiate the interior of her cloak by showing that it's lined with spotted fur. Remove those guiding lines that the cloak should keep hidden. Add more waves to those silken tresses. Darken the area around her eyes, and complete her face.

The screentone in the eyes draws your eyes there again, especially when set against her porcelain skin.

Notice how every part of the woman, from her hair to her clothes, drapes downward in folds.

5. Use lighter lines all the way around. Medieval characters are all about the details, and dark, bold lines draw the eye away from those details. The darkest lines in the entire illustration are reserved for the woman's eyes. Even the jewels dripping from the center of her circlet draw your eyes to her face.

6. With your screentones, pick out the borders of the woman's clothes. Add some shadows to the folds of her robe, showing how it sits in layers. Also add screentone to her eyes.

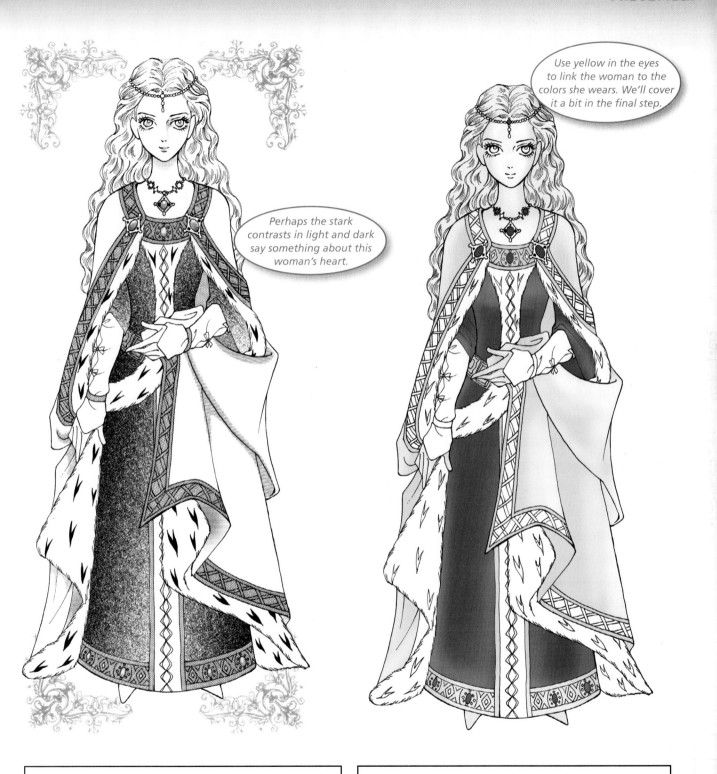

Use yellow in the eyes to link the woman to the colors she wears. We'll cover it a bit in the final step.

Perhaps the stark contrasts in light and dark say something about this woman's heart.

7. Use a screentone with a tight texture on the woman's dress. This makes it feel more solid and real. It also helps highlight her shape against the white shell of a robe she wears. Add some designs in the corners to frame the illustration.

8. Go back to your clean inks. Go with a golden yellow and a sea green for your basic colors. Leave the fur white. Give the girl pale, refined skin.

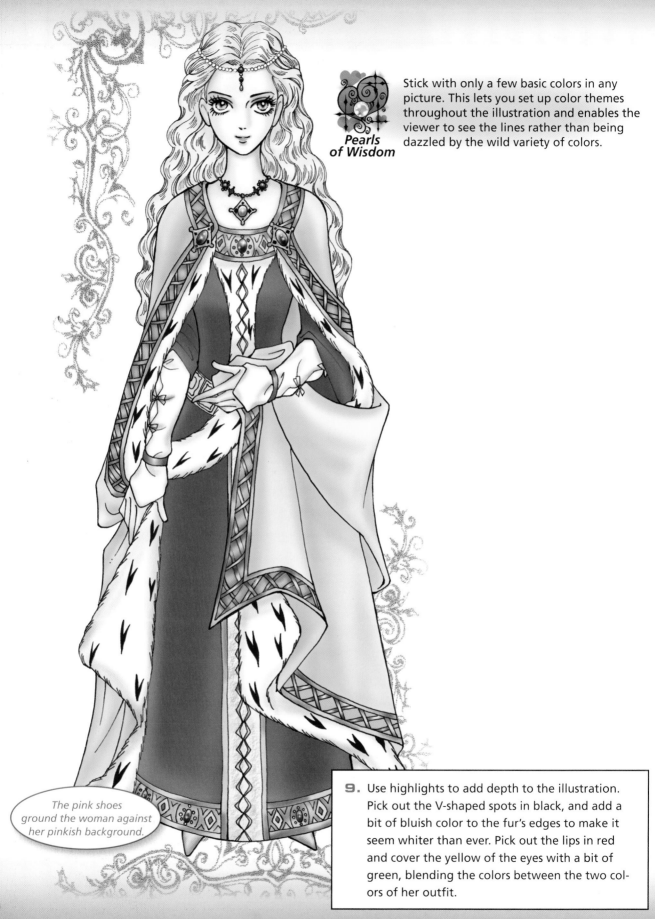

Stick with only a few basic colors in any picture. This lets you set up color themes throughout the illustration and enables the viewer to see the lines rather than being dazzled by the wild variety of colors.

The pink shoes ground the woman against her pinkish background.

9. Use highlights to add depth to the illustration. Pick out the V-shaped spots in black, and add a bit of bluish color to the fur's edges to make it seem whiter than ever. Pick out the lips in red and cover the yellow of the eyes with a bit of green, blending the colors between the two colors of her outfit.

Victorian

Victorian styles make medieval standards look positively loose. The era is all about covering nearly every inch of skin other than the face and hands. Plus, women often wore bustled dresses, just to make life more uncomfortable. Still, these restrictions make for interesting things to draw, and their appearance instantly tells the viewer just where (or when) the tale is set.

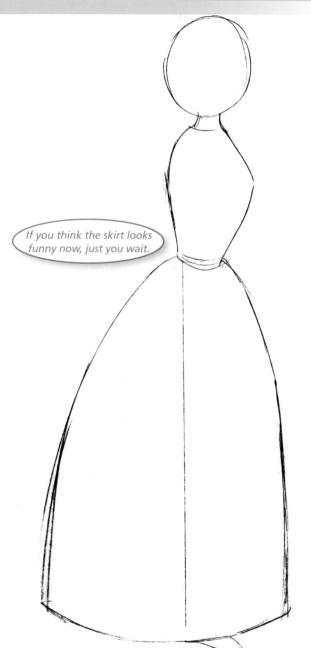

If you think the skirt looks funny now, just you wait.

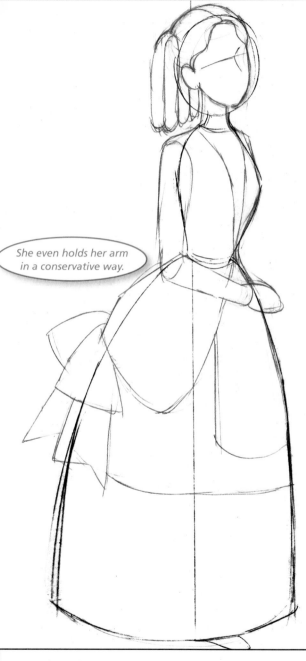

She even holds her arm in a conservative way.

1. As with the medieval woman, a girl in Victorian dress doesn't need a dynamic pose to stand out. Her clothes do that for her. Forget about the arms for now. Get down the position of her head and torso and the unusual shape of the skirt of her dress.

2. Add in the woman's arms and define her head, face, and hair. Place a coat over her dress and a massive bow on the back of her skirt. Think in layers as you dress her. Not all of the layers will show, but you need to know they're there to visualize her as you go.

AIIEEE!!!

Not everyone in Victorian times lived the same way, of course. However, they're called "Victorian" times after Queen Victoria of England, so try to stick to British subjects when you use the term.

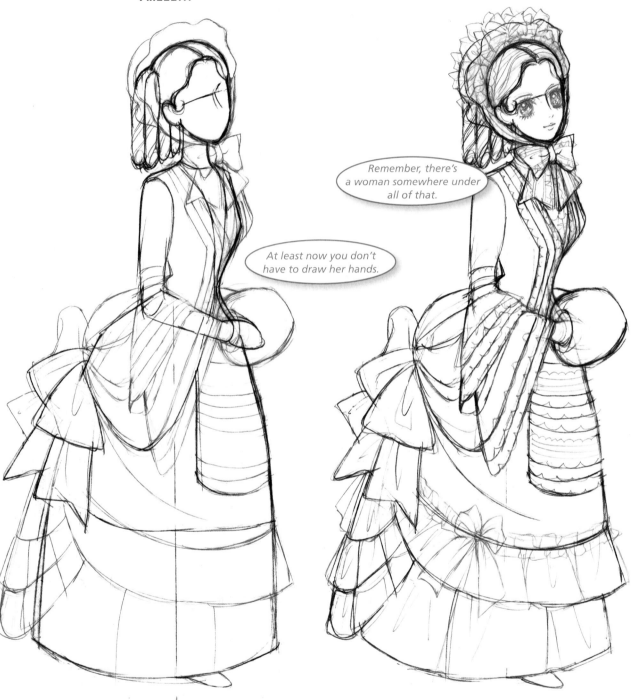

Remember, there's a woman somewhere under all of that.

At least now you don't have to draw her hands.

3. Put a bonnet on the woman's head and a muff around her hands. Add more layers and ruffles all around the dress. Place a bow under her neck.

4. Time for the details, and with Victorian dresses, that means ruffles and lace. Add frills to everything but the woman's skin and the muff. Show the layers and how they fall. This gives a sense of gravity to the picture.

**Pearls
of Wisdom**

If you're not intimately familiar with the various forms of dress in the historical period in which your story is set, hit your local library or the Internet for sources on such things. It's important to get the details right when drawing such elaborate clothes.

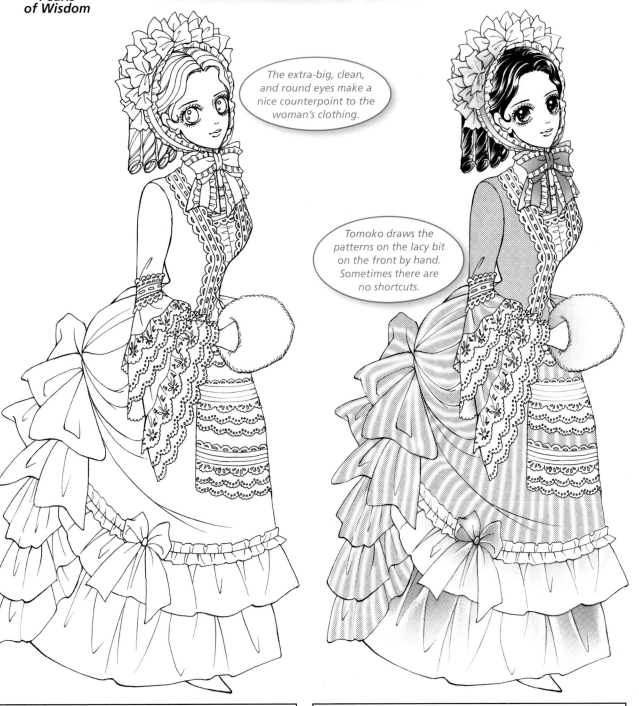

The extra-big, clean, and round eyes make a nice counterpoint to the woman's clothing.

Tomoko draws the patterns on the lacy bit on the front by hand. Sometimes there are no shortcuts.

5. Inking a piece like this takes time. There are so many details to take care of and so few straight lines. Take your time on them and enjoy the process. It's easy to blow a drawing by trying to hustle through the complex bits or taking short-cuts, so don't.

6. Go with blacks on the woman's hair and eyes. Add stripes to the skirt and go with a check pattern on the jacket. This helps show that they are different pieces of clothing. Use smooth patterns elsewhere for the same reason.

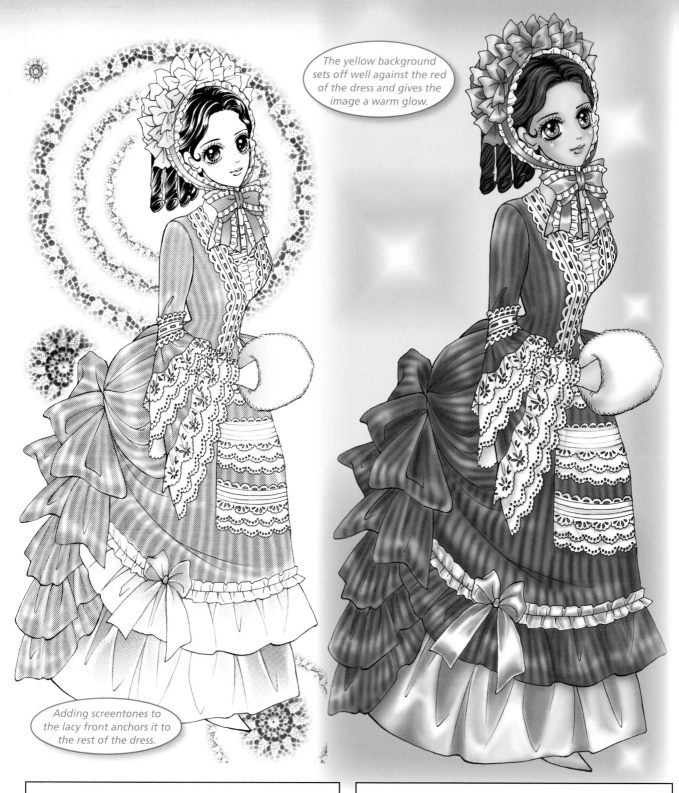

The yellow background sets off well against the red of the dress and gives the image a warm glow.

Adding screentones to the lacy front anchors it to the rest of the dress.

7. Layer on more screentones. These darken the look of the dress and also make the dress look more substantial. Add lace patterns in the background to frame the woman, if you like. Strip out the lines from your upper layers to create highlights throughout the dress.

8. Don't go back to your clean inks. You've put too much work in on the textures to waste them now. Layer over them with a single color in various intensities. The patterns give the eye enough to digest. Don't toss wild colors down on top of that.

Mod Girl

After Victorian times, styles had a long way to go before they escaped from their repressed looks. By the time the 1960s rolled around, though, tastes had swung about as far away from a bustled dress as they could get. Our mod girl is a prime example of a brave new look for a brave new world.

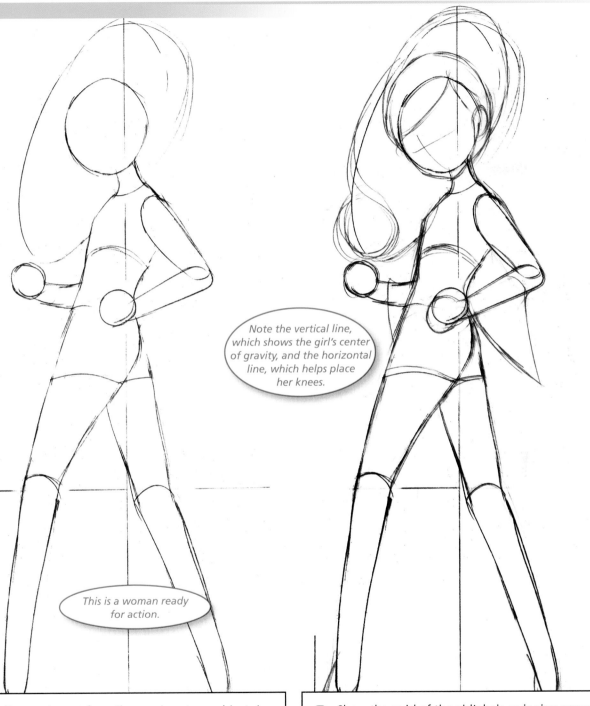

Note the vertical line, which shows the girl's center of gravity, and the horizontal line, which helps place her knees.

This is a woman ready for action.

1. To stand apart from the previous two subjects in the chapter, we'll start with a provocative pose. The mod girl has her back to us, but turns back to look at us. The oval around her head balances the figure and represents the big-hair look we'll go with here.

2. Show the swirl of the girl's hair, swinging around her head in motion. Drape bits of clothing from her arms for a retro look. Think high boots and short skirt for the rest.

Chimeric Koans

The '60s were a time of experimentation with fashions as much as anything else. For characters in this era, you can try out different styles and color combinations you won't find anywhere else. And don't forget to play with a little psychedelic streak, too!

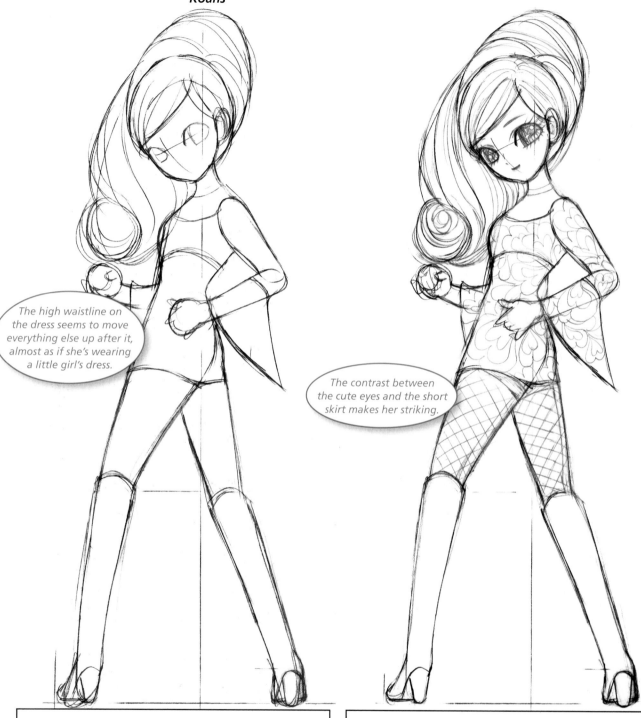

The high waistline on the dress seems to move everything else up after it, almost as if she's wearing a little girl's dress.

The contrast between the cute eyes and the short skirt makes her striking.

3. Add more texture to the hair and fill in the eyes. We'll go with wide pupils on this one, to emphasize the larger-than-life imagery. Use clean lines for most of her for now. We'll get to decorating her in the next step.

4. Go wild on the textures here. Draw all sorts of hearts on her dress in a crazy pattern. Put her in fishnet stockings, and show the black band of their tops. Finish those big, wide eyes, and top them with long eyelashes.

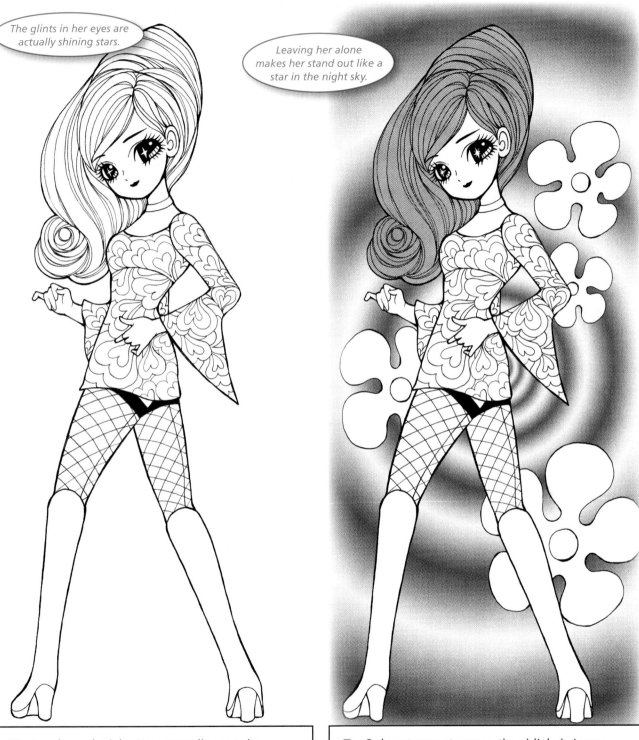

The glints in her eyes are actually shining stars.

Leaving her alone makes her stand out like a star in the night sky.

5. Lay down the inks. Use strong lines on the outlines of her figure, and use thinner ones everywhere else. Big blacks on the eyes make the viewer look at them, as do the heavy blacks on the top of the stockings.

6. Only put screentones on the girl's hair. Leave the rest of her alone. Put her in the middle of a psychedelic vortex and toss in a few white hippy flowers to anchor her in her era.

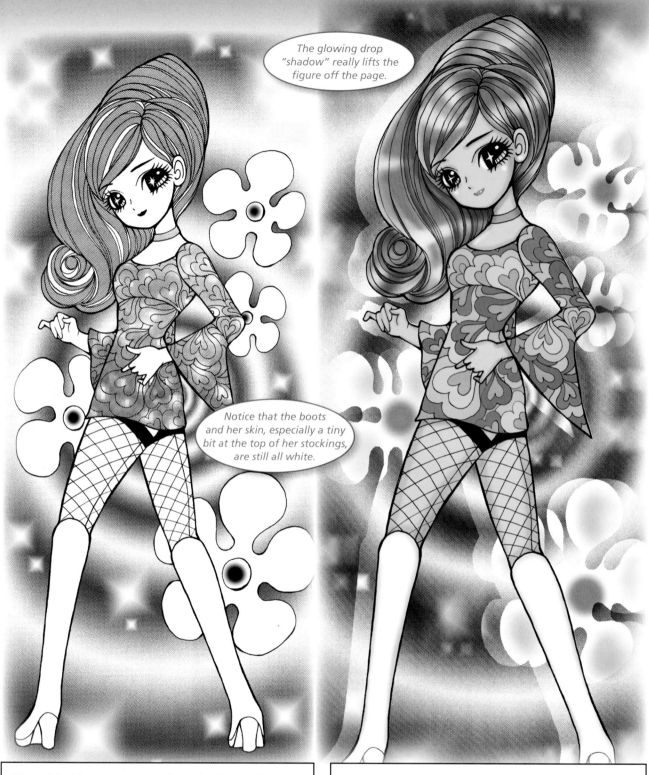

The glowing drop "shadow" really lifts the figure off the page.

Notice that the boots and her skin, especially a tiny bit at the top of her stockings, are still all white.

7. Add a blotty texture to the girl's dress and a very faint screentone to her stockings. Strip out a few streaks in her hair to give it even more texture and thickness. Add circles of color to the flowers in the background, as if you're pinning them to the wall.

8. Return to your clean inks. Pick two basic color combinations (in this case yellow-green and pink-purple) and use variants of them on her dress. Go wild with the background. Tomoko takes a copy of the picture, and layers it behind the first, knocking out the background colors just a bit. This makes the image look like it might be even better with 3D glasses.

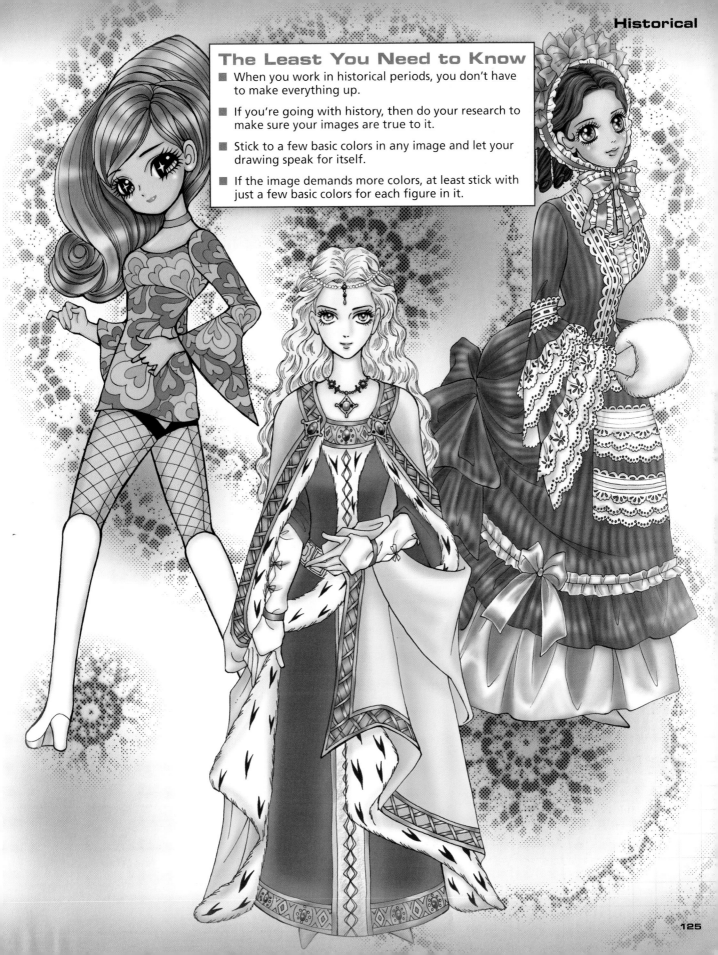

The Least You Need to Know

■ When you work in historical periods, you don't have to make everything up.

■ If you're going with history, then do your research to make sure your images are true to it.

■ Stick to a few basic colors in any image and let your drawing speak for itself.

■ If the image demands more colors, at least stick with just a few basic colors for each figure in it.

Part 3
Tropes and Trappings

Now that we know about characters and settings, it's time to consider your story's genre, the sort of story you wish to tell. Is it funny or serious? Light or scary? Realistic or fantastic?

We venture first into romance, a huge topic in many shoujo tales. In general, girls love stories about love, and shoujo fans are no exception.

From there, we wander into comedy and slip on a banana peel or two. Then we skirt through chill-inducing horror. We wind up in the wizardly realms of fantasy, just in time to live happily ever after.

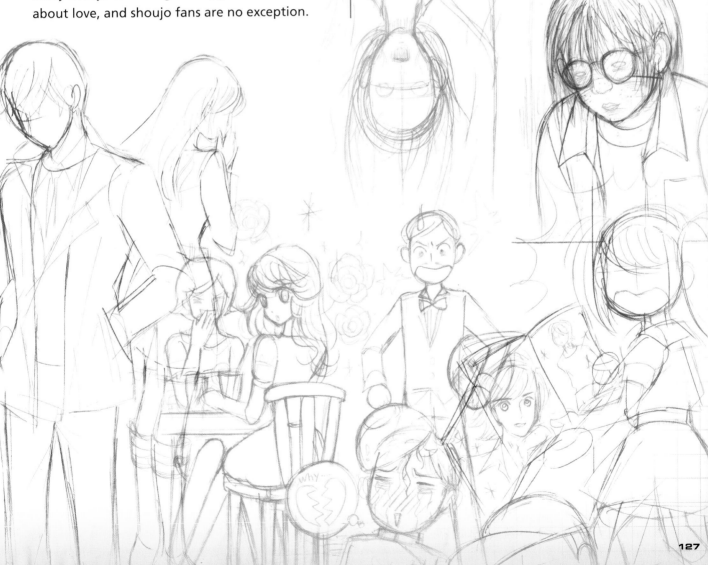

Romance: All You Need Is Love

In This Chapter

- **Boy meets girl**
- **Falling in love**
- **The big break-up**

Because shoujo manga is aimed at girls, it should be no surprise that romance is a huge topic. Many readers, after all, are in a time in their lives when they're just starting to become interested in romantic relationships or are waist-deep in them. Romance is the central issue in their lives, so it shows up in their reading as well.

We start out with the way most romances start, even in shoujo manga: boy meets girl. (Or girl meets boy, if you like.) This is the classic start of any love story, and the vast majority of shoujo romances are based upon it. In any case, putting an attractive young man and woman in a story means there's something for readers of all kinds to enjoy.

From there, we move on to showing the couple actually in love. This is the point in the relationship that everyone adores. The awkwardness of the early meetings disappears, and there's nothing but pleasant days ahead as far as anyone can see.

We wrap up with the big break-up. Not every relationship ends this way, but many first loves do. It makes for dramatic stories at the very least, and it helps readers understand not only the wonders but the risks that come with love.

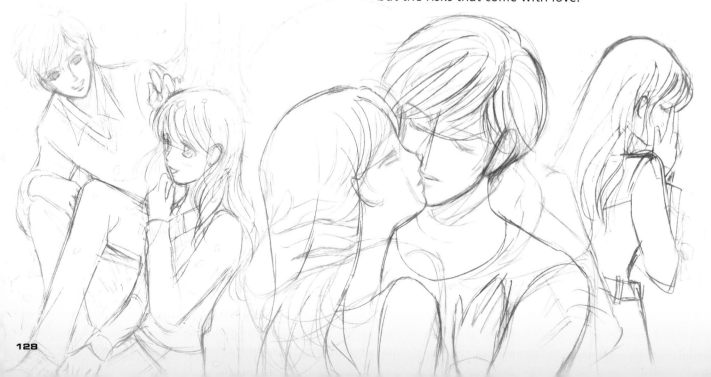

Boy Meets Girl

As a type of manga meant explicitly for girls, it's no wonder that shoujo features a great deal of romantic relationships. In general, girls prefer stories about characters and relationships, while boys like action and adventure. Shoujo can contain all of these, but it traditionally hews toward the girlish standards, not those found in the more explicit *hentai* or *ecchi*.

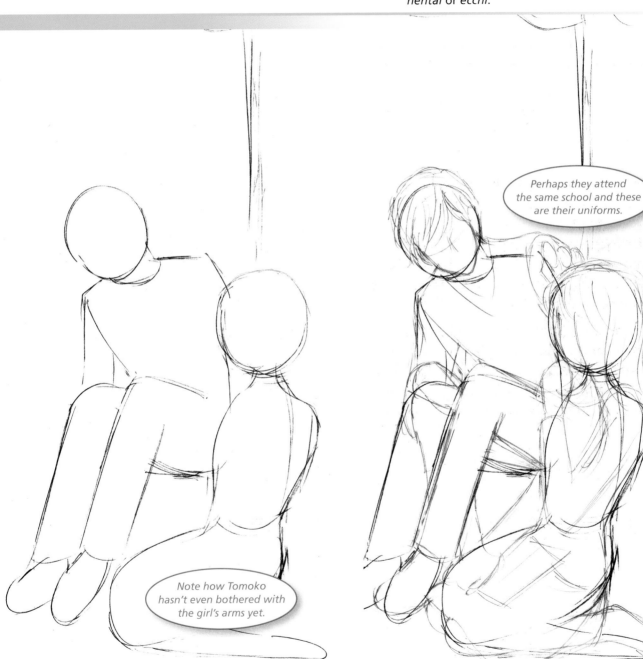

Perhaps they attend the same school and these are their uniforms.

Note how Tomoko hasn't even bothered with the girl's arms yet.

1. Block out the boy and the girl's shapes. They sit near each other in the shade of a tree. They look into each other's eyes as they chat.

2. Add in details on the hair and clothes. The girl wears a sweater and skirt, while the boy is in a similar sweater and slacks. Note how Tomoko changes her mind about the boy's pose and brings his right leg in a bit.

Manga-nese Being for girls, shoujo manga features romance but not explicit sex. That's called **hentai** instead. Manga that skirts the zone between romance and sexy (sexy but not pornographic) is called **ecchi**. Most shoujo manga is as clean as can be, although some of it may border on ecchi.

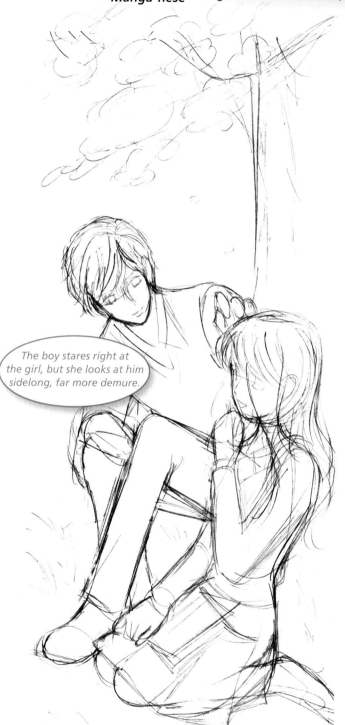

The boy stares right at the girl, but she looks at him sidelong, far more demure.

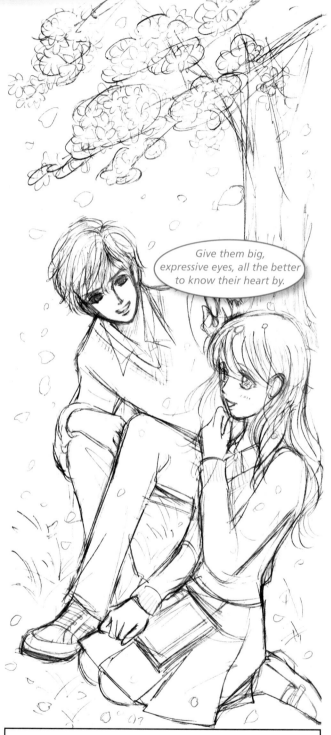

Give them big, expressive eyes, all the better to know their heart by.

3. Work in more details about the hair and clothes. The girl has a book open on her lap, the pages turned face-down. The boy reaches out to touch her hair with his left hand.

4. Go nuts on the fiddly bits here. Show the cherry blossoms falling from the tree behind them. Put laces or straps on the shoes. Add edging to each sweater's neck and sleeves.

Pearls of Wisdom

The fact that the two figures are close but not touching implies that they are not yet intimate friends. However, the fact that the girl has turned over her book signals that she is more interested in the boy than whatever she was reading.

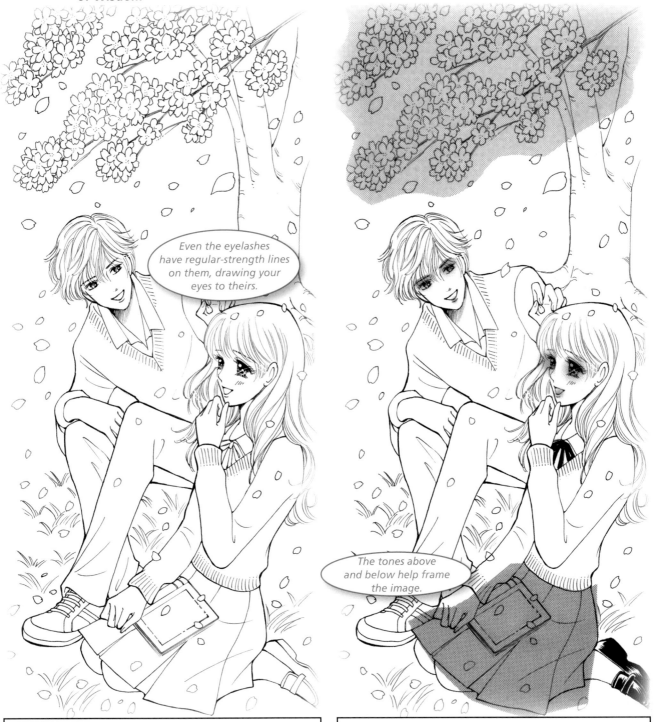

Even the eyelashes have regular-strength lines on them, drawing your eyes to theirs.

The tones above and below help frame the image.

5. Use fairly uniform lines here. This is about emotion, not action. Save your softest lines for frills and hair. Notice that the fingers use soft lines, too.

6. Apply screentones to the girl's skirt and to the cherry blossoms in the tree. Also a bit of screentone around the eyes shows that both the boy and girl are flushed with emotion.

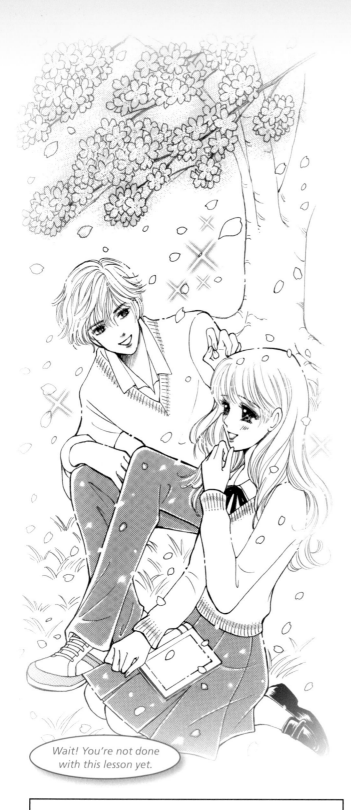

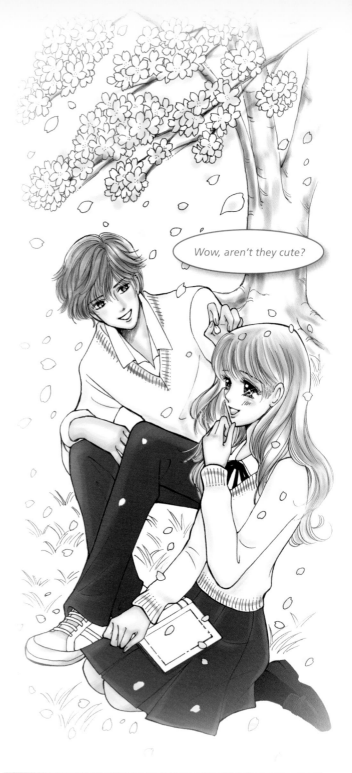

Wait! You're not done with this lesson yet.

Wow, aren't they cute?

7. Add screentone to the boy's pants, too. Then strip out some of the screentones on the figures' clothes to make highlights. Add sparkles in the air, and tone down the darkness of the cherry blossoms.

8. Go back to your clean inks. Give the boy and girl matching uniforms. Color her hair purple, and make his brown. Add a wash to the tree, marking it up in streaks.

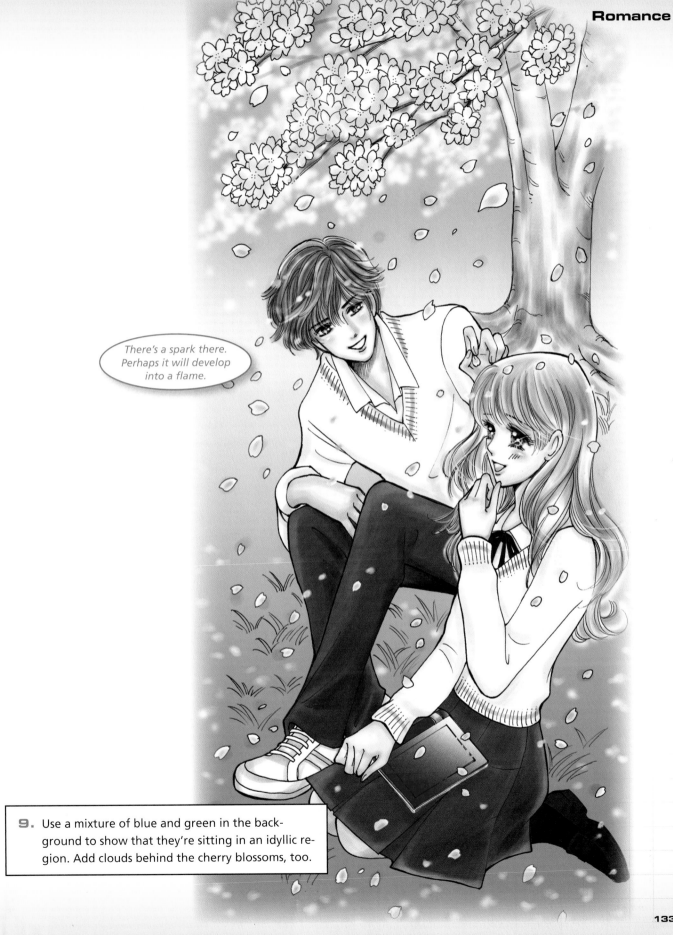

There's a spark there. Perhaps it will develop into a flame.

9. Use a mixture of blue and green in the background to show that they're sitting in an idyllic region. Add clouds behind the cherry blossoms, too.

Falling in Love

After the boy and girl meet, they become enamored of each other. They express their love in many ways. Most notably, they kiss.

During this phase in the relationship, the two are at their happiest. They have each other, and the rest of the world matters not. Storm clouds may gather, but they hang at the horizon for now, ignored if not unnoticed.

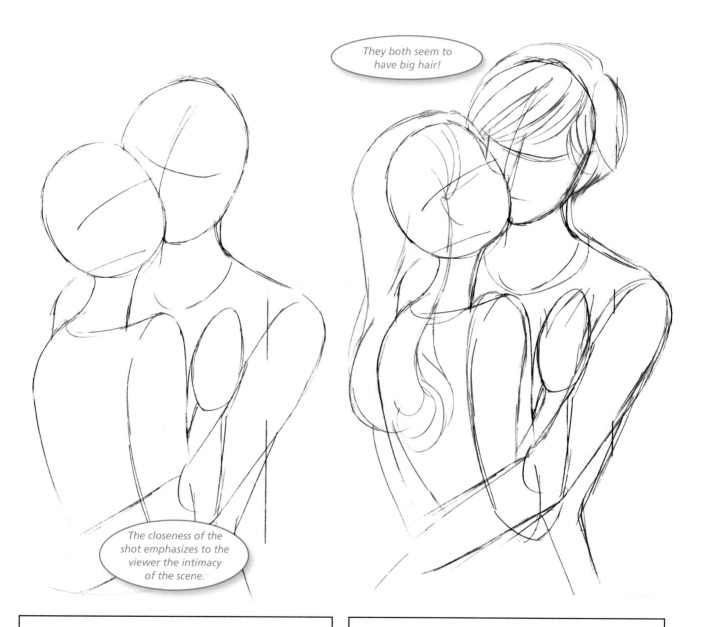

They both seem to have big hair!

The closeness of the shot emphasizes to the viewer the intimacy of the scene.

1. We start with two figures locked in a kiss. The woman is the shorter one, with her back to us. Instead of using a full-size image, we zoom in closer to only capture them from the waist up. Use basic shapes here, just to establish position.

2. Sketch in the hair and clothing. Add details like ears and fingers. Notice that we can see the woman's arm under the man's. This helps us keep the positioning correct, and we can erase the underlying bits later.

AIIEEE!!!

Not everyone is comfortable with public displays of affection, although most shoujo readers wouldn't blink an eye at a scene like this. Know yourself and your audience. It's better if people can evaluate your work on its own worth rather than how it reflects their personal biases.

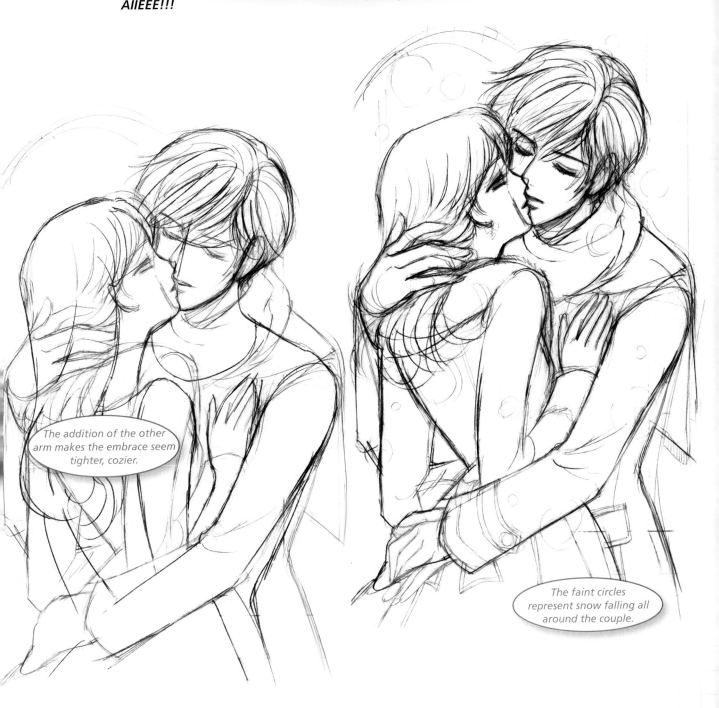

The addition of the other arm makes the embrace seem tighter, cozier.

The faint circles represent snow falling all around the couple.

3. Add clothing and work in the details of the face. Tomoko puts them in winter clothes, complete with scarves. She also sketches in the man's other arm, wrapping around the woman's shoulder and putting his hand on her neck.

4. Work in the details on the clothes, faces, hair, and so on. Notice that both figures have their eyes closed. Tomoko also tries out an arch in the background, something to partly frame the figures.

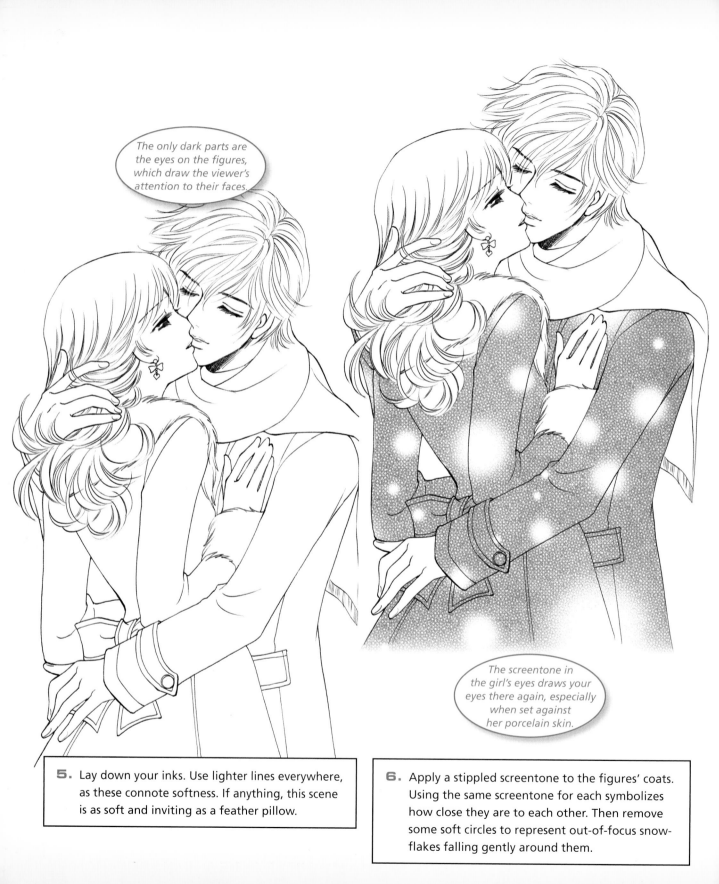

The only dark parts are the eyes on the figures, which draw the viewer's attention to their faces.

The screentone in the girl's eyes draws your eyes there again, especially when set against her porcelain skin.

5. Lay down your inks. Use lighter lines everywhere, as these connote softness. If anything, this scene is as soft and inviting as a feather pillow.

6. Apply a stippled screentone to the figures' coats. Using the same screentone for each symbolizes how close they are to each other. Then remove some soft circles to represent out-of-focus snow-flakes falling gently around them.

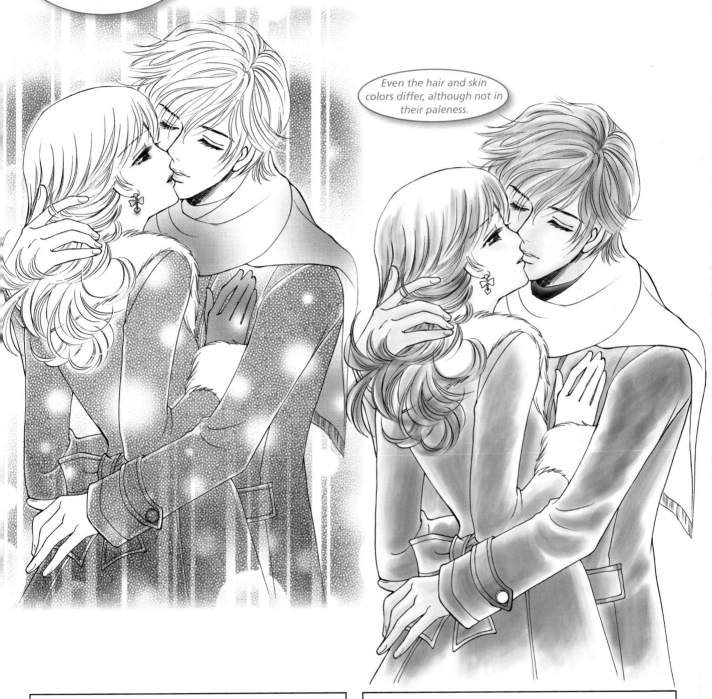

Removing the screentone around the figures' clothing makes it seem like there's a glowing light embracing them, too.

Even the hair and skin colors differ, although not in their paleness.

7. Add a silvery screentone to the man's scarf, helping frame his face, and a darker tone to the woman's earrings and gloves. Then apply the same stipple screentone you used before to darken the background. Remove enough of it around the figures to lift them away from the background.

8. Go back to your clean inks. A blue coat works for the boy, and a red coat for the girl. While they are of different colors, they are of the exact same paleness, showing again that they are different but the same.

Using streaks of white both behind and on top of the figures makes it seem as if they're surrounded by the weather. It gives the picture far more depth than if you'd only put the streaks in the background.

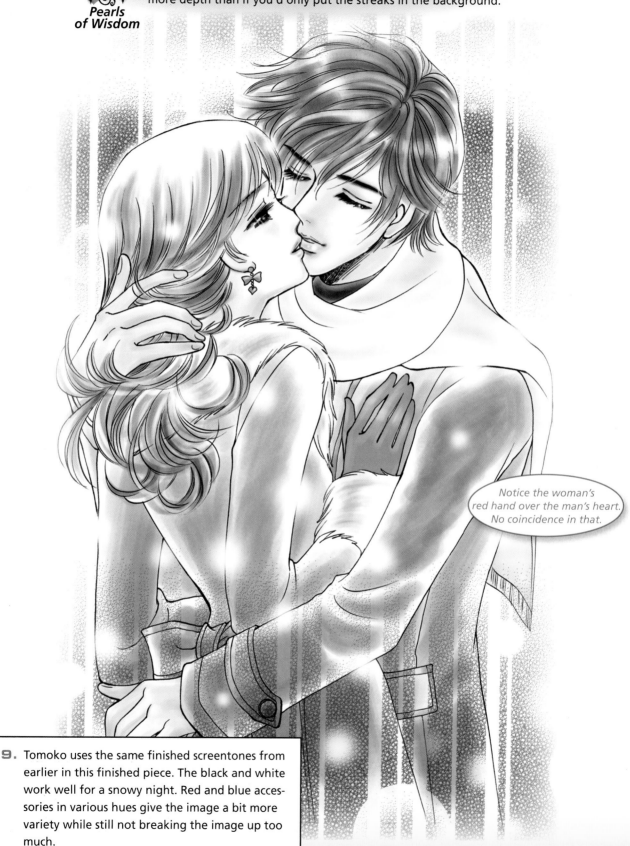

Notice the woman's red hand over the man's heart. No coincidence in that.

9. Tomoko uses the same finished screentones from earlier in this finished piece. The black and white work well for a snowy night. Red and blue accessories in various hues give the image a bit more variety while still not breaking the image up too much.

The Big Break-Up

While it might seem that love can last forever, it doesn't always work out that way. Sometimes a couple falls out of love. Other times, outside forces pull them apart. No matter what the cause, the result is the same: the end—at least for now.

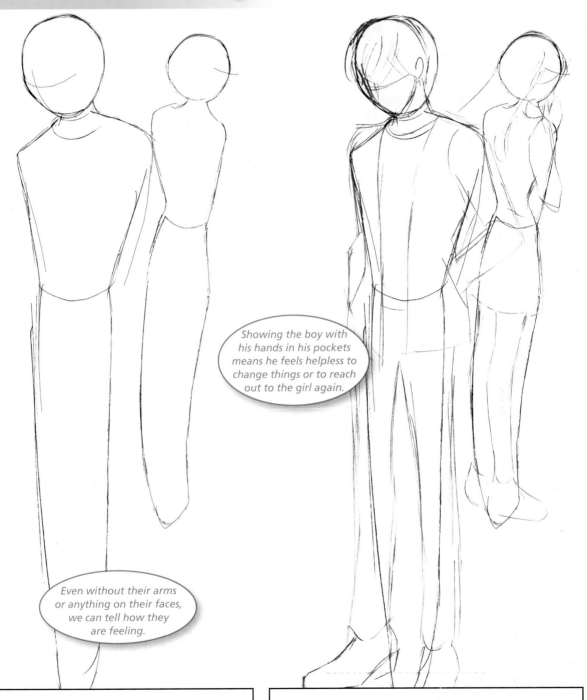

Showing the boy with his hands in his pockets means he feels helpless to change things or to reach out to the girl again.

Even without their arms or anything on their faces, we can tell how they are feeling.

1. Position the boy and girl. Put their backs to each other. Notice how their heads and shoulders sag with sadness.

2. Sketch in the positions of the boy and girl better. The girl covers her face with her hands as she sobs. The boy has his hands in his pockets.

The body language of the figures in a drawing plays an important role in any illustration. This enables the artist to communicate much about what a character feels, without ever having to resort to printed words.

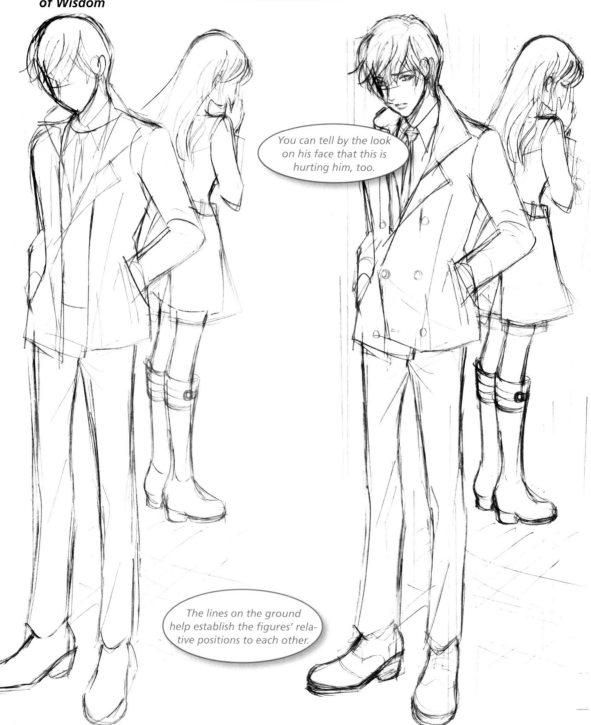

You can tell by the look on his face that this is hurting him, too.

The lines on the ground help establish the figures' relative positions to each other.

3. Work on the details of their hair and clothes. The girl stands in a fashionable outfit with a short skirt. The boy wears a blazer, tie, and slacks.

4. Add all sorts of details here. Dashes from the sky show that the two are standing outside in the rain, the foul weather mirroring their moods. Put buttons on his jacket, and concentrate on having his face show his emotions.

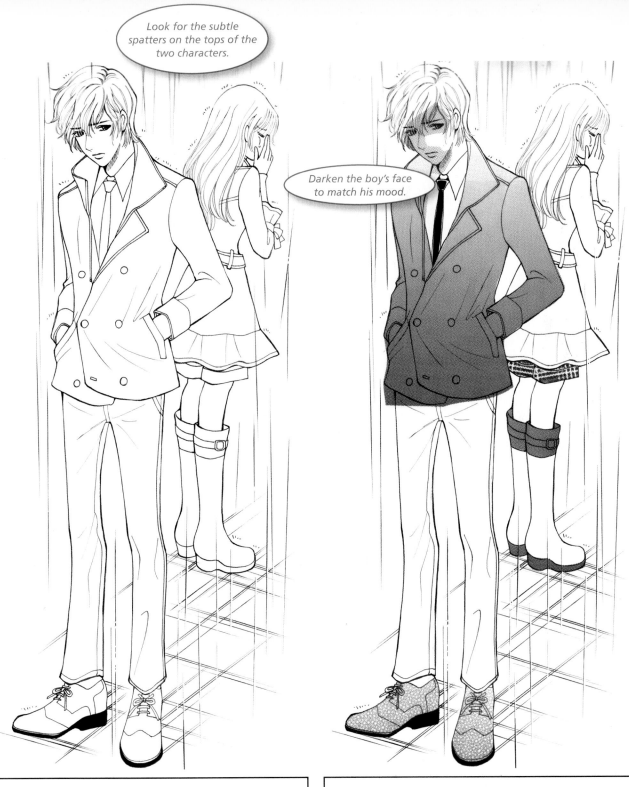

Look for the subtle spatters on the tops of the two characters.

Darken the boy's face to match his mood.

5. Again, you can use mostly uniform inks in this illustration. Pay attention to all the details and make it look real. Note the lines on the ground, the way the rain falls on the figures but does not obscure them.

6. Screentone the boy's jacket with a fading pattern. Use a lighter stippling on his shoes. Give the girl a plaid skirt and screentone the trim of her boots.

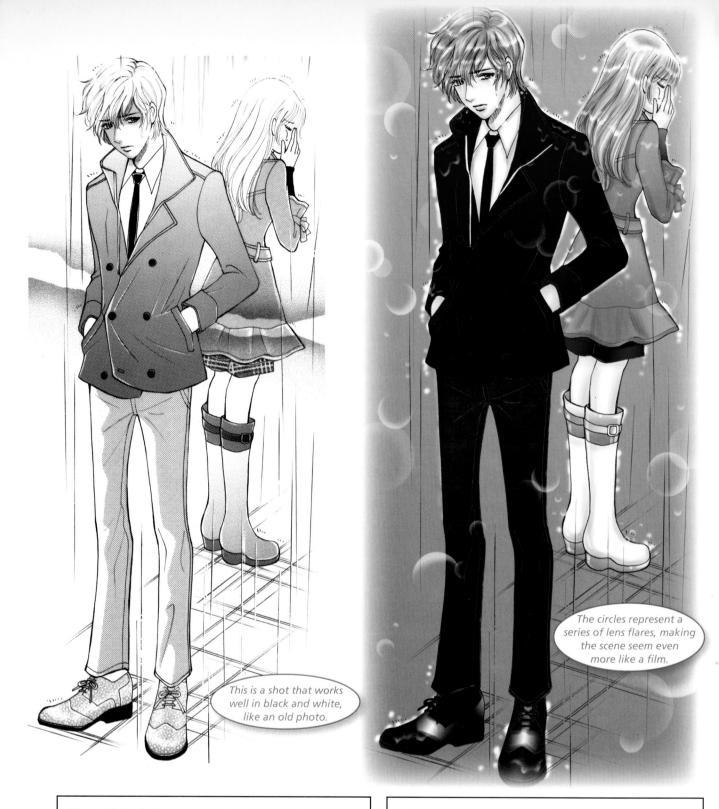

This is a shot that works well in black and white, like an old photo.

The circles represent a series of lens flares, making the scene seem even more like a film.

7. Add shaded screentones to the boy's slacks and to the girl's jacket and boots. Then strip out some of the edges to show highlighting. Tomoko places a band of mist between them, further separating the two by providing a boundary between them.

8. Return to your clean inks. Go with dark blues, grays, and blacks for the boy. For the girl, use browns, pinks, and reds, warmer colors. Add a halo of white around them both, right where the rain would be pounding down on them.

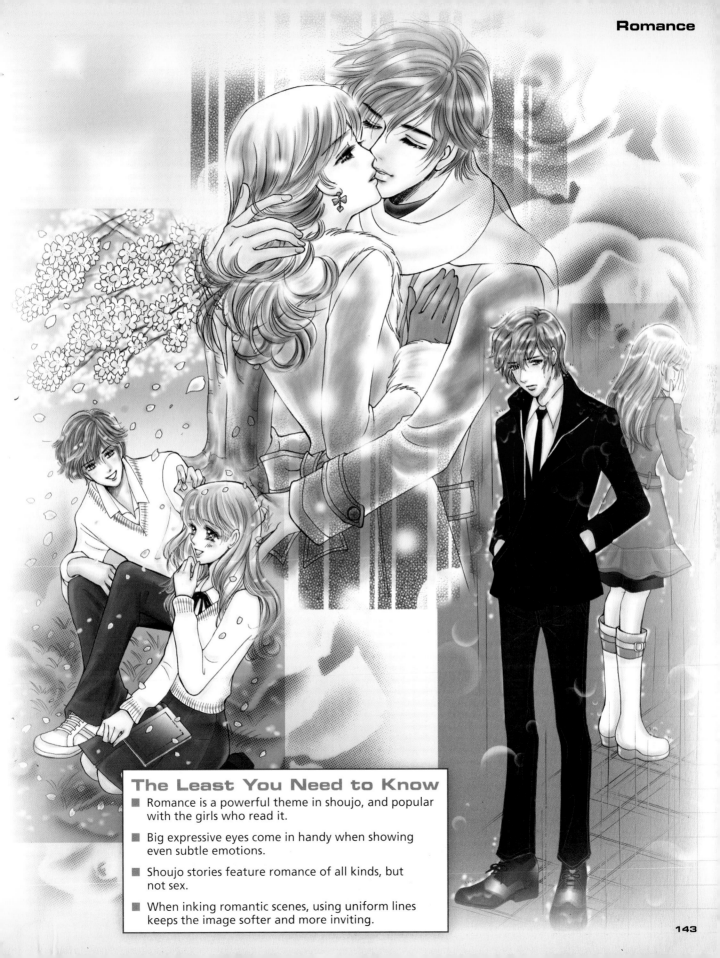

The Least You Need to Know

■ Romance is a powerful theme in shoujo, and popular with the girls who read it.

■ Big expressive eyes come in handy when showing even subtle emotions.

■ Shoujo stories feature romance of all kinds, but not sex.

■ When inking romantic scenes, using uniform lines keeps the image softer and more inviting.

Comedy:
Always Good for a Laugh

10

In This Chapter

■ The annoying little brother ■ A little slapstick ■ A big surprise

As in any sort of stories, comedy plays a big part. Sometimes it's the basis of the entire story, one joke after another. Other times it's a bit of relief from the grimmer elements of the tale, a bit of light to help us better see what's lurking in the shadows. With luck, though, it's at least funny. Comedy is a broad topic, enough for its own book, but here we tackle three different scenes.

We begin with one of the staples of any girl's story: the annoying little brother. Such characters help lighten the tale when the heroine is taking things perhaps a bit too seriously. They usually prove to be the most loyal friends, but not without giving the heroine a hard time throughout most of the story.

Next up, we deal with the troubles of a young waiter in love. He makes a fool of himself in front of the girl who secretly likes him, too. Viewed one way, this is funny, but of course the flipside of humor is tragedy.

We finish with one friend playing a joke on another. She wears a mask to scare her friend into thinking she's in trouble, but really she's just having fun at her friend's expense. Again, this is mean if done for the wrong reason, but can be funny if placed in the right context. Once the butt of the joke figures it out, she'll be relieved. She might be a little angry, but she could laugh a lot, too.

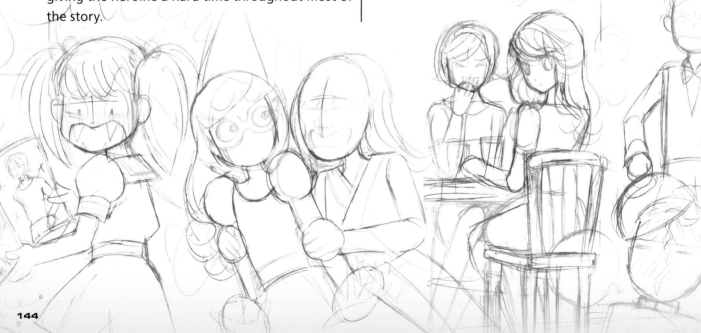

Sidekicks

Sidekicks appear in many stories in many cultures, and for good reasons. They work as a foil for the heroes, giving them someone to appear brilliant next to. They can save the hero when things look most grim. And, among other things, they can provide some comic relief when things look most grim.

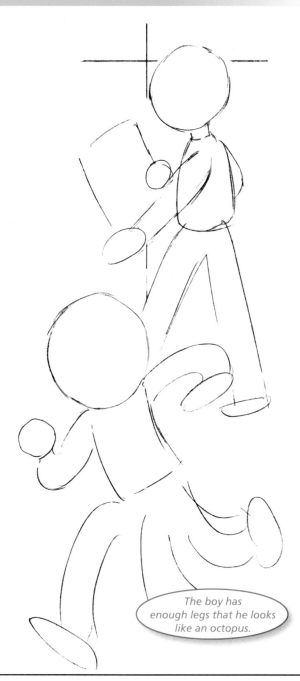

The boy has enough legs that he looks like an octopus.

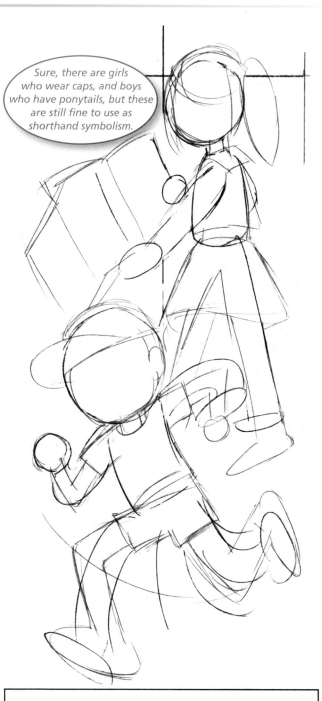

Sure, there are girls who wear caps, and boys who have ponytails, but these are still fine to use as shorthand symbolism.

1. We have two figures here, the heroine and her bratty little brother. Use basic shapes to set their positions. We want to draw the eye to where the cross is in the upper center of the picture. We'll erase later.

2. Rough in the hair and clothing. Show that the girl is looking at a gatefold poster in a magazine. The ponytail instantly says "girl," while the baseball cap says "boy."

Chimeric
Koans

Chimeric Koans Sidekicks have appeared in literature since the early days of the novel and probably before, although the word didn't come into use until the turn of the twentieth century. The term sidekick originally meant the front pocket of a coat or pair of pants, the hardest one for a pickpocket to reach.

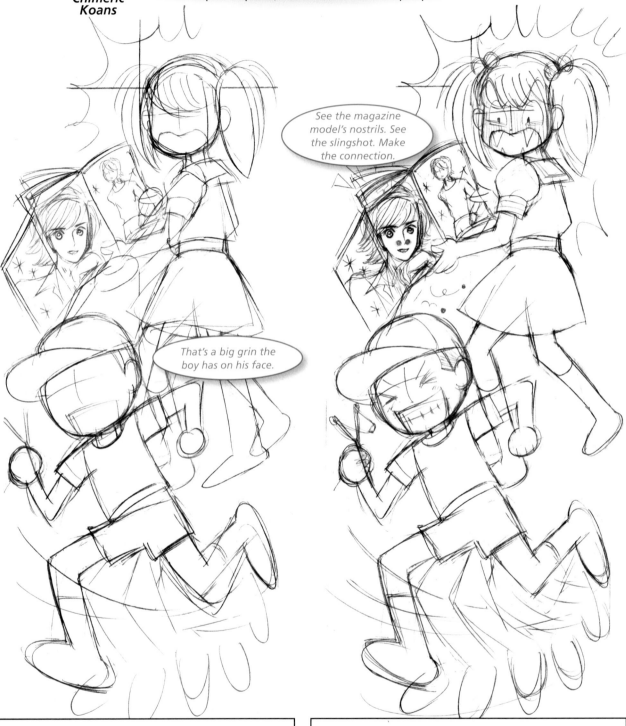

See the magazine model's nostrils. See the slingshot. Make the connection.

That's a big grin the boy has on his face.

3. Show the girl's face and put a burst around it to indicate surprise or anger—or maybe both. The boy carries something (a slingshot) in his hand. Tomoko moves the girl's legs a bit to make it clearer that she's turning toward the boy.

4. Add in the details. Because this is comedy, use a cartoony style. Give the girl fangs, for instance, and eyebrows that look evil. Show that the girl was looking at bishonen boys in a magazine.

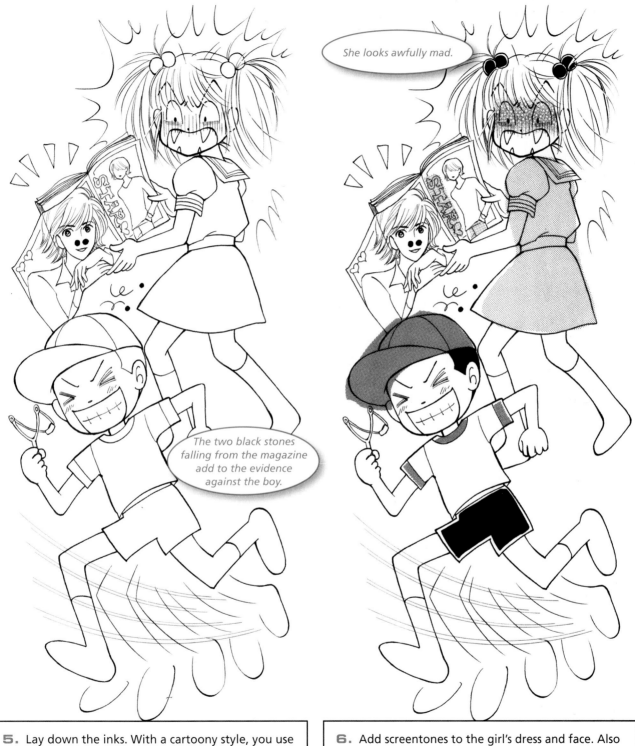

5. Lay down the inks. With a cartoony style, you use long, simple lines. We do not have frills or lace here. Hatch the girl's face with vertical lines to show how her face is flushed with rage.

6. Add screentones to the girl's dress and face. Also fill in the boy's cap and shirt trim, and black out his shorts. The darker colors up front draw your eyes there first, but then you see the girl's face in the background and realize what's going on.

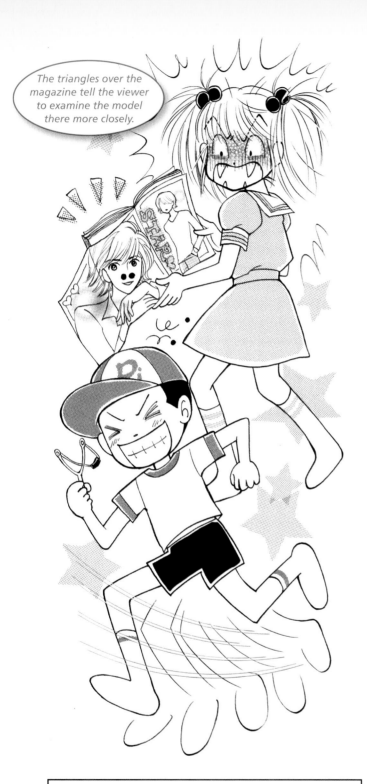

The triangles over the magazine tell the viewer to examine the model there more closely.

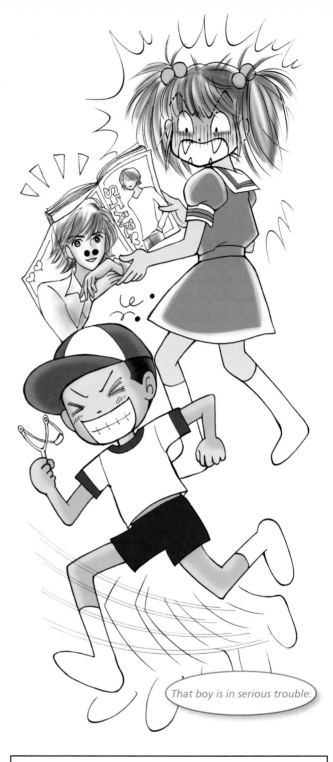

That boy is in serious trouble.

7. Trim the screentones off the girl's eyes, but let a little bleed over the edges to make them seem bloodshot with rage. Add some stars in the background to show that this is a sharp moment. Trim away some of the tones on the boy's cap for a fun design.

8. Return to your clean inks. Use softer colors on the magazine to let it fade into the background a bit. A strong blue on the boy works well. The pink of the girl's dress suggests the color of flushed cheeks. Meanwhile, her face is green-gray, not with embarrassment but rage.

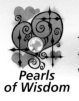

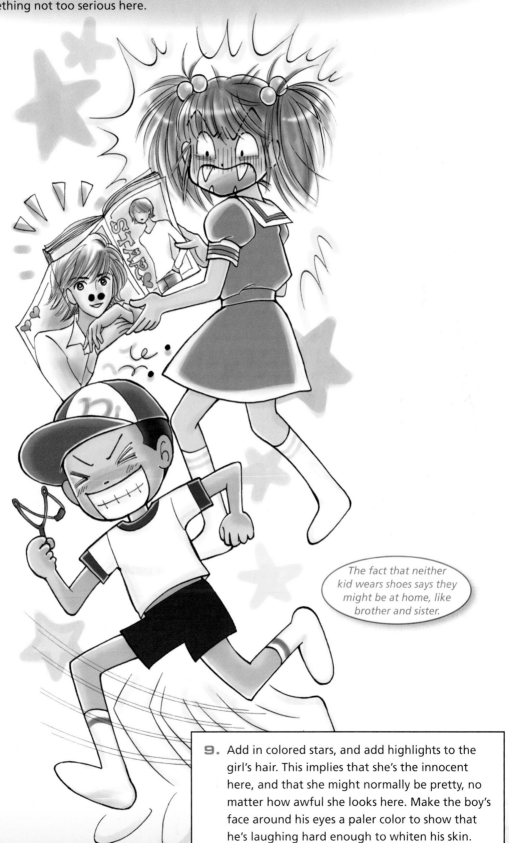

The crazy sets of running legs on the little brother do two things. First, they show motion, the fact that he's racing away. Second, they are overblown and goofy, which tells the viewer we're dealing with something not too serious here.

The fact that neither kid wears shoes says they might be at home, like brother and sister.

9. Add in colored stars, and add highlights to the girl's hair. This implies that she's the innocent here, and that she might normally be pretty, no matter how awful she looks here. Make the boy's face around his eyes a paler color to show that he's laughing hard enough to whiten his skin.

Humiliation

Another common element of comedy involves misfortune being heaped on someone's head. In our scene, a waiter in a restaurant serves a girl he likes, but he becomes nervous and dumps everything on himself. In one context this is funny, although in another it could be tragic.

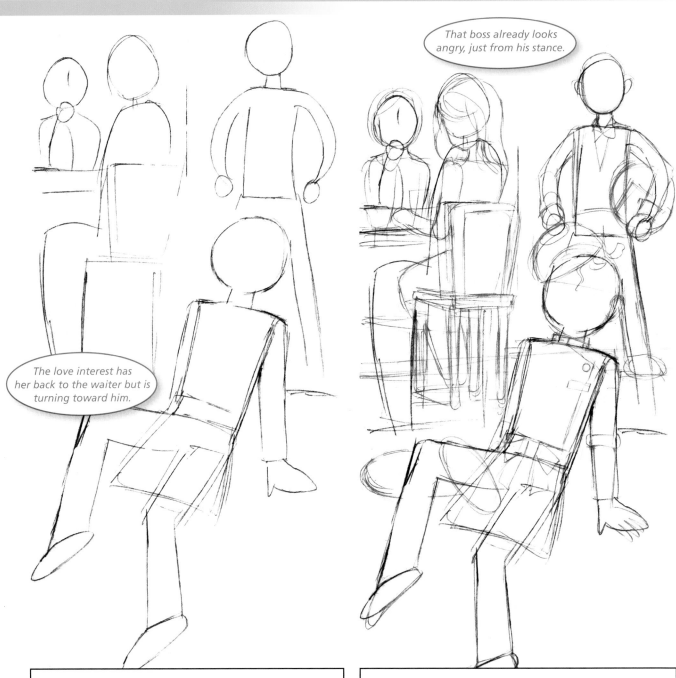

That boss already looks angry, just from his stance.

The love interest has her back to the waiter but is turning toward him.

1. This is a complex scene with four figures in it: the girl (to the right of the table), her friend (to the left of the table), the waiter (on the floor), and the waiter's boss (standing). Use simple shapes to position their bodies in the scene.

2. Work in more details. The boy has a bowl of food on his head and a serving platter next to him on the floor. The boss holds a menu and his own platter. The love interest feels bad for the boy, but her friend can't help but laugh cruelly.

Comedy that involves humiliation is always tricky to pull off. In the wrong context it ceases to become a joke and is just plain cruel. It's hard to convey the right context in a single image like this. When you create your own image, be sure to set up the joke properly, or no one will think it's funny.

AIIEEE!!!

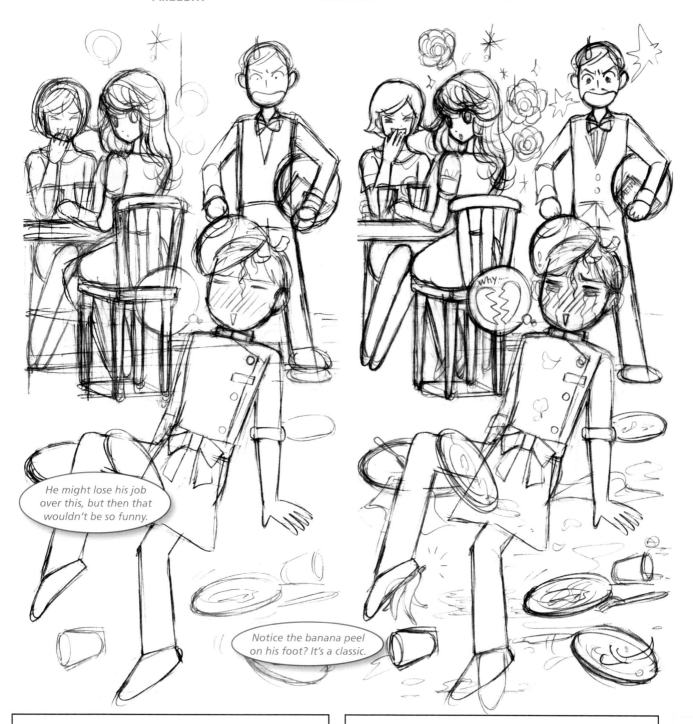

He might lose his job over this, but then that wouldn't be so funny.

Notice the banana peel on his foot? It's a classic.

3. Add in more details, especially on the clothes and faces. Hatch in some shame lines on the boy's face to show how he feels, and put him in a waiter's outfit. The girls are well dressed, and the boss looks like a maitre d'.

4. Hit the details hard. Add in symbols around the characters to show how they feel. The flowers around the love interest show she's still interested in the boy, but the stars around the boss show how angry he is. The boy's broken heart is right out there for the whole world to see.

Shoujo manga tends to "wear its heart on its sleeve" compared to American comics. The symbols around three of the four characters in this scene all tell you exactly how they're feeling, as if the expressions on their faces weren't enough. This makes for faster reading of a panel and less room for misinterpretation.

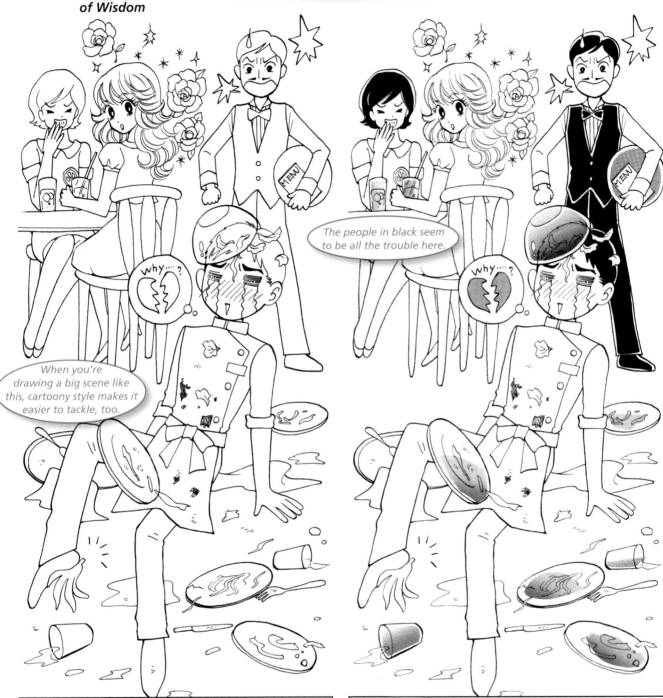

The people in black seem to be all the trouble here.

When you're drawing a big scene like this, cartoony style makes it easier to tackle, too.

5. As with the previous picture, go with simple and easy inks here. You don't need too much in the way of detail. A cartoony style works fine.

6. Blacken the boy's hair, and then screentone the food and the empty bowl on the boy's head. Make the tone transparent so you can see through the bowl as if it is made of glass. Tone the broken heart, too, as well as the boss's platter. Then give the girl's friend black hair and blacken the boss's outfit.

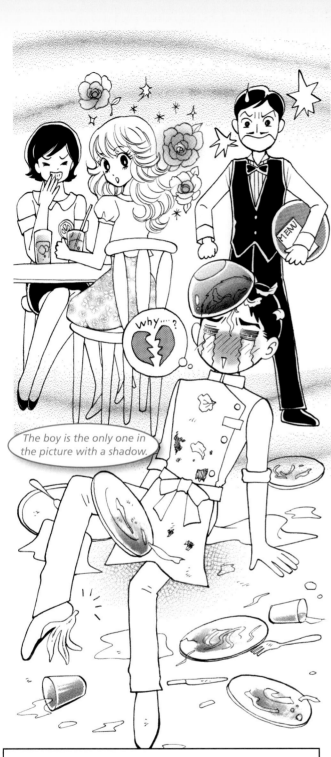

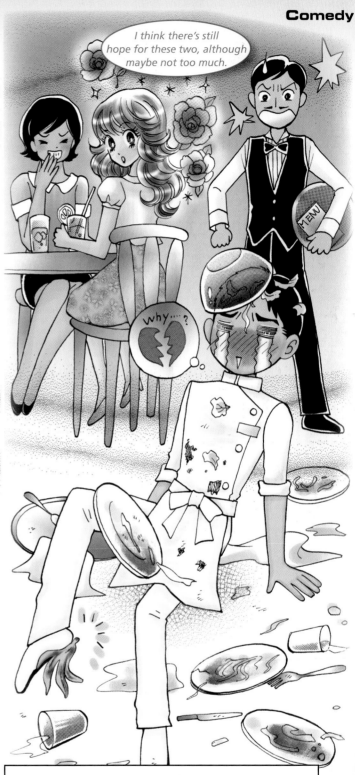

7. Add some swirls through the air to show the dizzying atmosphere in the restaurant. Also darken the floor beneath the boy to show his shadow. This grounds him harder and makes it clear he's not floating in space. Also screentone the shame lines on his face.

8. This time around, Tomoko colors over the finished black-and-white version of the illustration. A violet background lets the other contrasting colors jump out more. The boy wears white in opposition to his boss in black—and it shows the spilled food better. The love interest wears a color of love (pink) while her friend appears in a jealous color (green).

Relief

Relief can be a great motivation to laugh. In this picture, one friend scares another at a costume party. This could be terrifying, but because of the inset picture of the friend planning her prank, we known the truth.

It almost looks like the prankster is hugging the victim here.

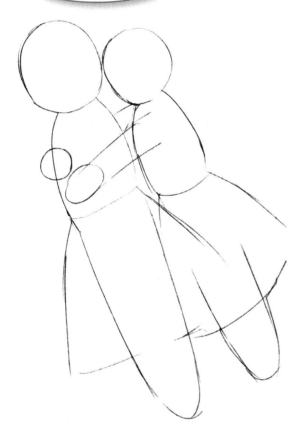

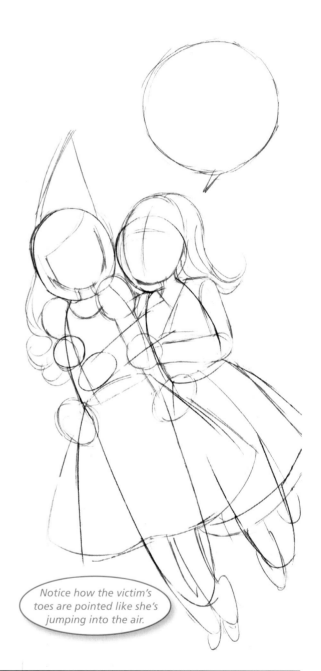

Notice how the victim's toes are pointed like she's jumping into the air.

1. This starts out far simpler than the last image. For one, there are only two figures, one grabbing the other. Use simple shapes to figure out their positions.

2. Give the figures more detail. Notice that Tomoko moves their arms around to make them look more natural, rather than like a girl hugging her favorite life-sized doll. She also places the inset bubble where it helps to balance the image.

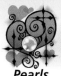

Pearls of Wisdom

It's hard to pack so much story into a single panel, but Tomoko does an excellent job. The party banner shows that this is something fun, not frightening, and the inset picture of the girl behind the mask makes it clear who's behind the surprise. In a manga story, you have more panels in which to work, but it's good to force ingenious solutions like this sometimes.

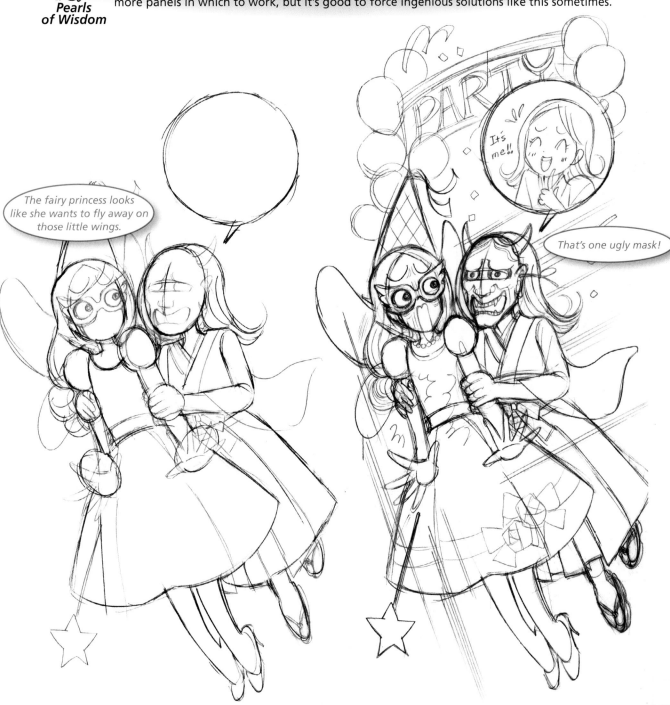

The fairy princess looks like she wants to fly away on those little wings.

It's me!!

That's one ugly mask!

3. Sketch in more bits. Concentrate on the prankster's mask and the victim's reaction. Her eyes and the way her fingers splay out say everything about how she feels.

4. Time to concentrate on the setting. Put a party banner and lots of balloons in the background. Lay in the motion lines to show how the prankster grabs the victim and the victim leaps up. Don't forget to fill in the inset balloon with an image of the prankster showing it's just a joke.

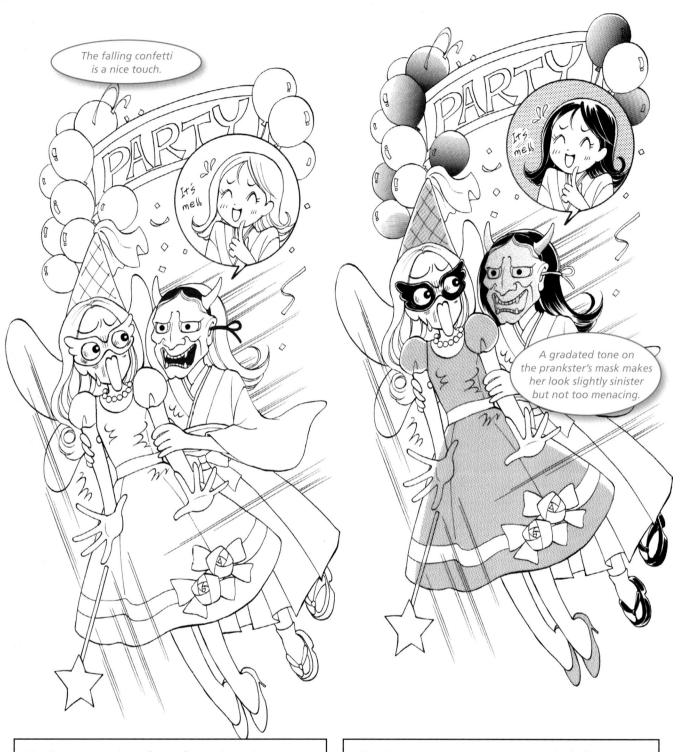

5. Because you have fewer figures here, it's tempting to go back to a variable line weight, but don't bother. It's still comedy, and relatively uniform lines work better for that. The only exceptions should be the movement lines, of course.

6. Alternate screentones through the balloons to differentiate them. Put the victim in a darker dress and the prankster in white (for now). A textured background in the inset makes it clear that the picture comes from another location or scene.

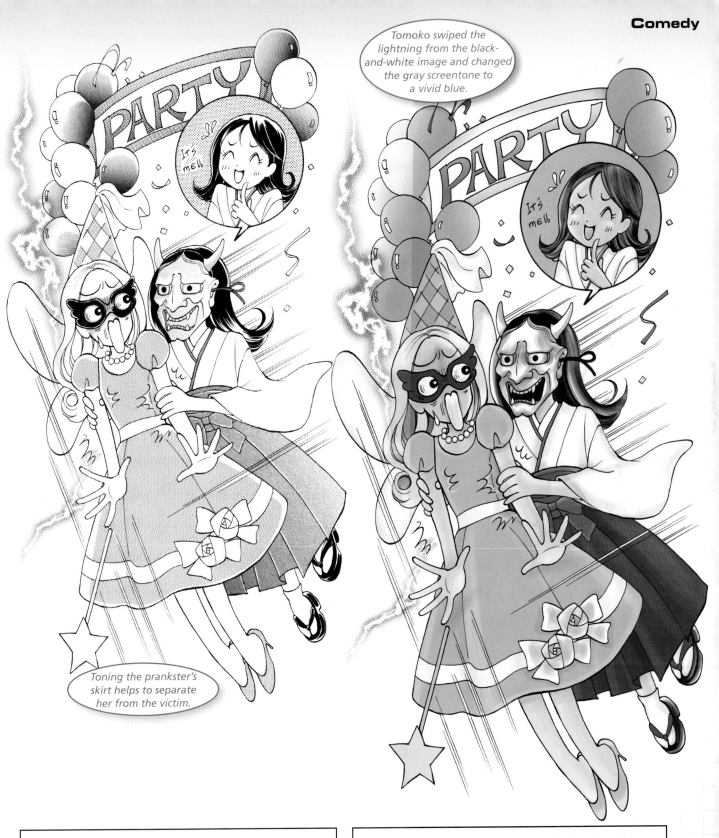

Tomoko swiped the lightning from the black-and-white image and changed the gray screentone to a vivid blue.

Toning the prankster's skirt helps to separate her from the victim.

7. Add bolts of lightning around the victim to show her shock. For this, lay down some screentone and then strip it out in a lightning pattern. The resultant negative space looks great. Finish up the tones elsewhere, and you're good to go.

8. Go back to your clean inks. Green for the victim shows she's feeling sick. Red makes the prankster seem more aggressive, while the blue in the inset is calming, the reverse of the red.

157

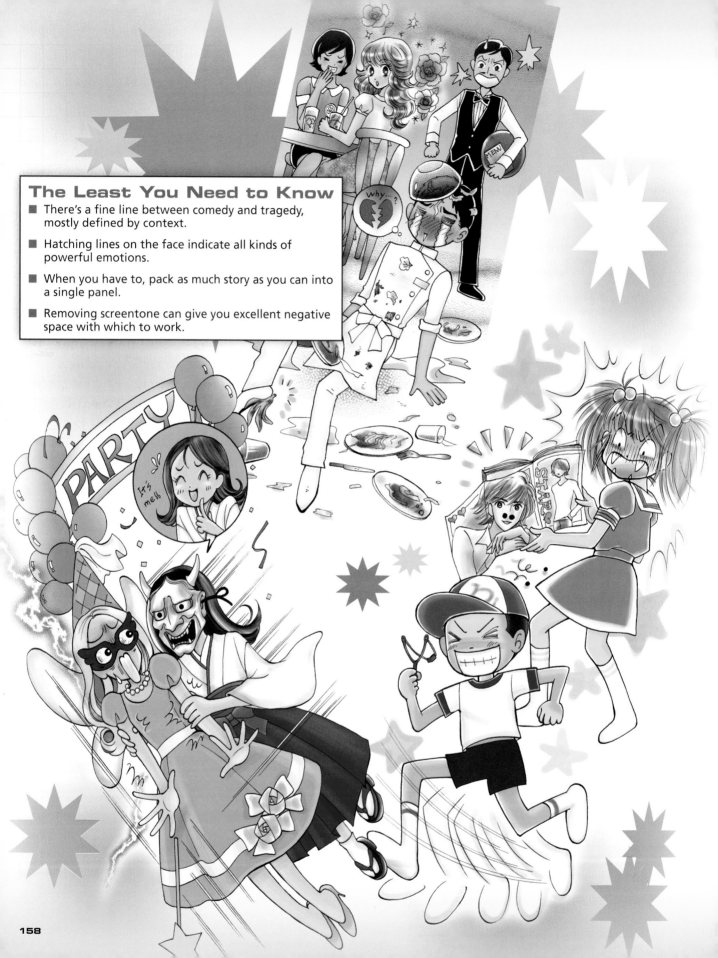

The Least You Need to Know

■ There's a fine line between comedy and tragedy, mostly defined by context.

■ Hatching lines on the face indicate all kinds of powerful emotions.

■ When you have to, pack as much story as you can into a single panel.

■ Removing screentone can give you excellent negative space with which to work.

Horror: Beyond the Veil

11

In This Chapter

- ■ The willowy ghost
- ■ The viper woman
- ■ The serial killer

Not everyone likes to be scared, but most of us can handle it well from the safe remove of reading about horrible things in a book. Even shoujo manga features such terrible tales, giving readers a good chill without having to suffer through any actual threats. The stories and their subjects vary widely, from ghost stories to mythical monsters to modern-day killers.

We start with an ancient Japanese legend of a ghost who lives in the heart of an old willow tree. Sometimes these spirits are friendly, but other times not. Therein lies the suspense of any horror tale that employs them.

After that, we tackle another Japanese myth, that of the snake-woman. She appears to be a regular woman at first. She finds an unwary young man, and to him she is sweet and seductive. When her prey's guard is down, though, she drops the façade and strikes.

We wrap up with an urban legend, that of the serial killer. In Japan, few guns are available, so many murders happen at the end of a knife instead. The blood involved in such tales means they aren't for children, but older shoujo readers enjoy them just the same.

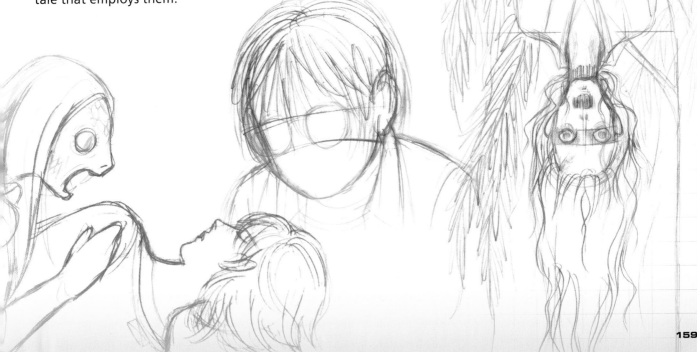

The Ghost

The ghost in the willow is a traditional Japanese tale, so let's give the tree a shake here and see what falls out. In Tomoko's interpretation, the spirit hangs upside down, her hair swaying in the wind like the branches on the tree. Sharp-eyed people passing by the tree are in for a terrifying surprise, though.

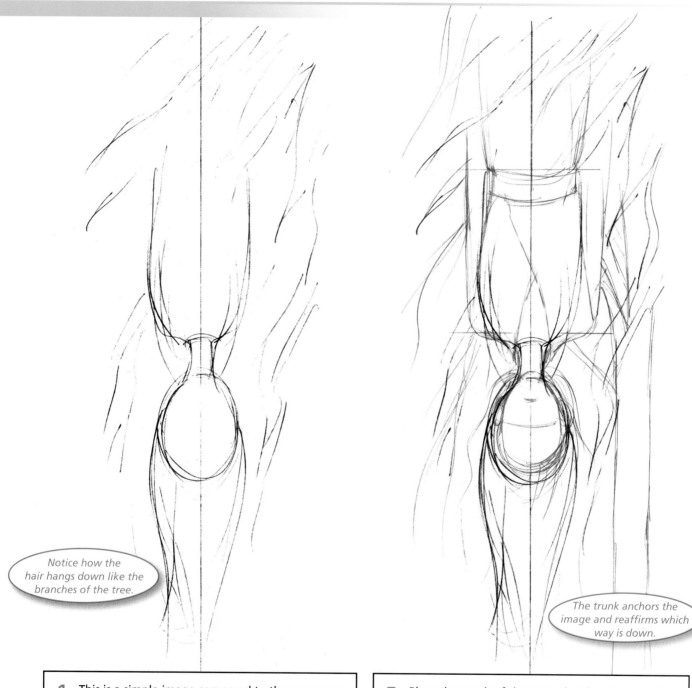

Notice how the hair hangs down like the branches of the tree.

The trunk anchors the image and reaffirms which way is down.

1. This is a simple image compared to the scenes we broke down in the last chapter, but the placement of the figure is unusual. Sketch in the tree and then place a woman upside down in it. We can only see her from her waist up (or down, in this case).

2. Place the trunk of the tree. Sketch in the spirit's kimono. Remember to fold the right side (her right, not yours) over the left. Keep her arms straight up as if they're unaffected by gravity. It's creepier that way.

Chimeric Koans

While in Western cultures the traditional color of death is black, in Japan it is white. Also, when the dead are buried in a kimono, the right side is folded over the left rather than the opposite, which is traditional for those still breathing.

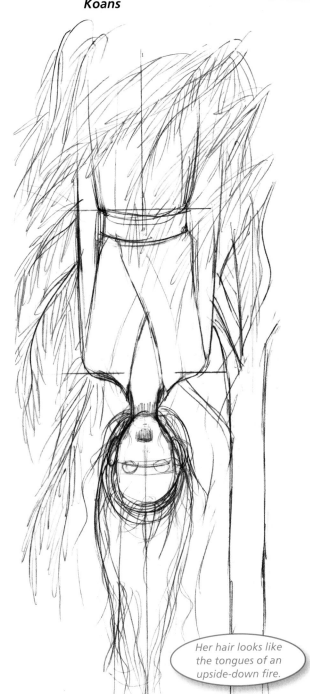

Her hair looks like the tongues of an upside-down fire.

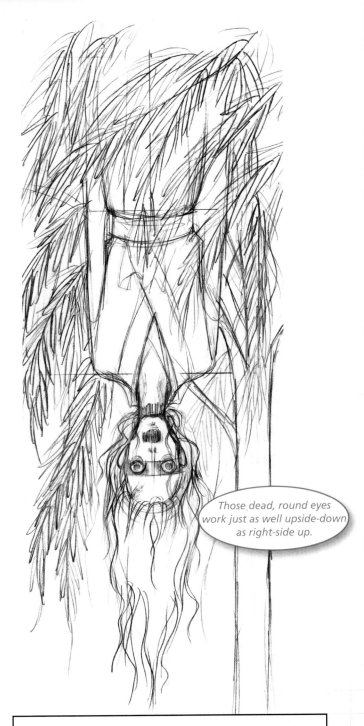

Those dead, round eyes work just as well upside-down as right-side up.

3. Rough in the willow branches. Add more detail to the spirit's hair, and place her eyes and mouth. The real creepiness of the image will come from her face, which we'll work hard on in the next step.

4. Fill out the leaves on the branches. Focus on the ghost's face. Give her sunken cheekbones and wide, lidless eyes. A gaping hole of a mouth fits well, too.

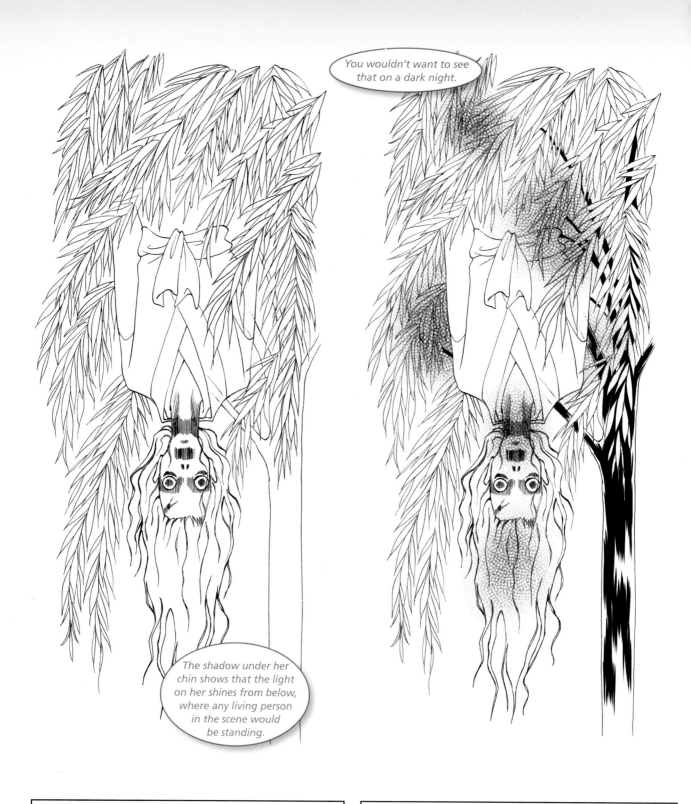

You wouldn't want to see that on a dark night.

The shadow under her chin shows that the light on her shines from below, where any living person in the scene would be standing.

5. For the inks, stick with a uniform line for the most part. The ghost is supposed to be trying to blend in with the tree's branches. Of course, if she's too good at it no one will see her, so betray her with some heavier lines in her hair and on her face.

6. Black out the tree's trunk and branches in streaks. A solid black will look like a silhouette instead of a tree. Smudge the spirit and the tree with the same tones to help complete the ghost's camouflage.

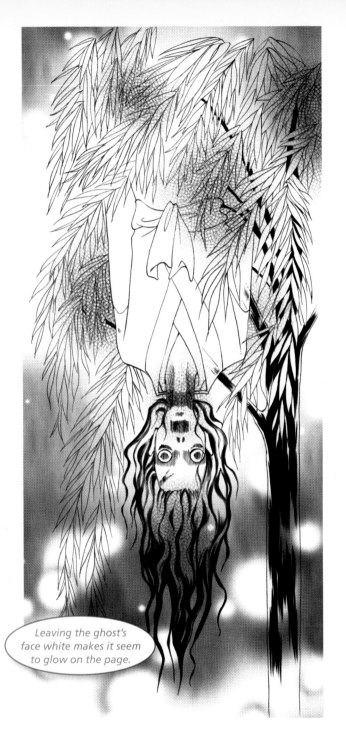

Leaving the ghost's face white makes it seem to glow on the page.

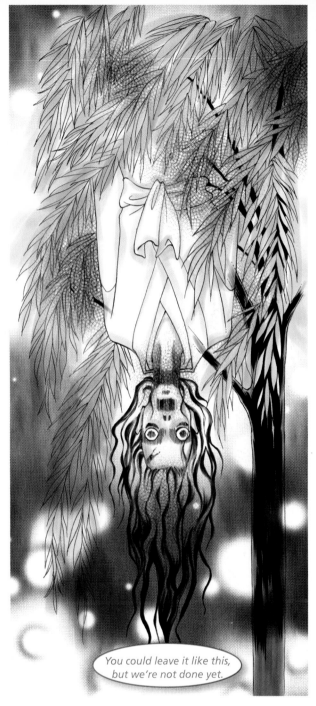

You could leave it like this, but we're not done yet.

7. Lay in a textured screentone in the background to imply the darkness around the tree and figure. You can lay it over her hair to make it seem like that part of her is transparent. Remove some of the tones in circles to imply poor weather or ghostly lights—or both.

8. Stick with your finished black-and-white image. Leave the ghost pale, but slip in some purplish shadows to make the whites pop more. Use the same color for the night around her. The green of the tree's leaves plays well against this color.

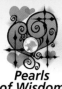

If you have a hard time drawing someone upside down, just turn the paper around to focus on that figure. Don't forget how gravity may affect parts of her, like her hair, but for basic anatomy and facial features, you can ignore its effects and just draw the figure normally but from a different angle. Then turn the paper back the right way to work on the background.

This is the moment of horror in which you ask, "What's next?"

9. Streak the ghost's hair with blue, and add some yellow to some of the circles of light. Then swirl tendrils of white around the ghost and the tree. This makes it seem like a spooky, mist-shrouded night.

Monster

Romance is a common theme in horror. The message is always, "Be careful to whom you give your heart." Those you don't know too well may turn out to have secrets that could be the death of you. The snake-woman is a classic Japanese version of this morality tale.

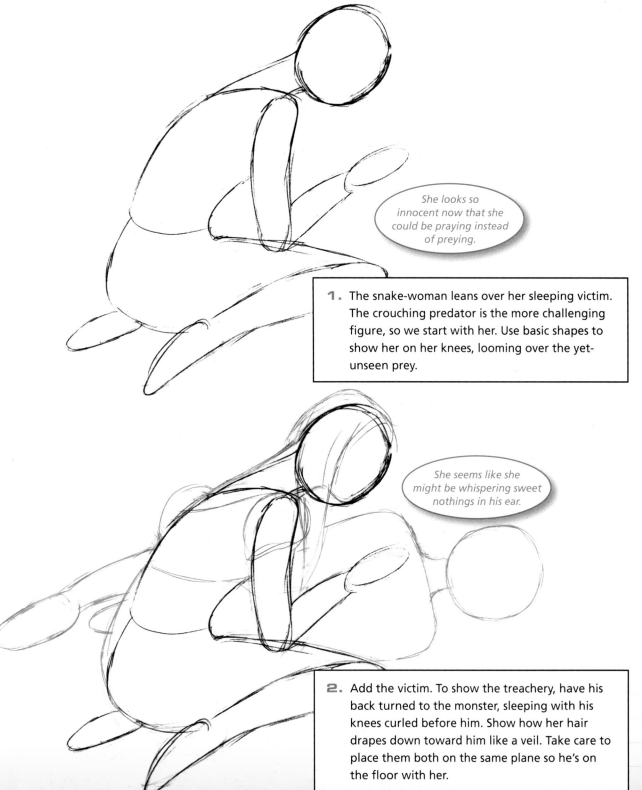

She looks so innocent now that she could be praying instead of preying.

1. The snake-woman leans over her sleeping victim. The crouching predator is the more challenging figure, so we start with her. Use basic shapes to show her on her knees, looming over the yet-unseen prey.

She seems like she might be whispering sweet nothings in his ear.

2. Add the victim. To show the treachery, have his back turned to the monster, sleeping with his knees curled before him. Show how her hair drapes down toward him like a veil. Take care to place them both on the same plane so he's on the floor with her.

You might think to put the snake-woman in goth or emo clothing, surrounding her with themes of death. It's more effective and creepier to put her in pinks, flowers, and frills. The contrast between such seeming innocence and her alien reality makes for a stronger reaction in the reader.

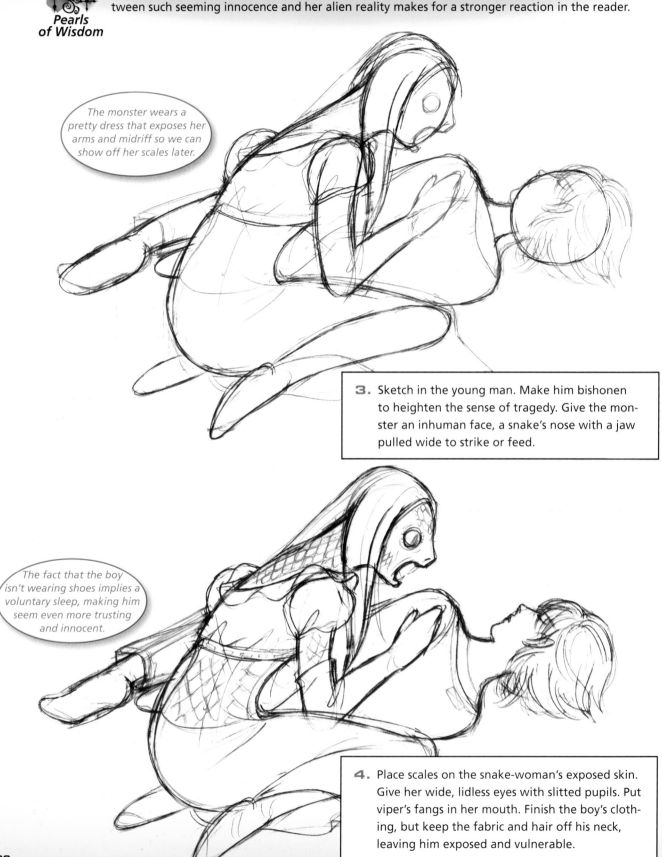

The monster wears a pretty dress that exposes her arms and midriff so we can show off her scales later.

3. Sketch in the young man. Make him bishonen to heighten the sense of tragedy. Give the monster an inhuman face, a snake's nose with a jaw pulled wide to strike or feed.

The fact that the boy isn't wearing shoes implies a voluntary sleep, making him seem even more trusting and innocent.

4. Place scales on the snake-woman's exposed skin. Give her wide, lidless eyes with slitted pupils. Put viper's fangs in her mouth. Finish the boy's clothing, but keep the fabric and hair off his neck, leaving him exposed and vulnerable.

AIIEEE!!!

Be sure to make something ugly about your monster, or you risk having the viewer sympathize with it. In this case, the snakelike features should be plenty, but we need to make sure we let the viewer see them. That's why we use a dress that shows off her scales.

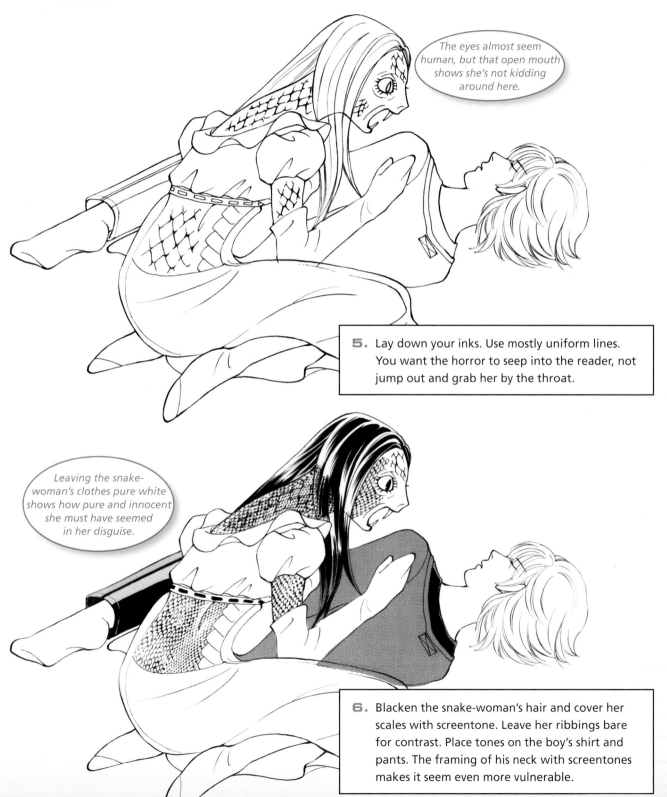

The eyes almost seem human, but that open mouth shows she's not kidding around here.

5. Lay down your inks. Use mostly uniform lines. You want the horror to seep into the reader, not jump out and grab her by the throat.

Leaving the snake-woman's clothes pure white shows how pure and innocent she must have seemed in her disguise.

6. Blacken the snake-woman's hair and cover her scales with screentone. Leave her ribbings bare for contrast. Place tones on the boy's shirt and pants. The framing of his neck with screentones makes it seem even more vulnerable.

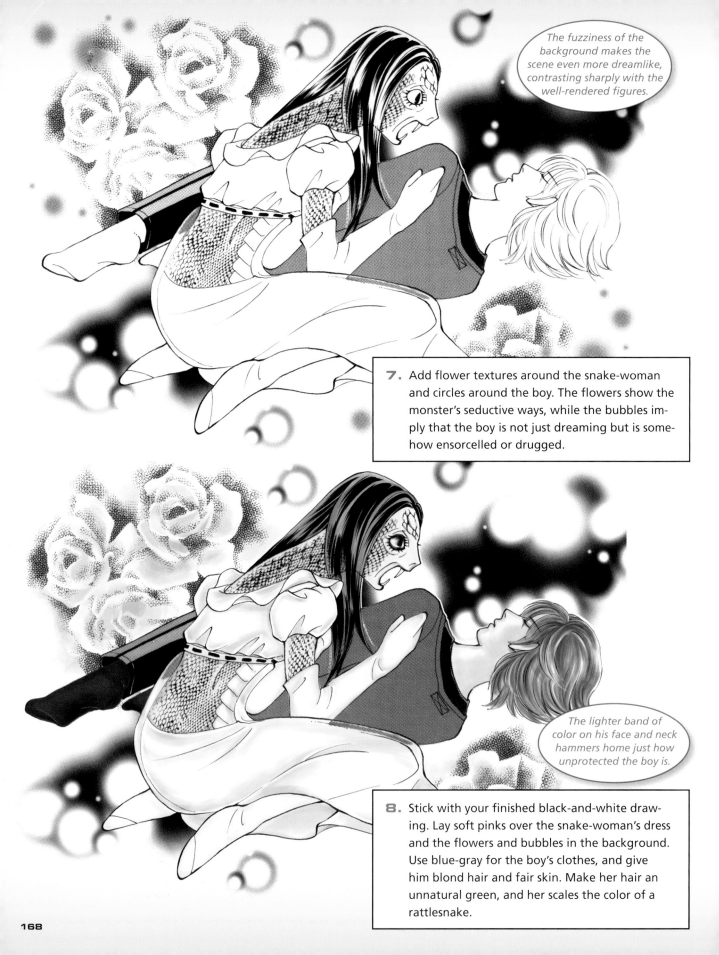

The fuzziness of the background makes the scene even more dreamlike, contrasting sharply with the well-rendered figures.

7. Add flower textures around the snake-woman and circles around the boy. The flowers show the monster's seductive ways, while the bubbles imply that the boy is not just dreaming but is somehow ensorcelled or drugged.

The lighter band of color on his face and neck hammers home just how unprotected the boy is.

8. Stick with your finished black-and-white drawing. Lay soft pinks over the snake-woman's dress and the flowers and bubbles in the background. Use blue-gray for the boy's clothes, and give him blond hair and fair skin. Make her hair an unnatural green, and her scales the color of a rattlesnake.

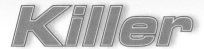

In Shoujo, the killer is often a creepy man with few if any redeeming social features. In our illustration, we hit that hard, creating a murderer with whom few could sympathize. It's not easy to ignore all that blood.

Even at this stage, there's nothing happy about this man.

This one's no fashion plate.

1. Start out with a single figure. Notice the guideline to show his center. Give him hunched shoulders and a bowed head to show that he's essentially a coward, crushed by his life and (perhaps) what he's done.

2. Rough in the figure's hair and clothes. Give him a bad haircut and roll up his sleeves to show he's been "working." He dresses badly, too, with an open shirt and pants just a bit too short.

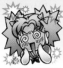
With the killer, we're going to push the envelope of good taste and what might be acceptable in a shoujo story. These are tales for girls, after all, but not all shoujo readers are as young as you might think. As an artist, you should always keep your audience in mind and figure out what's appropriate for them before you begin.

This is one pathetic person.

The blood dripping from the knife shows that he's just killed someone moments before.

3. Add an ugly pair of glasses and put the murder weapon in his hands. It's a knife, of course, of the kind you might see in any slasher flick. Notice he's wearing socks without shoes.

4. Work on the face. Make him ugly and sullen. The glasses warp his eyes to tiny things, making him seem less human. Spatter him everywhere with blood.

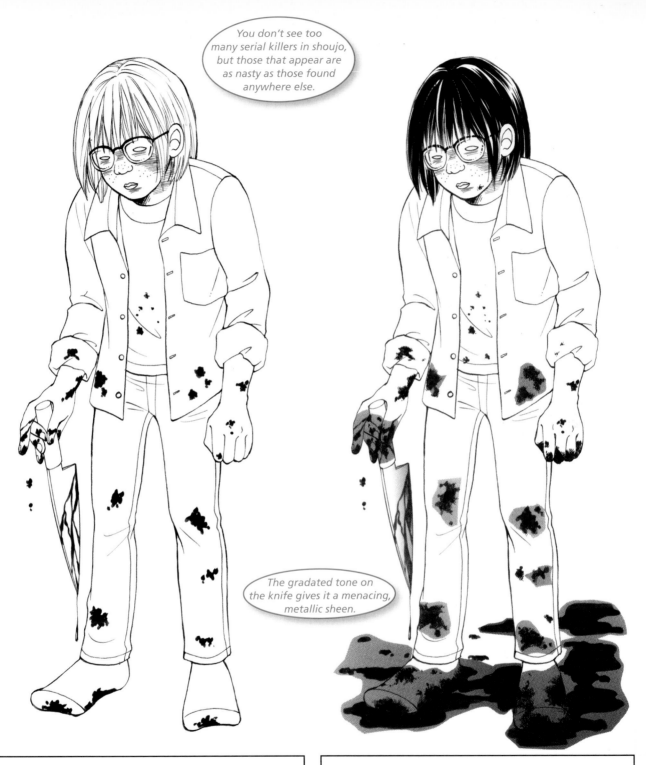

You don't see too many serial killers in shoujo, but those that appear are as nasty as those found anywhere else.

The gradated tone on the knife gives it a menacing, metallic sheen.

5. Time for your inks. Use uniform lines for most of this. You can use weaker lines in the hair to show that it's shaggy and matted. Use weaker lines on his face, too, to show he's a weak person striking out in a horrible way.

6. Go light with the screentones here. Use them first for the blood. The contrast with the white clothes makes the blood even more awful. Give the killer greasy, black hair, and shadow his face a bit to make him seem even creepier.

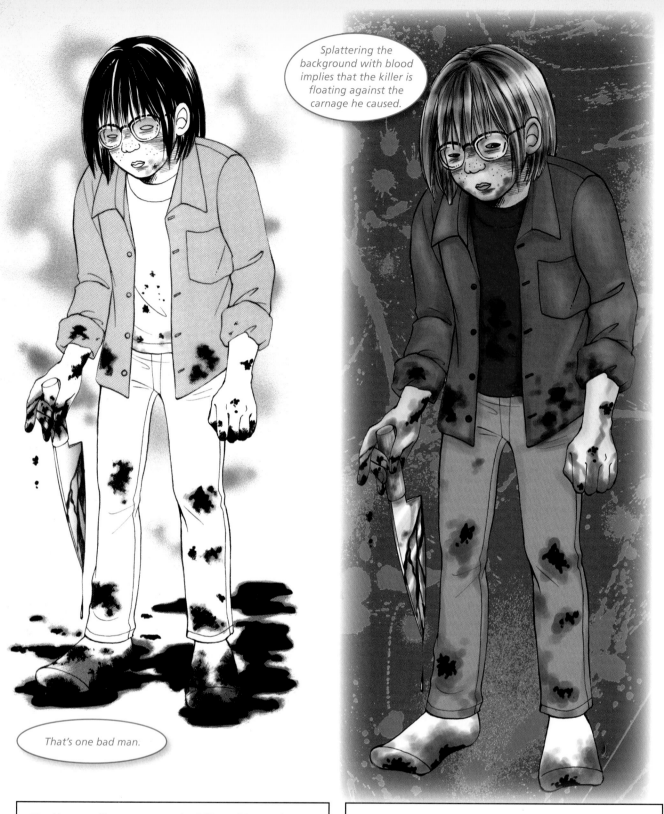

7. Use a uniform tone on the killer's shirt, and use a slightly darker tone to create a miasmic mist behind him. Trim back on the edges of the blood until the tones seem to seep from your blacks.

8. Go back to your clean inks. Choose solid colors for the killer's clothes, dark to neutral. Leave his socks white to show that he's soaked in blood. Spread crimson around every dark splotch of blood.

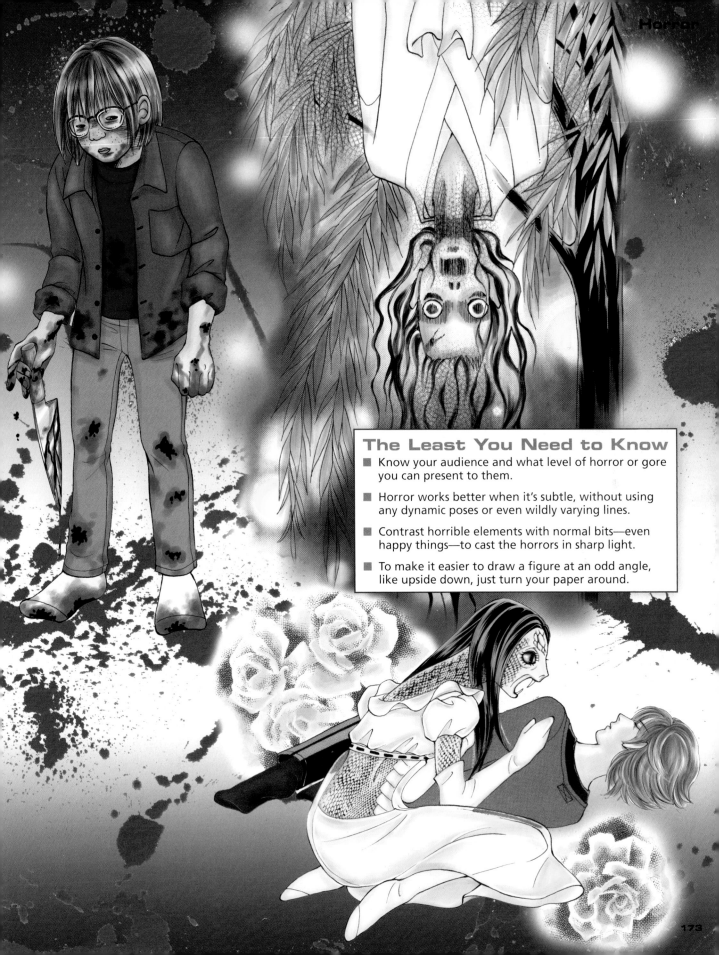

The Least You Need to Know

■ Know your audience and what level of horror or gore you can present to them.

■ Horror works better when it's subtle, without using any dynamic poses or even wildly varying lines.

■ Contrast horrible elements with normal bits—even happy things—to cast the horrors in sharp light.

■ To make it easier to draw a figure at an odd angle, like upside down, just turn your paper around.

Fantasy:
A Happy Ending

In This Chapter

- A princess on wings
- A dashing hero
- A formidable foe

You'd have to have been living under a rock to not see how popular fantasy stories have become over the past 10 years or so. With the advent of *Harry Potter* and *The Lord of the Rings* films, more people enjoy fantasy stories now than ever before. Shoujo manga has offered fantasy tales for years, and you can expect to see many more of them in the future.

We start out with a winged princess. Anyone familiar with Tomoko's work should recognize this kind of character from her *Princess Prince* books. She's a beautiful young lady with wings, which marks her as far more than human.

Then we move on to a handsome prince, the object of many a girl's affection. In many shoujo fantasy stories, the young men wear their hair so long and adopt such elaborate fashions that it can be hard to tell them from the girls. This one's a lover, not a fighter.

We wrap up the chapter (and the book) with a dark and mysterious villain. Despite his badness, he's handsome as can be, symbolizing perhaps the lure that the forbidden can have. Is he really evil, or just misunderstood? That's something only your story can reveal.

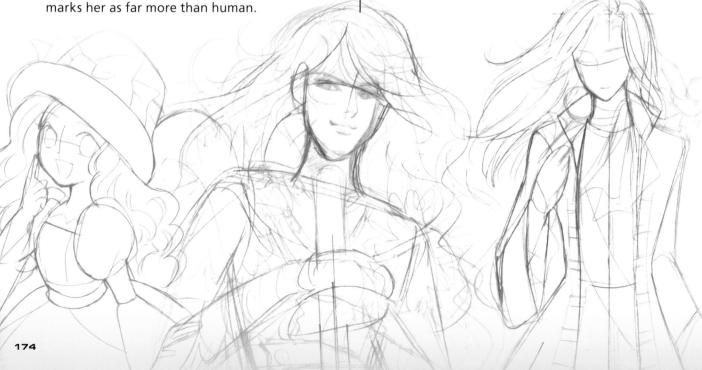

Winged Princess

This girl dresses in a pseudo-Victorian style, complete with frills, knee socks, and fancy hat. She's the epitome of cute. She also has wings. Is she someone's guardian angel or something more?

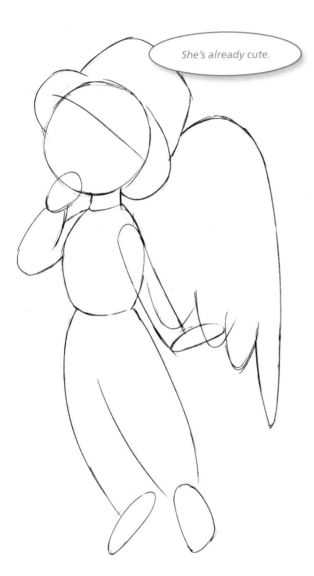

She's already cute.

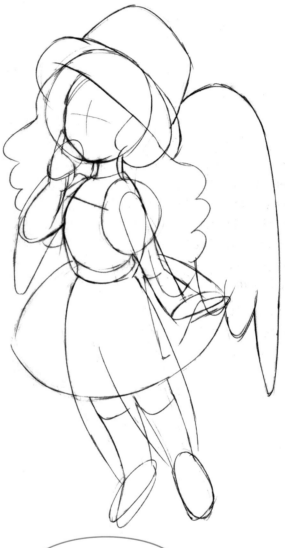

It doesn't matter if she looks like she's floating in air because she just might be!

1. We're only tackling a single figure here. Begin by breaking down her position with basic shapes. She is perky and happy, and that should show in her stance. Her wings, as well, should be both cute and positive, not menacing in any way.

2. Add her hair. Make it long, curly, and flowing. Give her a short, cute skirt that flares out dramatically. Narrow the legs a bit and add feet.

Angels figure strongly in Western literature but not as much in nations that haven't been so influenced by Judeo-Christian traditions. Still, winged people appear in all sorts of stories and point directly to something strange and magical going on.

She looks like she has something happy to say.

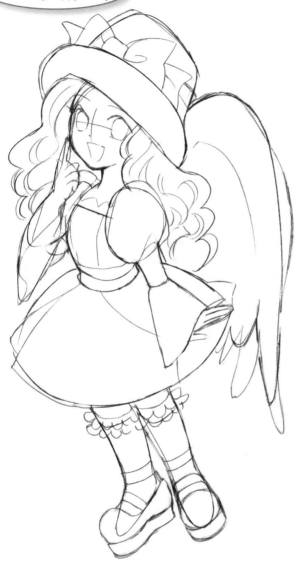

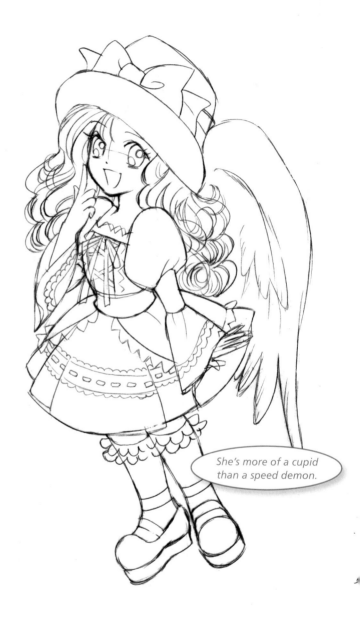

She's more of a cupid than a speed demon.

3. Work on the details of her dress and add the curls to her hair. Flesh out her wings a bit more. Add details to her shoes and socks, and put a big bow on her hat. Give her wide, expressive eyes and a big smile.

4. Refine her face and add lights in her eyes. Detail some of the feathers in her wings, and add some frills to her dress, both on the skirt and the bodice. Give her long eyelashes, too.

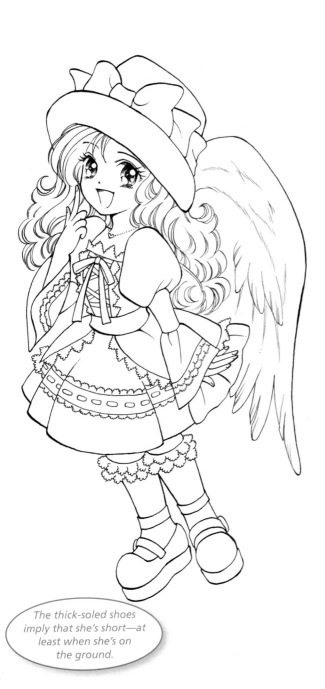

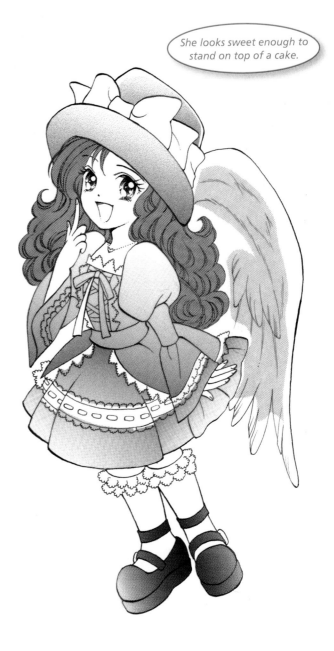

She looks sweet enough to stand on top of a cake.

The thick-soled shoes imply that she's short—at least when she's on the ground.

5. Lay down your inks. Use thinner lines for the hair and for the feathers in the wings. These should, in fact, almost mesh together. Use heavier lines for her eyes, eyebrows, and clothing.

6. Put a solid screentone on the girl's hair, and a slightly lighter solid on the inside of her wings. Use gradated fills on her dress, shoes, and hat. Let them run darker toward her middle, as if light surrounds her on every side.



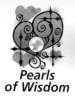

Pearls of Wisdom

If you're working this figure into a story, you would want to develop a more detailed background to set her in. However, even then you'd want to put a soft glow around her. This lifts her off the page and gives her the otherworldly look we're going for.

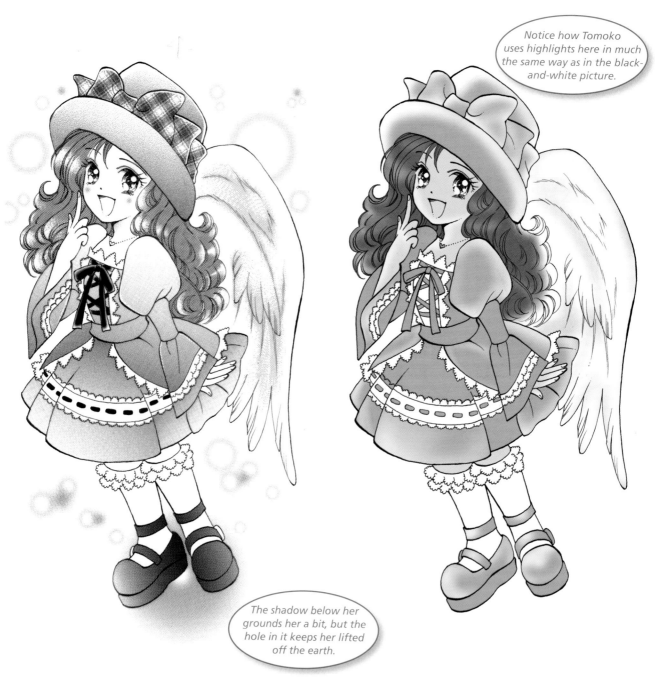

Notice how Tomoko uses highlights here in much the same way as in the black-and-white picture.

The shadow below her grounds her a bit, but the hole in it keeps her lifted off the earth.

7. Remove some of the tone in her hair to create highlights. Add a plaid screentone to the bow. Work down the tones in her feathers to blend into the white better. Add some circles all around her like lens flares from many lights.

8. Return to your clean inks. Give her shiny brown hair. Make her dress, shoes, and hat pink and leave her socks white. Add some bluish shadows to the wings to give them texture.

She looks like she's coming out of the rising sun.

9. Work up a colored background. Make it yellow in the center and orangish at the edges. Dabble in a few spots of white and red.

Prince

The prince is a staple of many fantasy stories, especially those featured in shoujo. He is the hero of many tales and the object of desire or affection in many others. Princes are usually bishonen, beautiful beyond belief. This may make them effeminate by Western standards, but most shoujo readers don't mind.

That's not a skirt he's wearing. It's the flare of his tailored tunic.

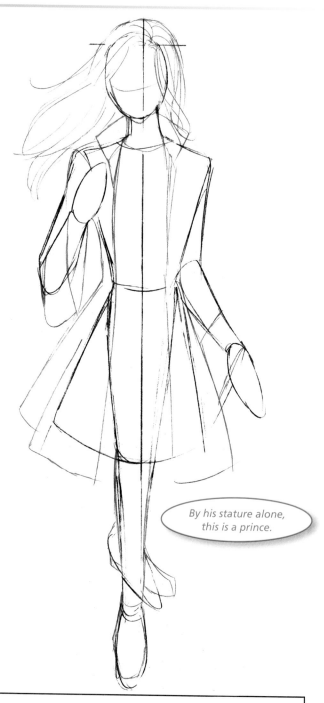

By his stature alone, this is a prince.

1. This is a single figure again. The pose is not dynamic, but Tomoko acknowledges the forced perspective of such a shot by placing one leg back and depicting it higher. This, along with the placement of the prince's arms, gives him a more dramatic look.

2. Add the prince's hair, making it long and flowing. Put a long coat on him over his tunic. Notice the vertical line showing his center, and see how his head nods forward, out of line.

Chimeric Koans

Japan had its own kind of royalty (the Imperial dynasties) during its feudal period, but that part of history speaks of shoguns and samurai, not wizards and royalty. Most of what Westerners recognize as fantasy is based upon medieval Europe and England in particular.

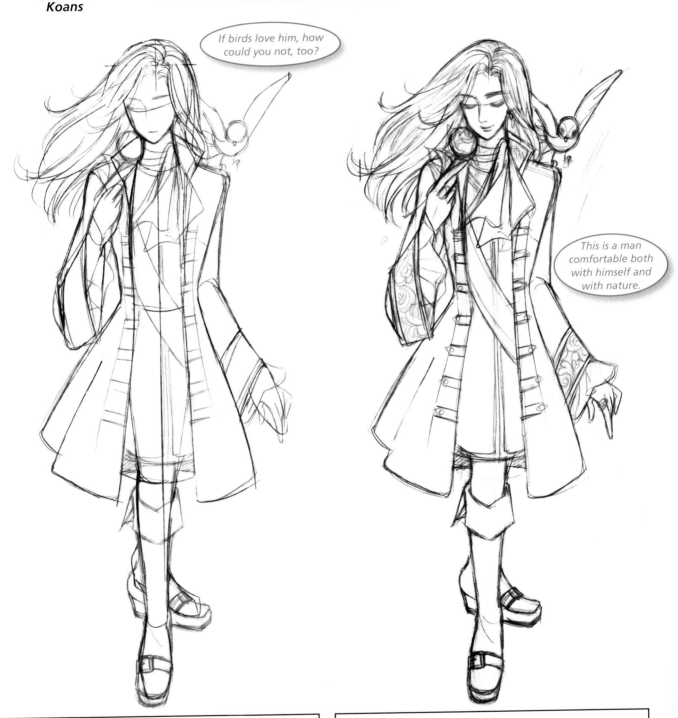

3. Give him a scarf around his neck and a bird around his shoulder, too. Add in more details, on his coat, shirt, and boots. Put a sash over one shoulder.

4. Work on the prince's kind face. Cast his eyes downward toward the rose he holds in his hand. Embroider details on the cuffs of his coat and add decorations throughout. Use more lines to thicken his hair.

You can tell a lot about a man by how he interacts with children and animals. If he is kind to them, he will likely be kind to women as well. The bird on the prince's shoulder shows that he is so kind that even a creature as skittish as a bird feels safe in his presence.

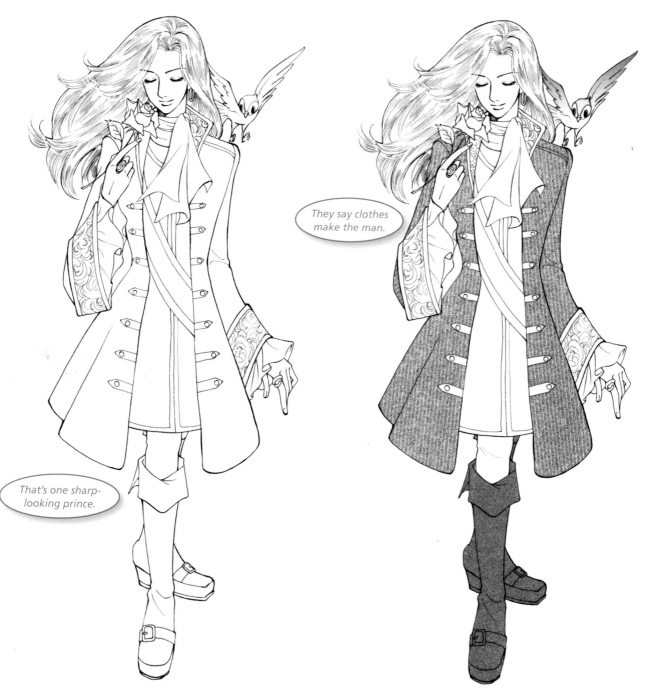

They say clothes make the man.

That's one sharp-looking prince.

5. Use uniform inks for this picture. Only go soft with the most delicate details like his hair and the designs on his cuffs. Going heavier on his eyelashes draws the eyes to his face.

6. Use a fibrous screentone on the prince's coat. A felt-like texture works well on his boots. Use a gradated tone on the bird on his shoulder, too.

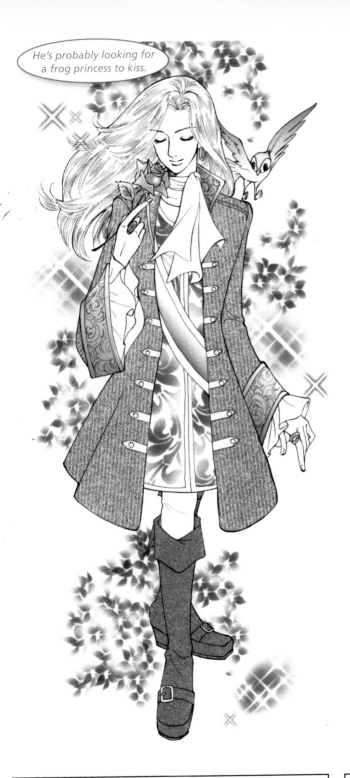

He's probably looking for a frog princess to kiss.

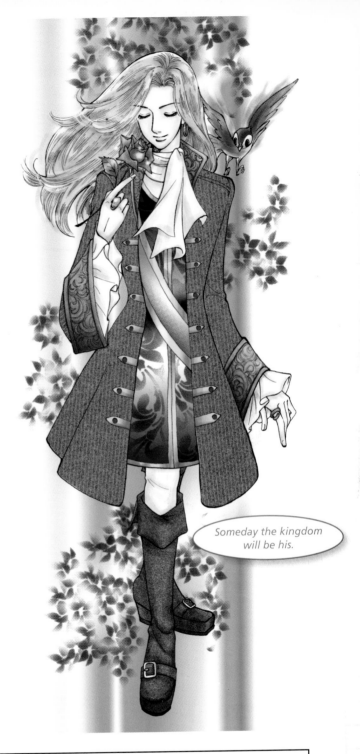

Someday the kingdom will be his.

7. Add an intricate texture to the prince's tunic. Use gradated tones on his cuffs and his sash. A pattern of leaves behind him reinforces the idea he's on a walk through the woods. The sparkles show how shiny good he is.

8. Stick with your finished black-and-white image. Use yellows and blues throughout, mixing them for various shades of green. The only exceptions are the red of the rose, which draws attention to the prince's face, and the purple of his tunic, which centers him under all the finery.

Here we tackle a hearty, white-haired villain wielding a black-bladed sword. Whether or not he's evil doesn't matter. He stands between the heroine and what she wants, and that's enough to provoke the sort of battle to shake the heavens.

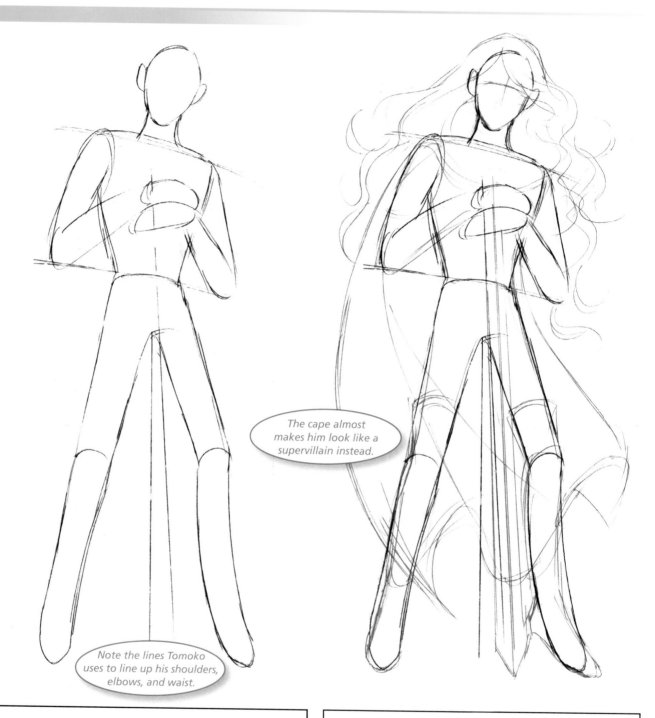

The cape almost makes him look like a supervillain instead.

Note the lines Tomoko uses to line up his shoulders, elbows, and waist.

1. We start out with a rough figure of our villain, his hands folded over the hilt of his sword. He glares down at us imperiously. Use basic shapes to capture this.

2. Add long, flowing hair to the villain and give him a cape to flap in the wind. Sketch in the sword more strongly, too. Take the forced perspective into account and make it wider at the bottom of the picture than you might expect.

**Chimeric
Koans**

Great villains make for great heroes. Without an overwhelming challenge, heroes never get to prove themselves or test their limits. Powerful, cunning villains push heroes beyond what they know and force to them to dig into their deepest reserves to save their world, their friends, and themselves.

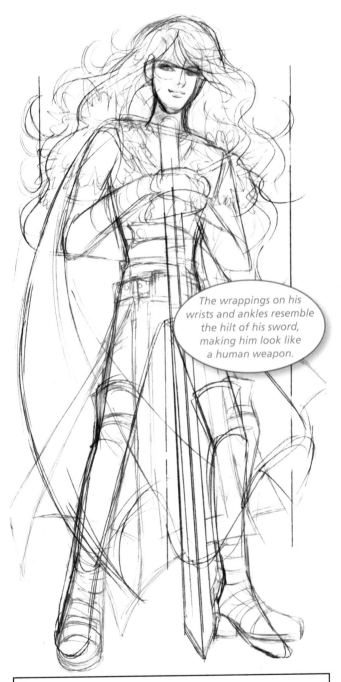

The wrappings on his wrists and ankles resemble the hilt of his sword, making him look like a human weapon.

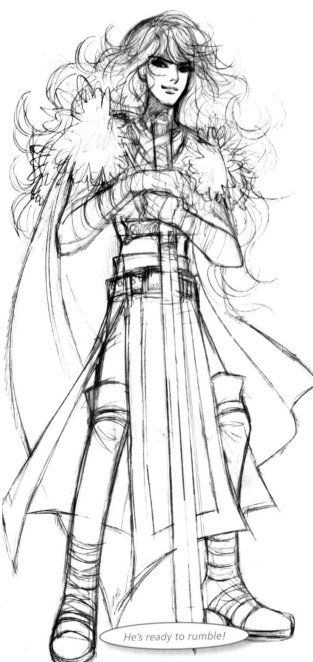

He's ready to rumble!

3. Work in the narrowed eyes and the wry, confident smirk. Add tufts of fur to his shoulder to bulk him up a bit. Fill out the hair and spend some time on the details of his clothes. Notice how his head is now tilted just a hair away from the viewer, as if we're barely worthy of his notice.

4. Work out the details on his clothing and remove many of the underlying lines you were using for guides. Bulk up the wrappings on his limbs a bit more. Decorate the sword's crossguard.

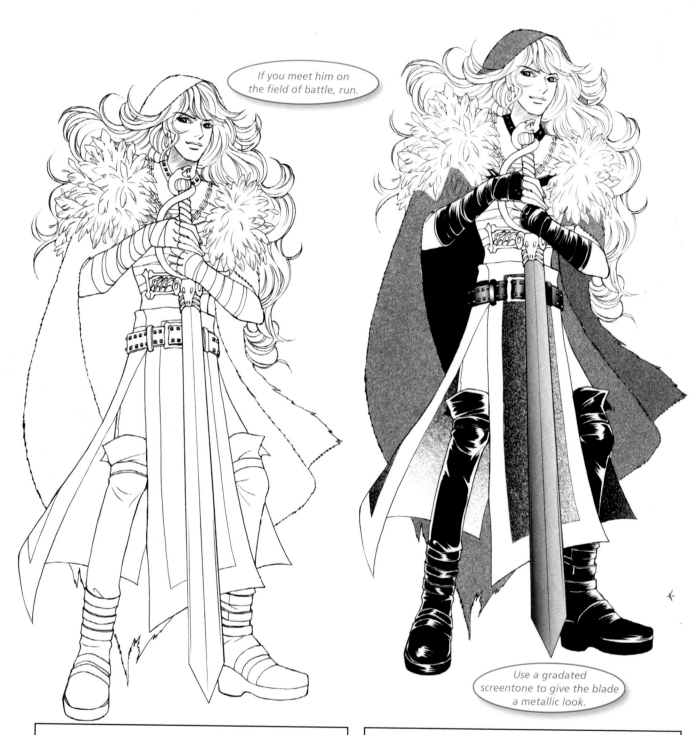

If you meet him on the field of battle, run.

Use a gradated screentone to give the blade a metallic look.

5. The pose is dramatic enough, so go with mostly uniform inks here. Notice how Tomoko sketches at the lines along the edges of the villain's cape, making the fabric look like fur instead of cloth. His hair has heavier lines than normal, with only the bursts of fur on his shoulders using fainter lines.

6. Use a feltlike texture for the outer part of the cape, and blacken the inside of it. Use something similar but slightly darker on the bulk of his tunic. Blacken his boots and the wraps on his arms. Leave highlights to give them the look of polished leather.

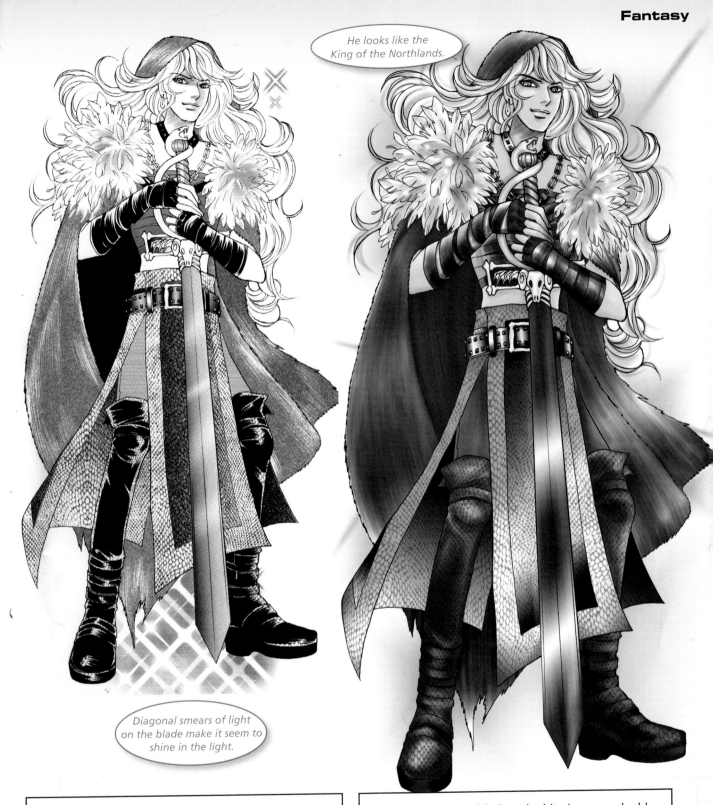

He looks like the King of the Northlands.

Diagonal smears of light on the blade make it seem to shine in the light.

7. This is a rough-and-tumble figure, so rough up everything. Scratching up the cape gives it a weathered look. Use a herringbone pattern on the trim and the inside of his clothes. Smudge the center of the fur bursts a bit to give them depth. Put a pattern underneath to make it look like he's standing on shimmering ice.

8. Stick with your black-and-white image and add color to it. Replace lots of the blacks with grays, and edge the fur and hair with violet, as well as the edging on the kilt. A burst of blue behind the villain makes him look wintrier than ever.

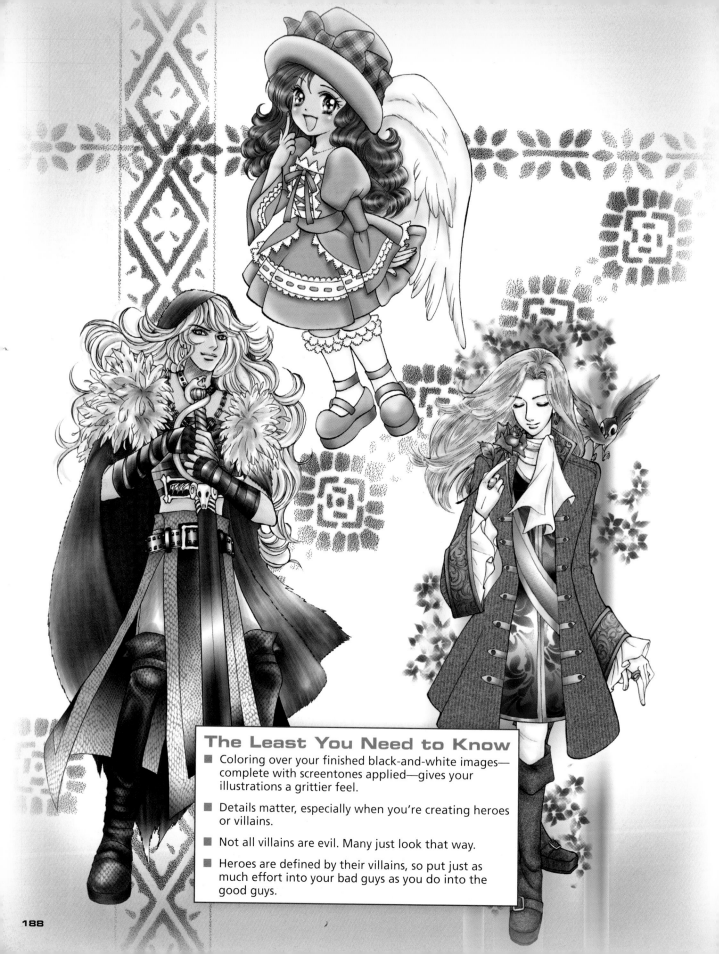

The Least You Need to Know

■ Coloring over your finished black-and-white images—complete with screentones applied—gives your illustrations a grittier feel.

■ Details matter, especially when you're creating heroes or villains.

■ Not all villains are evil. Many just look that way.

■ Heroes are defined by their villains, so put just as much effort into your bad guys as you do into the good guys.

Appendix A

Glossary

anime Japanese animation. This generally shares the style and the tropes of printed manga.

bishoujo A type of manga that features beautiful girls, usually in their teens. While shoujo is for girls, bishoujo is about girls.

breakdown The roughest stage of a drawing. Here, you put down simple shapes in pencil, figure out the poses of the creatures and items involved, and determine the angle at which the viewer sees the contents of the picture.

chibi A style of manga in which the figures are infantilized by giving them large heads and features atop tiny bodies.

coloring After a drawing is inked, it is often colored. Originally, this was done with paints, markers, or colored pencils. Today, most comics are colored on a computer.

comic (or comic book) A pamphlet or book that tells a story using sequential art and often words.

curvilinear perspective A process that uses five vanishing points and curved perspective lines to show depth in a drawing.

finished pencils A pencil drawing that is as complete as you can make it. Often such drawings are then inked and colored.

foreshortening The forced use of perspective to make things closer to you appear larger.

ganbatte Japanese for "good luck."

graphic novel A comic book published in book form, usually containing either a complete story or a substantial arc of a larger story.

hentai manga Sexually explicit manga made for adults only.

inking Going over finished pencils with ink to make the art permanent and sharp.

josei manga Japanese for "women's manga." These are for women from older teenagers all the way up to middle age.

manga Originally, comics published in Japan, but the term now encompasses any comics work that uses the artistic styles and tropes that originated in Japan.

manga-ka A person who creates manga.

penciling Drawing a picture with a pencil. Artists often start with breakdowns and work their way up to finished pencils, which are then inked and colored.

perspective The fact that things farther from the eye look smaller than those that are closer. Artists mimic this in two-dimensional drawings to give their work the perception of depth.

perspective lines Straight lines that meet at a vanishing point and are used to help mimic three-dimensional depth on a page. They can seem almost parallel at first but they eventually meet somewhere, even off the page.

rough A drawing in a preliminary stage, after you've got down the breakdown and the skeleton, but before you have used the finished pencils.

sayonora Japanese for "goodbye."

screentone A rub-on pattern—often simply dots or lines—used to add shading, depth, and texture to a drawing.

seinen manga Japanese for "men's comics." These are intended for older teenagers up to the start of middle age.

shoujo manga Japanese for "girl's comics." These tend to focus more on characters and their relationships.

shonen manga Japanese for "boy's comics." These tend to be filled with action and adventure.

skeleton The underlying framework of any creature, whether it has bones or not.

translation To take the words of one language and put them into another.

vanishing point The point at which the perspective lines in a drawing meet. Look to the end of a long, straight road to see this effect in real life.

Appendix B
Visual Glossary

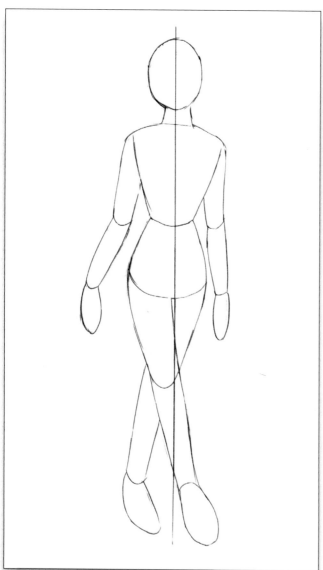

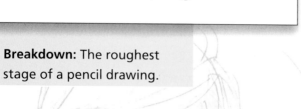

Breakdown: The roughest stage of a pencil drawing.

Colors: The final stage of a drawing, in which you color it in whatever fashion you like. Most manga is produced without colors.

Finished pencils: A pencil drawing that is as complete as you can make it. Often such drawings are then inked and colored.

Finishes: After you apply screentones, you need to rough them up or hone them down to "finish" your black-and-white drawing.

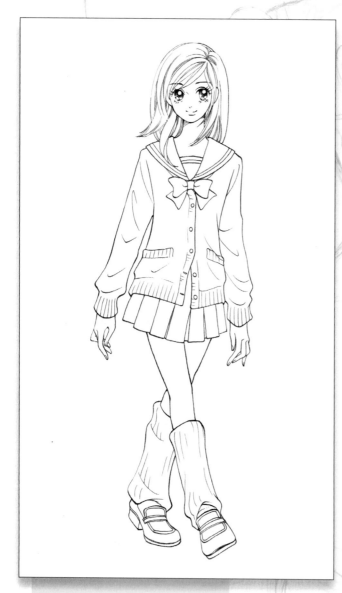

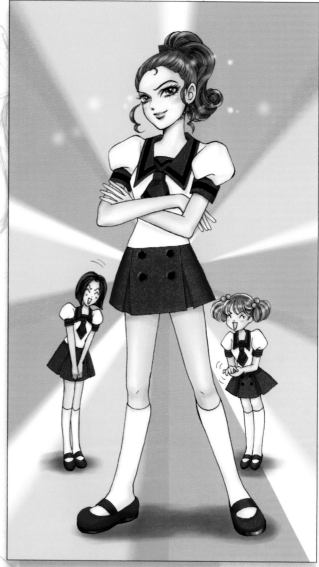

Inks: The stage of a drawing at which you go over your pencils with ink to make them more permanent. Some artists skip this step, preferring the look of the finished pencils instead.

Perspective: The fact that things farther from the eye look smaller than those that are closer. Artists mimic this in two-dimensional drawings to give their work the appearance of depth.

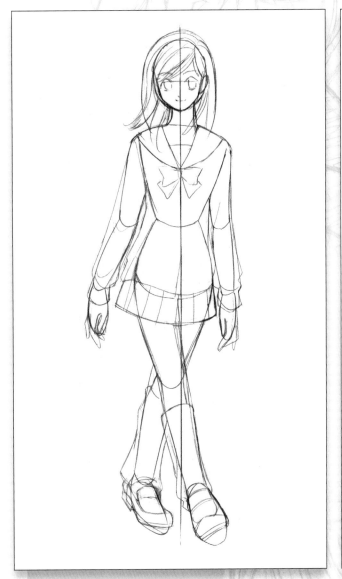

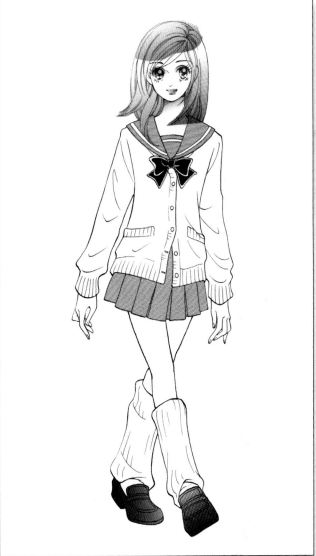

Rough: A drawing in a preliminary stage, after you've got down the breakdown and the skeleton, but before the finished pencils.

Screentone: After the inks are complete, you may wish to apply screentone (rub-on patterns) to give your drawing more depth and intricacy.

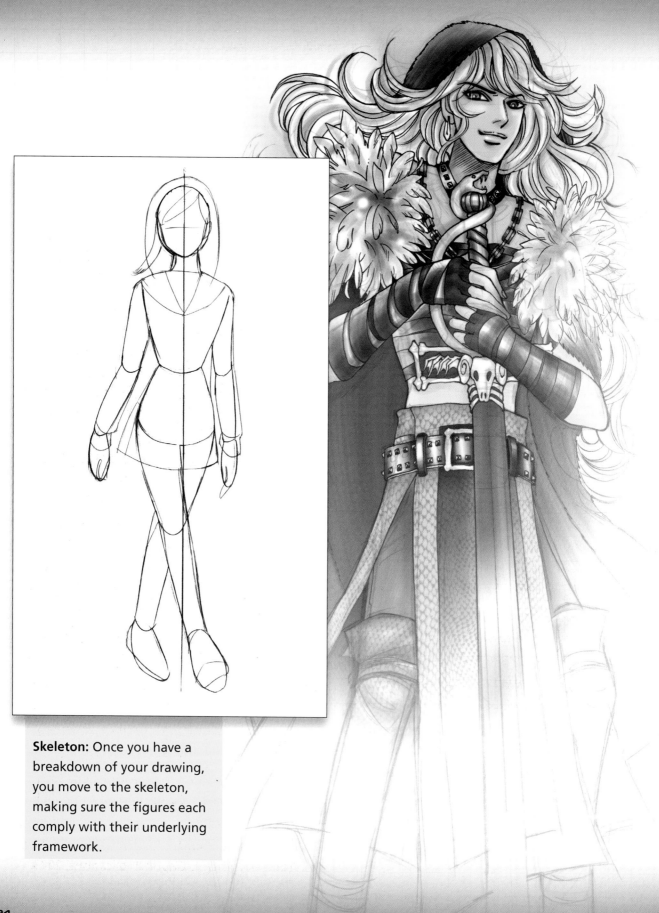

Skeleton: Once you have a breakdown of your drawing, you move to the skeleton, making sure the figures each comply with their underlying framework.

Appendix C

Recommended Reading

The Original

This book stands squarely on the shoulders of another, the first book in the series: *The Complete Idiot's Guide to Drawing Manga, Illustrated*, by John Layman and David Hutchinson. If you haven't read that book and you're truly a newbie when it comes to manga, then rush out and get it right away. If that's so, I'm surprised you made it this far into this book. Grab that book, read it, and come back here for the advanced course.

Just to make this all official, the following is the information you need to find the original book:

Layman, John, and David Hutchinson. *The Complete Idiot's Guide to Drawing Manga, Illustrated.* Indianapolis, IN: Alpha, 2005.

Also, be sure to pick up the previous book in this series by the authors of the book you're holding:

Forbeck, Matt, and Tomoko Taniguchi. *The Complete Idiot's Guide to Manga Fantasy Creatures, Illustrated.* Indianapolis, IN: Alpha, 2007.

A couple other guides in *The Complete Idiot's* series should prove useful, too:

Gertler, Nat, and Steve Lieber. *The Complete Idiot's Guide to Creating a Graphic Novel.* Indianapolis, IN: Alpha, 2004.

Hoddinott, Brenda. *The Complete Idiot's Guide to Drawing People, Illustrated.* Indianapolis, IN: Alpha, 2004.

Jarrett, Lauren, and Lisa Lenard. *The Complete Idiot's Guide to Drawing, Second Edition.* Indianapolis, IN: Alpha, 2003.

Other Drawing Books

Now that you've plumbed *The Complete Idiot's Guides*, here are a number of other books you might find useful. They range from books that cover the same subject as this work to intellectual examinations of exactly how comics work. Dip in deeply, and enjoy liberally.

Casaus, Fernando, and Estudio Joso. *The Monster Book of Manga: Draw Like the Experts.* New York, NY: Collins Design, 2006.

Dean, Martyn. *The Guide to Fantasy Art Techniques.* New York, NY: Paper Tiger, 1988.

Doran, Colleen. *Girl to Grrrl Manga: How to Draw the Hottest Shoujo Manga.* Cincinnati, OH: Impact, 2006.

Edwards, Betty. *The New Drawing on the Right Side of the Brain.* New York, NY: Tarcher, 1999.

Eisner, Will. *Comics and Sequential Art, Expanded Edition.* Tamarac, FL: Poorhouse Press, 1985.

———*Graphic Storytelling and Visual Narrative.* Tamarac, FL: Poorhouse Press, 1996.

Hart, Christopher. *Draw Manga Monsters!* New York, NY: Watson-Guptill Publications, 2005.

———*Manga Mania Fantasy Worlds: How to Draw the Amazing Worlds of Japanese Comics.* New York, NY: Watson-Guptill Publications, 2003.

Hogarth, Burne. *Dynamic Figure Drawing*. New York, NY: Watson-Guptill Publications, 1996.

Martin, Gary. *The Art of Comic Book Inking*. Milwaukie, OR: Dark Horse Comics, 1997.

McCloud, Scott. *Making Comics: Storytelling Secrets of Comics, Manga and Graphic Novels*. New York, NY: Harper Paperbacks, 2006.

———*Reinventing Comics: How Imagination and Technology Are Revolutionizing an Art Form*. New York, NY: Harper Paperbacks, 2000.

———*Understanding Comics: The Invisible Art*. New York, NY: Harper Paperbacks, 1994.

Okum, David. *Manga Fantasy Madness*. Cincinnati, OH: Impact Books, 2006.

———*Manga Monster Madness*. Cincinnati, OH: Writer's Digest Books, 2005.

Plex, Inc. *Let's Draw Manga: Monsters*. Gardena, CA: Digital Manga Publishing, 2004.

Tsubota, Noriko, and Big Mouth Factory. *Let's Draw Manga: Fantasy*. Gardena, CA: Digital Manga Publishing, 2005.

Tomoko's Shoujo Manga

There are hundreds of different shoujo titles out there, and you should sample as many as you can. If you enjoyed the artwork in this book, we humbly suggest you check out some of the following titles created by the artist half of our team, Tomoko Taniguchi.

Aquarium, Volume 1. Central Park Media, 2003.

Call Me Princess. New York, NY: Central Park Media, 2003.

Just a Girl, Volume 1. New York, NY: Central Park Media, 2004.

Just a Girl, Volume 2. New York, NY: Central Park Media, 2004.

Let's Stay Together Forever. New York, NY: Central Park Media, 2003.

Miss Me? New York, NY: Central Park Media, 2004.

Popcorn Romance. New York, NY: Central Park Media, 2003.

Princess Prince. New York, NY: Central Park Media, 2003.

Appendix D

Recommended Websites

All Done with Machines

In today's world, books may seem quaint. They're static, which means changing anything in them requires a reprint or a whole new edition. You can't index them with a search engine. They don't consume electricity.

Of course, instant classics like this book are exceptions to the rule. Lessons like those you find in here never go out of style. And if you're trying to reproduce something on a page, there's no substitute for actually seeing it on a page first.

Still, the World Wide Web complements any other source of wisdom well. While you're surfing around, point your favorite browser to the following places for some further enlightenment.

Anime Expo *www.anime-expo.org.* A large convention centered on anime, manga, gaming, Japanese culture, and fan culture.

CMX *www.dccomics.com/cmx.* DC Comics' division devoted to publishing manga.

Comic Book Resources
www.comicbookresources.com. A great site for news about comics of all types.

Comipress *www.comipress.com.* A manga-centric news site.

The Drawing Board *www.sketchbooksessions. com/shanesboard.* An artists' community.

Emily's Random Shoujo Manga Page
www.shoujo-manga.com. A site filled with all sorts of reviews and summaries of shoujo manga, as well as information about the genre.

Forbeck.com *www.forbeck.com.* The official website of the writer of this book.

Manga Tutorials *www.mangatutorials.com.* Free tutorials on how to draw manga.

Manganews.net *www.manganews.net.* A news site devoted to manga.

Newsarama *www.newsarama.com.* An excellent general-comics news site.

The Pulse *www.comicon.com/pulse.* Up-to-the-minute comics news.

Shoujo Beat *www.shoujobeat.com.* The official site of the largest shoujo-focused magazine published in the United States.

System Apex *http://apex.syste.ms.* A site filled with links to Japanese artists' websites.

Tokyopop *www.tokyopop.com.* A top manga publisher.

Viz *www.viz.com.* A top manga publisher.

Learn how to draw Manga-style!

FULL COLOR!

THE COMPLETE IDIOT'S GUIDE TO

MANGA FANTASY CREATURES *Illustrated*

Matt Forbeck and Tomoko Taniguchi for Idea + Design Works, LLC

ISBN: 978-1-59257-636-4

- Hundreds of step-by-step illustrations

- An overview of the different types of manga characters and their props—and solid advice on how to draw them

- Idiot-proof tips on bringing your work to life with shadow, speed lines, angles, and point of view

- Basic drawing techniques to get you started

THE COMPLETE IDIOT'S GUIDE TO DRAWING MANGA *ILLUSTRATED*

♦ **Stroke-by-stroke explanations** of how to draw manga heroes, villains, and other characters

♦ **Idiot-proof tips** on bringing your work to life with shadow, speed lines, angles, and point of view

♦ **Expert advice** on crafting compelling backgrounds and environments

John Layman and David Hutchison for IDEA + DESIGN WORKS, LLC

ISBN: 978-1-59257-335-5